THE HOLY FAMILY
IN ART AND DEVOTION

THE HOLY FAMILY
IN ART AND DEVOTION

EDITED BY JOSEPH F. CHORPENNING, O.S.F.S.

WITH CONTRIBUTIONS BY

BARBARA VON BARGHAHN

JOSEPH F. CHORPENNING, O.S.F.S.

ROLAND GAUTHIER, C.S.C.

D. STEPHEN LONG

THOMAS M. LUCAS, S.J.

SCOTT R. PILARZ, S.J.

JOHN SAWARD

MOST REVEREND CARLOS A. SEVILLA, S.J., D.D.

CHRISTOPHER C. WILSON

WENDY M. WRIGHT

SAINT JOSEPH'S UNIVERSITY PRESS

PHILADELPHIA

36065979

ISBN 0-916101-25-8 paper

Published by:

SAINT JOSEPH'S UNIVERSITY PRESS
5600 City Line Avenue
Philadelphia, Pennsylvania 19131-1395

Saint Joseph's University Press is a member of the Association of Jesuit University Presses

Library of Congress Cataloging-in-Publication Data
The Holy Family in Art and Devotion / edited by Joseph F. Chorpenning.
 p. cm.
 Papers selected from those delivered at the Holy Family Symposium, held April 12-13, 1996 at Saint Joseph's University.
 Includes bibliographical references.
 ISBN 0-916101-25-8
 1. Jesus Christ—Family—Cult—Congresses.
2. Jesus Christ—Family—Art—Congresses. I. Chorpenning, Joseph F.
BT313.H63 1996
232.92—dc21
 96-39975
 CIP

Cover: Engraving after C. Wanloo, *The Flight into Egypt*, 19th c. Philadelphia, Saint Joseph's University Collection.

TABLE OF CONTENTS

TABLE OF CONTENTS

INTRODUCTION

1996 marked the seventy-fifth anniversary of the extension of the Feast of the Holy Family to the liturgical calendar of the Universal Church. To commemorate this significant event in the life of the Church, as well as to support the Church's mission of evangelizing families on the eve of the third millennium, Saint Joseph's University, Philadelphia's Jesuit university, and the Wilmington-Philadelphia Province of the Oblates of St. Francis de Sales co-sponsored the exhibition and symposium "The Holy Family as Prototype of the Civilization of Love: Images from the Viceregal Americas."

The essays collected in this volume, under the title "The Holy Family in Art and Devotion," were selected from among papers presented at the Holy Family Symposium held at Saint Joseph's University on April 12-13, 1996. The common thread which ties these essays together is that each offers a substantial analysis of a particular aspect of the iconography of, or the evolution of devotion to, the Holy Family. These essays are arranged chronologically according to topic. Thus, they provide an overview of select key moments in the development of the veneration of the Holy Family from the Middle Ages to the late twentieth century.

Scott R. Pilarz appeals to mid-1990s TV family types as a point of entry into late medieval English mystery plays, at the center of which were also families, such as Adam and Eve, Noah and his nasty, nagging wife, and the Holy Family of Jesus, Mary, and Joseph. In accord with the central Christian dogma of the Incarnation, the plays sought to make tangible and to give immediacy to salvation history by bringing its events and participants to life in English towns of the late Middle Ages. With a mixture of jest and seriousness, the domestic life of the Holy Family, as brought to life by friends and neighbors, embodies the audience's hopes and dreams for themselves and their own families.

Intense regional interest in St. Joseph's cult and the concomitant veneration of the Holy Family during the late Middle Ages and Renaissance blossoms into widespread popular devotion after the Council of Trent (1545-1563). It is a commonplace in the history of spirituality that Ignatius Loyola (1492-1556), Teresa of Ávila (1515-1582), and Francis de Sales (1567-1622) played a pivotal role in this popularization. The essays by Thomas M. Lucas, Christopher C. Wilson, and Joseph F. Chorpenning examine and define the contribution of each of these three great saints to the growth of devotion to St. Joseph and the Holy Family.

Lucas begins by pointing out that, in making the *Spiritual Exercises*, "the retreatant spends a considerable amount of time—up to five hours a day for four full days—in the company of the Holy Family." He then proceeds to examine the images of the Holy Family in Ignatius' restored rooms in Rome. Apropos of the journeyman Italian cinquecento painting of the Holy Family which hung over the altar in Ignatius' private chapel, Lucas observes: "it is before this image that Ignatius repeatedly celebrated the Eucharist, experienced mystical visions, and wept so many tears of devotion that his physician forbade him under obedience to weep during Mass in order to preserve the saint's failing health. Ignatius' *Spiritual Diary* testifies to the fact that he took many of the most difficult dilemmas he had to confront while composing the Constitutions of the Society of Jesus to this altar. It is not much of an exaggeration to say that the Society of Jesus took flesh before this painting."

A seventeenth-century Jesuit author simply but eloquently describes St. Teresa as "greatly beloved by and a great lover of the Holy Family" (*Jesuit Relations*, 22:211). The Holy Family was a decisive and formative presence in St. Teresa's life and Carmelite reform. For example, a vision which Teresa had prior to the foundation of her first reformed monastery of St. Joseph's in Ávila revealed that St. Joseph and the Virgin Mary watching over and rapt in contemplation of the Christ Child in the stable of Bethlehem and in the House of Nazareth was to be the prototype for the Teresian Carmel. Wilson's essay demonstrates that Teresa's testimony, recorded in her writings, of the privileged relationship with the Holy Family which she and her nuns enjoyed was an important source of inspiration for devotional art in Colonial Spanish America. Paintings from Mexico and the School of Cuzco in Peru of episodes from Teresa's life and of complex allegorical subjects, such as The Carmelite Garden, are a visual chronicle of the significance of St. Joseph and the Holy Family in the Mother of Carmel's life and reform. They also visualize the manifold contributions made by Teresa and her reformed Carmelites to disseminating these devotions in the post-Tridentine Church in both Europe and the Americas.

Francis de Sales was another saint and Doctor of the Church who exalted the Holy Family in the period after the Council of Trent. It is noteworthy that, as a student at the Jesuit College of Clermont in Paris and then under the direction of the Jesuit humanist, jurist, and papal diplomat Antonio Possevino (ca. 1533-1611) at Padua, Francis was schooled in the imaginative world of the *Spiritual Exercises*. He was also deeply impressed by the spiritual theology of St. Teresa, whose writings he read in French translation. The Holy Family is as significant in Francis' spiritual doctrine as it is in Ignatius' and Teresa's. As Chorpenning's study of Francis' rich and well developed theology of the Holy Family shows, the bishop of Geneva proffers the Holy Family "as enfleshing, indeed as

the prototype, of the major themes of his own spiritual doctrine, specifically the significance of little things, the hiddenness of authentic spiritual growth and greatness, and making the humble, gentle heart of Jesus come to life in human relationships—in this case, married and family life." Moreover, Francis' reflections on the familiar life of Jesus, Mary, and Joseph can be of invaluable assistance in responding to Pope John Paul II's invitation to the world's families to find in the Holy Family "their sure ideal and the secret of their vitality," because the Gentleman Saint's writings help us to access this ideal and to unlock this secret.

John Saward offers another perspective on the burgeoning cult of the Holy Family in seventeenth-century France, namely, that of the French School, which he defines as a school of spirituality, a movement of missionary endeavor, and a climate of reforming zeal. Its founding fathers are Cardinal Pierre de Bérulle (1575-1629), the founder of the French Oratory, his disciple in the Oratory, Charles de Condren (1588-1641), and Condren's disciple, Jean-Jacques Olier (1608-1657), founder of the Sulpicians. Saward examines the French School's doctrine of the Holy Family which contributes to a veritable explosion of its cult both in Old and New France. The most striking element of his analysis is undoubtedly the contrast between *le grand siècle* when France was at its cultural and political apogee and the French School's emphasis on the evangelical tradition of non-conformity to the world. In the author's own words, "In the very years when the princes of this world parade their glittering greatness, the Bride of Christ honors the hidden life of the King of Kings. There is a breathtaking divine wisdom at work here. As the world swells with pride before the splendors of Versailles, the Church kneels before the humilities of Nazareth."

Yet another manifestation of the strength of French devotion to the Holy Family is its rapid spread in seventeenth-century New France, as Canada was called during the Colonial period. This is the subject of Roland Gauthier's essay. Gauthier charts the growth of the veneration of the Holy Family in this harsh and dangerous frontier land by focusing on key moments in this story: its beginnings in the 1630s and 1640s, e.g., the missionary vocation of the Ursuline nun Blessed Marie of the Incarnation (1599-1672) to build a house in Canada where Jesus, Mary, and Joseph would be honored and the consecration by the founders of Montreal of the city to the Holy Family of Jesus, Mary, and Joseph; the foundation of the Confraternity of the Holy Family by the Jesuit missionary Pierre Joseph Chaumonot (1611-1693), who conceived of this association as a way of promoting the Holy Family as a model for all Christian homes; the institution of the Feast of the Holy Family by Blessed François-Xavier de Montmorency-Laval (1623-1708), the first bishop of New France; surviving examples from New France of the iconography of the Holy Family.

Barbara von Barghahn's essay also focuses on the Americas during the Colonial era, specifically the Viceregal Americas, a generic term which refers to those territories, which, until the nineteenth century, were Spanish dominions. Well into the seventeenth century the word "family" was generally understood to mean "extended family," or all those living under the authority of the *paterfamilias*, rather than "nuclear family," as it does today. Devotional art often reflected this historical reality by including members of Jesus' extended family—Anne and Joachim, John the Baptist and Elizabeth—alongside the members of His nuclear family. Von Barghahn's study explores this theme by examining the importance of the cult of St. Anne in Spain and Viceregal Peru. One of the hallmarks of Viceregal

devotional art is that it often blends Amerindian and European cultures. Interestingly, the indigenous population of the Andes associated Anne with the Inca queen or *coya*, who was the matriarch of the empire, as well as with the Inca goddess Pachamama, who represented Mother Earth.

Pope Leo XIII (reigned 1878-1903) ushers in the modern era of devotion to the Holy Family. Confronted with attacks on the family by the Industrial Revolution, the State, and selfish individualism, Leo insisted, throughout his pontificate, that imitation of the Holy Family is the primary means to revitalize and to strengthen family life. While Leo's major contribution to the evolution of the liturgical cult of the Holy Family has long been recognized, the connection between his promotion of veneration of the Holy Family and his social teaching has not received the attention it merits. D. Stephen Long's commentary on Leo's most well-known encyclical *Rerum Novarum* (1891) fills this lacuna. Long argues that, in this cornerstone of the modern tradition of Catholic social teaching, Leo's insistence on the Holy Family as the exemplar of economic virtue is a necessary corrective to economic liberalism's view that the family is a function of the economy.

The initial essay in this collection suggested that the portrayal of the Holy Family in English mystery plays modeled for late medieval people how to become what they beheld—holy families. Coming full circle, Wendy M. Wright's essay makes an analogous point, but with an important difference: it is we, not our medieval forebears, who are invited to embrace the holiness incarnated in familied life. For Wright, this invitation is grounded in the Ignatian/Salesian spiritual tradition, which is profoundly incarnational, sacramental, and dynamic. The divine is imaged and revealed in what is most human. Accordingly, the family is holy ground, with the divine presence being identified "with the sacrament of the care of others, with the mutual sacrifices and loving service performed on each other's behalf, in the hospitality offered to those outside the family, in the rituals of mutual need and nourishment enacted at the family table, in the solicitous protection and instruction of the young, and the honor and care given to the elderly."

Our volume is rounded off with two documents which were occasioned by the Holy Family Symposium and which were read at this program's Opening Mass. The first is a letter from the Vatican Secretariat of State to Anthony Cardinal Bevilacqua, Archbishop of Philadelphia. This letter extends Pope John Paul II's cordial greetings to those attending the Opening Mass and to all the Symposium participants, communicates the Holy Father's conferral of his Apostolic Blessing, and offers a profound meditation on the Symposium's theme of the Holy Family as Prototype of the Civilization of Love. The second document is the homily delivered by Bishop Carlos A. Sevilla, S.J., D.D., who was the principal celebrant at the Opening Mass. Bishop of Yakima (Washington) and a member of the U.S. Bishops' Committee on Marriage and Family Life, Bishop Sevilla presents a masterful synthesis of the "most significant elements" of the teaching on the Holy Family of Pope John Paul II, especially his 1981 apostolic exhortation *Familiaris Consortio* on the role of the Christian family in the modern world, and of the bishops of our own country. These documents invite us to enter ever more deeply into contemplation of the mystery of the Holy Family of Nazareth and its essential significance for the world's families on the eve of the third Christian millennium.

The Symposium's co-sponsors express again their deep gratitude to the Holy See, to Bishop Sevilla, to all the scholars who presented papers, and to all those who attended. We hope that this program, as well as the accompanying exhibition, serve as a catalyst for reflection on the Holy Family of Jesus, Mary, and Joseph in a way which strengthens and builds up married and family life, particularly in our own region.

Joseph F. Chorpenning, O.S.F.S.
Editor

LETTER FROM THE VATICAN SECRETARIAT OF STATE TO ANTHONY CARDINAL BEVILACQUA, ARCHBISHOP OF PHILADELPHIA

SECRETARIAT OF STATE

FIRST SECTION - GENERAL AFFAIRS

N. 388.777

FROM THE VATICAN, March 23, 1996

Dear Cardinal Bevilacqua,

The Holy Father was pleased to be informed of the Symposium on the Holy Family, to be held at Saint Joseph's University in Philadelphia, on April 12-13, 1996. He asks you kindly to convey his cordial greetings to those present at the Opening Mass and to all the participants in the Symposium.

As the second Christian Millennium draws to a close, His Holiness is urging the Church to renew her commitment to the evangelization of the family, since it is through this community of persons that there "passes the primary current of the civilization of love, which finds therein its 'social foundations'" (*Letter to Families*, 15). The Holy Family of Jesus, Mary and Joseph is the living icon and exemplary model of spousal and family love which is at the very heart of the New Covenant (cf. Eph 5:32). The message of God's saving plan for all families radiates from the Family at Nazareth, in which the Gospel of life was proclaimed by the witness of word and deed. Imitating the Holy Family, every family is called to become a school of human enrichment and Christian virtue, a community of solidarity, a vital cell of the civilization of love.

Entrusting those taking part in the Symposium to the protection of the Holy Family, His Holiness prays that they will devote themselves with ever greater fervor to building a culture of life and love, in which the family can truly flourish. As a sign of his special affection, the Holy Father imparts the requested Apostolic Blessing.

With every good wish, I am

Sincerely yours in Christ,

+G.B. Re
Substitute

Cardinal Anthony J. Bevilacqua
Archbishop of Philadelphia
222 North 17th Street
Philadelphia, PA 19103

THE HOLY FAMILY'S CONSECRATION, COMMUNION, AND MISSION

Most Reverend Carlos A. Sevilla, S.J., D.D.

Dear Brothers and Sisters in Christ,

The Church teaches us that the power of God at work in the early generations of disciples led to the formation of the Gospels in written form through the contemplation of the decisive importance of all the events related to the life of Jesus. First, His death and resurrection, then, the events from the time after the resurrection to the coming of the Spirit at Pentecost (this is the context for our readings today from the Acts of the Apostles and the Gospel of John), but then also the public life of Jesus and, finally, the pre-history of Jesus as man, as well as the events related to His birth and those of the years before His public ministry.

There is a symmetry, then, it seems to me, without denying the extremely significant difference, between our gathering to reflect on the Holy Family of Jesus, Mary, and Joseph in this Symposium during this week after Easter, and the way the first generations of disciples were nourished by their Spirit-inspired contemplation of the Holy Family in the years after the first Easter. Indeed, a strong case could be made that every generation of Christians needs to be nourished by a contemplation of all the events related to the life of Jesus, so that we can live out His Gospel more authentically in our own lives and make it known more joyously in all the world for its salvation and peace. And so we see the importance of the present exhibition of images of the Holy Family from the Viceregal Americas. They are an example of the ongoing contemplation of Jesus, Mary, and Joseph by the community of faith we call the Catholic Church. These images nourish faith and commitment in the unique manner that art offers us a prism through which the material world reveals the presence of God.

In our own generation, Pope John Paul II has made a major contribution to this ongoing, loving contemplation of the Holy Family through a number of his writings. I would emphasize

especially his apostolic exhortation *Familiaris Consortio* (1981), on the nature and tasks of the Christian family, in which the Holy Father also considers the scope of pastoral care needed by families, and his *Letter to Families* and *Letter to Children*, both published in 1994, the year designated the "Year of the Family" by the United Nations. In that same year and related to the same observance, the United States Catholic Bishops' Committee on Marriage and Family Life published a widely acclaimed pastoral message to families entitled *Follow the Way of Love*.

I think it important now to highlight in synthetic form the most significant elements in the teaching on the Holy Family found in the documents I have just cited of Pope John Paul II and the bishops of our country in which these shepherds all carry out the Church's mission of evangelization of families by letting the Holy Family "speak to modern families" by its example. There are three points to be made: consecration, communion, mission.

First, *consecration*. If, as was written by the early Christian writer and Father of the Church St. Irenaeus, in the second century, "the glory of God is man fully alive," then the fullness of being a human person and a community of human persons is consecration to God. This was so true of the Holy Family that, as we know, it was sometimes described as the earthly trinity and is so depicted in one of the major works of this exhibit. Consecration to God implies familiarity with the God who is holy and who hungers to share His life with all the human persons He has lovingly brought into being. Family life is holy ground, and the family is holy, not because it has achieved the perfection of holiness, but because, as the domestic church, the primary community of faith, it strives to live out its baptismal consecration with ever more integrity through its commitments of spousal, parental, and filial fidelity. Every family, according to its measure of grace, is called to move toward a greater and greater mirroring of the perfection of God by its consecration to Him.

Second, *communion*. The Holy Family was no stranger to suffering. The Gospels of Matthew and Luke call our attention to this when they describe the unusual circumstances following Mary's betrothal to Joseph; Mary's concern for her cousin Elizabeth; the difficult days in Bethlehem at the birth of Jesus; the impact of Herod's rage when he heard of the birth of a king and the resulting flight of the Holy Family into Egypt; Simeon's prophecy on the occasion of Jesus' presentation in the Temple that He will be a "sign of contradiction" and that "a sword will pierce" Mary's heart; as well as the anguish of Mary and Joseph when Jesus could not be found after their journey to the Temple in Jerusalem. But suffering seems to have enlarged the Holy Family's capacity to love selflessly and to be in communion with one another and with others through compassion and forgiveness.

I think the communion of heart and mind between Jesus and Joseph is especially important. For example, it might never have occurred to Jesus, taking only His human nature into account, to refer to His heavenly Father as *Abba*, which we know is a tender and familiarly intimate way for a child to refer to its father, if Jesus as a child had not had precisely the kind of relationship with Joseph which led Him, in all probability, first to address Joseph as His earthly *Abba*.

The saving love of Jesus on the cross for all of us is the fullness of love He humanly learned from the loving and self-sacrificing communion of His family life. Every family is called to this loving communion of selfless love.

Third, *mission*. The Holy Family was well aware that it did not exist for its own sake, but that its life was for the world, to carry out the life-giving mission of evangelization, of proclaiming the good news of God's unconditional love and fulfilling justice to all. This is seen, of course, in Jesus, but also in the person of Mary at Cana and at Calvary when she is a divine intrument of grace for others. Every family is called to take part in this mission of evangelization by sharing with others the challenging and consoling message contained in the words, actions and life of Jesus. Pope John Paul II has called our attention to the need for a new evangelization. Not in the sense that something needs to be added to the good news revealed by Jesus, but in the sense that Jesus' Gospel needs to be proclaimed with greater ardor, greater creativity and greater outreach.

Christian families must be their own first focus of this evangelizing mission. Every family is called to deepen its faith by the fuller understanding that can come from study, reflection and discussion of the Bible and of the documents of the Church. Every family is called to a loving outreach to relatives, friends, and neighbors who no longer practice their faith, as well as to those who live their lives in the difficult circumstances of divorce or single-parent and blended families. Our families also need to be prophetic faith communities regarding political and economic realities in our world and in our nation that touch on the well-being of families. Families must stand strongly committed to life in a society that is often deceived by a culture of death in which abortion, euthanasia, violence and prejudice undermine the healing and hope that, especially today, Jesus offers to the world.

Art for art's sake, yes, but it's not enough to admire the beauty of the images that summon us to this Symposium. Let our contemplation of the Holy Family lead us to strengthen families, especially those we belong to and know. May we, through a greater spirit of consecration, communion, and mission, like Jesus, Mary, and Joseph, embody for the human family the hope and joy that comes to those who believe.

"I HAVE OUR HELP HERE IN MY ARMS":
THE HOLY FAMILY ON THE MEDIEVAL STAGE

Scott R. Pilarz, S.J.

Ask an average American college student to describe her family, and she might well do so in terms of the domestic units that live in television land. "We're a cross between the Bradys and the Simpsons," she might say. When it comes to conversations about family life, for at least two generations now our points of reference have been TV types: Williams, Cleavers, Petries, Flintstones, Clampetts, Bunkers, Huxtables, Conners, and Cranes. And if in this sequence of sitcom clans you detect a subtle but certain shift in the direction of dysfunctionality, you are not alone. Writing in *The New York Times* on December 3, 1995, cultural critic Caryn James contends that "television helps shape reality": "The series present these families as typical. . . . In the vicious circle that flows between television and society, a show takes [a] kernel of real life, exaggerates it, then beams it back in its most outrageous form, still posing as ordinary. Experience to the contrary, viewers may begin to wonder if what they are watching is normal everywhere else in the country. The most powerful subterranean message sent by television, after all, is: if it's on TV, it must be true."[1]

James wants to show how the images of family life presented in most half-hour programs are not sustaining. If clans such as the Cleavers were too good to be true, then today's sitcom families are too troubled. TV relations who modeled fifties-style conformity "ultimately imploded on the strength of their own unbelievable goodness." Likewise, James predicts, the nineties' version of the same is headed for a train wreck because these days the familial tracks lead not to Petticoat but to Dysfunction Junction. "As sitcoms approach dysfunction overload," she writes, "they have come to resemble melodrama and soap opera more than they reflect comic versions of real life": "As their problems pile up, these proud-to-be-dysfunctional families seem ever less attached to reality." As an antidote to all this, James wants to argue that such shows will work best "when they assume a leavening attitude toward weighty problems." James complains that if television is holding a mirror

up to the nature of American family life, then the glass is much too dark. She, and many of us with her, want more light.

Might I suggest a medieval solution to this postmodern problem? The representation of family life by means of an artifact of popular culture is nothing new.[2] In fourteenth-century England, audiences were annually treated to enactments of domestic life in the medium known as the mystery or cycle play. Once a year, usually on the feast of Corpus Christi, various civic and professional groups staged a series of pageants in the streets of major cities.[3] (If Philadelphians need an analogue, we might think of our mummers.) These pageants would present the whole history of salvation, from Creation to Doomsday.[4] Each biblical event was rehearsed in a short segment by a particular guild or confraternity, and often enough there was some connection between occupation and episode. For example, the sausage makers would stage the suicide of Judas. At the dramatic conclusion of the scene, when Judas' guts would burst open and spill out, the sausage makers could easily provide the props.[5]

In the course of the cycle, audiences would watch several families in action, including Adam and Eve; Noah and his nasty, nagging wife; and, finally, Jesus, Mary, and Joseph. I introduce the first two families as evidence that there is nothing uniquely postmodern about kin-in-crisis. When today's TV families suffer from alcoholism, spousal abuse, unemployment, impotence, infidelity, and incest, they simply prove themselves to be near-relations of these biblical broods. And on the medieval stage, as well as on last week's episode of any number of sitcoms, these problems are mixed with what is meant to be a fair amount of wit. There is a decisive difference, however, both in terms of the types of humor intended in these two genres, and in their respective ways of resolving of domestic difficulties. Contemporary TV families routinely settle for the easy laugh and the quick fix— snappy answers to complicated questions. In the mystery plays, it is God who has the last laugh, and the audience learns a lesson about taking the long view of their problems. For all of their collusion with the economic powers-that-were, the mystery plays did not labor under the pressure to find solutions, both funny and fast, just in time for one final commercial.[6] On the medieval stage, the joke was always on the forces of evil, often on Satan himself; and solutions came in good time. They came in God's time. It took the whole of one of the longest days of the year to stage a complete medieval cycle, just as it will take the whole course of salvation history for families, along with the rest of creation, to be saved. But be saved they will, and there's the important rub for us. The cycle plays show that for all its fragility, foibles, and fractures, the family can still be a site where grace builds on nature. Medieval men and women believed in salvation by association, and the mystery plays make it clear that family ties can be among the most redemptive of relationships.

In what follows, I will read these plays with an eye toward uncovering the familial attitudes of the lay majority in early modern England. According to recent historians, this lay majority has for too long been considered "the great mute," or "a people without archives or faces."[7] In considering the Holy Family on the medieval stage, I hope to provide some sense of how these ordinary people faced the realities of family life. Too often, we settle for an elitist view of life in the Middle Ages, based "on the thoughts of 'high-brows'—theologians, philosophers, poets, and historians."[8] While much too sophisticated to be dismissed as "low-brow" entertainment, the plays which I will

discuss were the products of medieval popular culture, and as such they constitute rich sources "which allow us to approach the mentality of the masses."[9] So, I will concentrate on the familial *Weltanschauung* of ordinary medieval people, their "mental make-up" and the collective psychological setting, insofar as these are revealed in the medieval drama. My hunch is that in annually producing the cycle plays, the residents of York, Coventry, and other cities were rehearsing not only stage craft but also "a system of implicit norms."[10]

Year after year, as Jesus, Mary, and Joseph appeared on the pageant wagons, they not only revealed to their audiences how things were thought to be in biblical times, but also how things ought to be in early modern times. As is true of the medieval construction of saints in general, "it was precisely in . . . [this] constant repetition of the same motifs that certain fundamental social values were confirmed [and] . . . the presence of this ideal in the context of [popular] culture was in itself an important aspect of religious education."[11] Our task, then, is to employ the mystery plays in order to "elucidate those mental constructs and customary orientations of consciousness, the 'psychological equipment' and 'spiritual rigging' of medieval people,"[12] with a particular eye toward how these related to family life. The members of the Holy Family, or at least two of them, are saints; and, as scholars remind us, "we study saints in order to understand piety; [and] we study piety in order to understand society, for it is one of our basic premises that the pursuit as well as the perception of holiness mirrored social values and concerns."[13]

In order to play out my hunch about the function of the Holy Family in the Corpus Christi drama, then, something needs to be said about the role of saints in medieval society. We need to appreciate how the people were in close contact and mutual interaction with saints, and how the saints actively participated in and influenced human life. If this sounds odd to postmodern ears, consider the fact that some people—even some of us sophisticated academic types—still resort to burying statues of St. Joseph, upside down no less, when trying to sell a house. How many people whom you know put a plaster statue of Mary in the window on the night before their wedding? Medieval people would have done this without feeling the least bit sheepish because they believed that saints were "endowed with human emotions, passions, interests and reactions—nothing human was foreign to [them]," and certainly not family life.[14] Even when saints' lives were written by clerics, these texts "embodied" what one scholar calls "the memory of the crowd."[15] How much more, then, will this be the case with saints who appear in plays produced by ordinary tradesmen?

When the guilds of medieval York presented the Holy Family to their fellow citizens, they were depicting "an embodiment of their hope for achieving equal sanctity."[16] Equal, that is, to the kind of sanctity possible for priests and nuns. And even more to the point, they were making a case that such sanctity could be achieved in a very specific place, York itself.[17] According to the historian Georges Duby, it was during the thirteenth and fourteenth centuries that "the cult of the saints was 'brought to earth' [and] ... particularized."[18] This, I think, is precisely what happened to the Holy Family on the medieval stage. In and through the cycles, each major English city was appropriating Jesus, Mary, and Joseph for itself. As a result of the fact that these characters were played by citizens of a particular city, they were imagined to become citizens of that city. The point, of course, is that sanctity was possible in that very time and place. If York could be home to one very Holy Family,

even if only for a day, then it might well be home to lots of holy families. It must have seemed to the audience that the major events in salvation history were taking place in the here and now. The entire city has been transformed into a stage, and because "the characters are Yorkshire people [and] the place is York . . . the spectators gradually recognize that they are really in [Bethlehem or] Jerusalem." In the Nativity play, for example, "Joseph and Mary are, of course, pictured as a poor Yorkshire couple, just arrived in the city which is inordinately crowded, and they are forced to stay overnight in a broken-down stable. The scene is, in general, true to its historical source; but it also puts one in mind of the present time where the crowded city street is lined with spectators, and the audience consequently becomes part of the dramatic setting. The Holy Family is thus put into the midst of the poverty of Yorkshire. . . . Jesus is born into its midst; He has for now become a son of York."[19] The result of this mode of dramatic representation is nothing less than "a new understanding of the road to salvation."[20]

In the mystery plays, then, we can observe "the struggle . . . of the Christian laity to carve out for themselves a religious role that would concede some spiritual dignity to the circumstances and concerns of their daily lives."[21] The plays point to the "growth of the laity's role [in the early modern Church]," and this growth is related to "the rehabilitation of the active life in Christian spirituality . . . in the context of an incarnational Christianity which exalted God's humanity."[22] In fact, the construction of the Holy Family on the medieval stage may be the best available evidence that the fourteenth century constituted "the golden age of the laity, which is all the more remarkable for its striking contrast with the epochs that immediately preceded and followed it."[23]

As V. A. Kolve argues, "the greatest strength of the Corpus Christi drama . . . lies in its manner of showing human goodness,"[24] and it is my contention that nowhere is this strength more evident than in its presentation of the Holy Family. In the mystery plays, Jesus, Mary, and Joseph "are not pale abstractions, . . . but creatures of flesh and blood."[25] Perhaps because they were alienated from other aspects of Church life, including reception of the Eucharist, lay men and women were hungry for a kind of communion with these characters, and the plays made this communion possible.[26] For example, we repeatedly encounter dramatic devices aimed at "including the spectator as an actor within the . . . play, rais[ing] him from observer to participant, not only of the play—but of the religious experience it represents."[27] Among the most popular of these devices, of course, is comedy. For example, when the York cycle presents Adam and Eve, the antitypes of Mary and Joseph, we are meant to laugh at their marital strife. Eve complains about Adam's postlapsarian lust, and we are reminded that the old "not tonight dear, I have a headache" argument was once new. The dramatist hopes to make the audience identify with these characters through laughter: "Adam and Eve's squabble about their respective responsibilities draws the audience toward identification precisely because it is archetypical. Both the actors and the spectators are emotionally involved in an age-old struggle," and this old struggle does not end with the onset of the New Covenant.[28] Mary and Joseph also argue, and some of the difficult issues sound awfully familiar.

Take, for example, the York play of The Flight into Egypt.[29] Here the holiest of husbands and wives have a dispute about directions. The pageant opens with Joseph hoping to catch a nap:

I waxe as wayke as any wande,
For febill me faylles both foote and hande;
Whateuere it mene,
Methynke myne eyne
Hevye as leede.
Therfore I halde it best
A whille her in this stede
To slepe and take my reste. (17-24)[30]

(I grow as weak as any shoot,
For my foot and hand both fail me in feebleness;
Whatever it mean
Methink mine eyes
Heavy as lead.
Therefore I hold it best
A while here in this place
To sleep and take my rest.)

Just as he dozes off, an angel arrives to annoy him, and not for the first time. Ever since his betrothal to Mary, Joseph has been suffering from a kind of angelically-induced insomnia. Every time he goes to bed, he gets more bad news from Gabriel. When he tells Mary that the Angel wants them to flee Bethlehem for Egypt, she becomes extremely, if understandably, agitated. He loses his patience with her and shouts, "We, leue Marie, do way, late be!/ I praye the, leue of thy dynne . . ." (147-48), 'Beloved Mary, have done, stop it!/I pray thee, stop your clamoring.' As they pack up, Mary forgets where they are going. An exasperated Joseph responds, "To Egipte—talde the lang are," 'To Egypt—I told you long before this.' She innocently asks if her husband knows how to get there. He does not have a clue: "What wate I?/I wote not where it stande," 'What do I know?/I don't know where it is.' Nevertheless, like all men before and since, Joseph sets out without a map and refuses to ask for directions. Surely, the audience responds to this recognizable trait with laughter; but the comedy here does not indicate a lack of reverence. On the contrary, its effect is "to turn the theological mystery of the Incarnation into a homely, human event," for the point of the pageant is that "the miraculous happens in the natural world."[31] "Joseph and Mary are charged with the rearing of Jesus, and though God and His angels may intervene at will, it remains a human marriage. The medieval dramatist thought that to conceive it so was to do it honor. . . . The silences of Scripture are filled in with details designed to show the Incarnation happening among, and for, people like those in the audience."[32]

 The laughter which lures the audience into the play is hardly an end in itself. Instead, it is propaedeutic to a medieval brand of mystagogy, or the interpretation and explanation of various signs and symbols.[33] While some scenes in the life of the Holy Family are certainly played for laughs, others model a pattern for marital sanctity that is surprisingly progressive. There is, for example, a

considerable degree of mutuality in the marriage of Mary and Joseph. They seem to share responsibilities for their son, and at various times each partner takes the lead in explaining God's will to the other. It becomes very clear that they need one another in order to discover and do God's will. In the York version of Joseph's Trouble about Mary, the pageant that immediately follows the Annunciation, Joseph is presented as a bit dense in regard to the divine agenda. Sex is a sticking point for him, and only Mary's calm insistence and careful instruction enable him to get his mind off the subject. That this model husband is willing to listen to and learn from his wife is evinced in the following pageant of the Nativity which opens with Joseph praying rather than complaining. He still needs Mary's advice at this point, but he is willing to ask for it: "Say Marie, doughtir, what is thy rede,/How shall we doo?" (20), 'Say, Mary, dear wife, what is your counsel, what shall we do?' Immediately after the birth of Jesus, Joseph still requires Mary to explain God's plan for him. She must reveal that the birth of her son is the fulfillment of prophecy (99-105). The benefits of listening to his wife soon become evident, however. At the close of the scene Joseph, too, can understand the meaning of Scripture: "O, nowe is fulfillid, forsuth I see,/That Abacuc in mynde gon mene/ An prechid by prophicie" (136-38), 'O now understand that what Habaccuk had in mind and preached by prophecy is fulfilled.'

Let me end by returning to the play with which I began, The Flight into Egypt. When Joseph speaks at the start of the play it is to set forth sound doctrine for the edification of his wife and his audience, and any cares he expresses are out of concern for his family (4-12). The complaining Joseph of the Trouble play now takes his turn as the model parent and provider. Whereas earlier in the cycle it was Joseph who repeatedly had to ask Mary about the meaning of events, here their roles are reversed. Joseph recognizes that in this instance his wife needs him. She calls forth from him both strength and sensitivity. He admits "are was I wayke, nowe am I wight./My lymes to welde at my wille./I loue my maker most of myght/That such grace has graunte me tille" (219-222), 'previously I was weak, but now I am strong, and can use my limbs at will. I love the Almighty, my maker, that has granted me such grace.' When Mary is too tired to carry her infant Son, Joseph gladly holds Him for her. In this moment of model mutuality, he can speak the most touching and true lines in the play: "Nowe schall no hatyll do us harme,/I haue oure help here in myn arme" (223-224), 'Now shall no man do us harm, I have our help here in my arms.'

At our historical distance from the era in which the cycle plays were performed it is difficult to gauge the effect of the performances on their original audience or to measure any possible influence they might have had on behavior. What is clear, however, is that the people of medieval England recognized that "the central Christian mystery [of the Incarnation] furnished a dramatic situation that was theatrically complex, theologically sensitive, and socially relevant."[34] In their construction of the Holy Family in the Corpus Christi cycles, the women and men of the Middle Ages might well have been acting out their hopes and dreams for domestic life. While watching their friends and neighbors play Jesus, Mary, and Joseph, they would have had good reason for wanting to become what they beheld—holy families. In a very recent novel entitled *Morality Play*, concerning a troupe of traveling players in the fourteenth century, a character speaks of such desires and their possible effects: "'We learned through the play. . . . We learned through the parts we were given. It is

something not easy to explain. I am new to playing but it has seemed to me like dreaming. The player is himself and another. When he looks at the others in the play he knows he is part of their dreaming just as they are part of his. From this come thoughts and words that outside the play he would not readily admit to his mind.'"[35] For families in the fourteenth century, the kind of domestic life modeled by Jesus, Mary, and Joseph was such stuff as dreams are made of. Perhaps we can learn from them and their plays to make the Holy Family part of our dreaming as well.

NOTES

[1] "Dysfunction Wears Out Its Welcome," *The New York Times*, Dec. 3, 1995, sec. 2: 37.

[2] Along with J. W. Robinson, I want to acknowledge that the word "popular" is ambiguous. As he notes, "the plays were not necessarily popular in the sense that Elizabethan plays (which were commercially viable) were, but rather in the sense that they were officially backed, financed by a tax imposed on employers, and performed during a holiday period" ("The Late Medieval Cult of Jesus and the Mystery Plays," *PMLA* 80 (1968):508-14, at 512). On a similar score, V. A. Kolve contends that the Corpus Christi plays constitute "the most truly popular drama England has ever known." As evidence for his claim, he points to the enduring affection of the medieval audience, noting that "[even] though some fifteen hours were required to play the story out, its audiences came to watch it again and again, [and] it held the stage for more than two hundred years" (*The Play Called Corpus Christi* [Stanford: Stanford University Press, 1965], 1).

[3] There are four extant versions of the plays, York, Chester, Towneley or Wakefield, and N-Town or Coventry, but as Kolve notes, many other cycles including Newcastle, Norwich, and Beverly, are lost to time.

[4] The reason why these plays grew up around the Feast of Corpus Christi is treated by Kolve (33-56). The feast itself was effectively established in 1311, and the first mention of a play associated with it is in a York record of 1376. While there are medieval plays which celebrate the doctrine of transubstantiation, oddly enough the Corpus Christi plays do not. Instead, as Kolve shows, "the primary dramatic response to the Corpus Christi occasion was . . . a play of the history of the world, from Creation to Judgment": "This was a very different way of 'celebrating' this maximum gift of God: instead of concentrating on the Sacrament's temporal power to work miracles, to convince and convert, it looked instead on its eternal power to alter the destiny of the human race. . . . To play the whole story, then, is in the deepest sense to *celebrate* the Corpus Christi sacrament, to explain its necessity and power, and to show how that power will be made manifest at the end of the world" (48).

[5] Additional examples of this kind of "symbolic affinity" are cited by Mervyn James. He notes that "the Bakers, connected with bread, were commonly given the Last Supper Play; [and] Watermen and Shipwrights almost always furnished the plays of the Flood and Noah's Ark" ("Ritual, Drama and Society in the Late Medieval English Town," in *Society, Politics and Culture: Studies in Early Modern England*, edited by Mervyn James [New York: Cambridge University Press, 1986], 16-47, at 37). According to Martin Stevens, this kind of symbolism is "no mere comic by-product of dramatic presentation but a vital part of its motivation and meaning": "Modern sophistication often makes fun of the quaintness and artlessness of medieval play craft, [but] the fact is that the trade or craft was defined by what it did, and the demonstration of its wares or skills as a part of the anachronism of play craft linked the performer with the play and created a larger meaning for the performance. The linkage helped to incorporate the city's ordinary purpose—its daily ritual of work and human intercourse—into the play action and thus into the grand design of salvation history" (*Four Middle English Mystery Cycles* [Princeton: Princeton University Press, 1987], 29).

[6] The relationship between the plays and the prevailing economic order is explored by James who foregrounds the late medieval social background and the needs and pressures against which the cycles were performed. He wants to show how "social wholeness was the central emphasis" of both the Feast of Corpus Christi and the pageants. To this end, the plays "defined the identity and projected honor of the particular occupational community in relation to the social body in which it was involved" (James, 33). As years went by and the fortunes of various guilds rose and fell, pageants, some of which were costlier to stage than others, were assigned on the basis of which guilds could afford to produce them. Thus, the drama "provided a mechanism by means of which status, and the honor which went with status, could be distributed and redistributed with a minimum of conflict resulting" (James, 34-35). The plays also served a self-consciously civic function. In York, for example, "the Corpus Christi play was no mere popular entertainment, no ordinary annual festive occasion; it was the city's proud and solemn celebration of itself" (Stevens, 17).

[7] Aron Gurevich, *Medieval Popular Culture: Problems of Belief and Perception*, translated by Janos M. Bak and Paul A. Hollingsworth (New York: Cambridge University Press, 1988), xiv.

[8] Gurevich, xiv.

[9] Gurevich, xv.

[10] Gurevich, xvii. For a discussion of the didactic quality of the plays see Alicia K. Nitecki, "The Dramatic Impact of the Didactic Voice in the York Cycle of Mystery Plays," *Annuale Mediaevale* 21 (1981): 61-76, who makes a case that such didacticism contributes to dramaturgy. She rightly observes how the most didactic moments in the York cycle result in "the reduction of aesthetic distance." Consequently, "the past, historical act is rendered on stage in terms of its present spiritual application for all" (61).

[11] Gurevich, 43. In using the term "construction" in reference to the cults of saints, I am building on the work of Pierre Delooz. As he states, "All saints are more or less constructed in that being necessarily saints for other people, they are remodeled in the collective representation which is made of them. It often happens, even, that they are so remodeled that nothing of the real original is left, and, ultimately, some saints are solely constructed saints simply because nothing is known about them historically: everything, including their existence, is a product of collective representation" ("Towards a Sociological Study of Canonized Sainthood in the Catholic Church," in *Saints and Their Cults: Studies in Religious Sociology, Folklore, and History*, edited by Stephen Wilson [New York: Cambridge University Press, 1983], 195). Cf. Donald Weinstein and Rudolph Bell, *Saints and Society: The Two Worlds of Western Christendom, 1000-1700* (Chicago: University of Chicago Press, 1982), 9.

[12] Gurevich, xix.

[13] Weinstein and Bell, 6.

[14] Gurevich, 49.

[15] Gurevich, 50. While most saints were constructed by the clerical elite, it should be remembered that the ideals of sainthood in the early modern period did not entirely reflect their mentality. According to Weinstein and Bell, "in the fourteenth and fifteenth centuries . . . saints' cults gave expression to innovative forms of piety that served the needs of lay people." Often enough, "saints responded to religious impulses that did not wait upon official initiative or direction" (4).

[16] Gurevich, 54. As Gurevich points out, the "colossal" growth of the cult of saints in the Middle Ages was not only due to this recognition that the saints provided models of sanctity. He rightly notes that "the most attractive thing about the saint was his ability to perform miracles." There was, moreover, a theological aspect to this phenomenon in that "the distant and incomprehensible deity was overshadowed by human and accessible saints, endowed with human features and active among the people" (73).

[17] The particularity of York and of the other extant cycles is best argued by Stevens. In his study of the York, Wakefield, N-Town, and Chester cycles, he argues that each "explores its metaphysical universe in its own unique way" (ix). It is Stevens' conviction, and my own, that the four cycles are best read "as individual dramatic works, each with its own interpretation of salvation history, each exercising its own options in developing the familiar material drawn from a wide variety of such sources as sermons, Gospel harmonies, liturgical plays, and the Scriptures themselves" (11). Given this conviction, I will limit my observations to a single cycle in what follows.

[18] *The Age of Cathedrals: Art and Society 980-1420*, translated by Eleanor Levieux and Barbara Thompson (Chicago: University of Chicago Press, 1981), 268.

[19] Stevens, 74.

[20] Stevens, 52.

[21] Daniel E. Bornstein's preface to his edition and translation of Andre Vauchez, *The Laity in the Middle Ages: Religious Beliefs and Devotional Practices* (Notre Dame: University of Notre Dame Press, 1993), xi. Of this struggle, Vauchez writes, "one of the novel characteristics of the period . . . was the ability of lay people to create autonomous forms of piety which, while generally avoiding clashes with orthodoxy, succeeded in reshaping the religious message disseminated by the clergy to meet their feelings and specific needs" (265).

[22] Bornstein's introduction to Vauchez, xviii. The laity did not meet universal opposition from the clergy in these efforts. In fact, the mendicant orders were particularly willing to assist them. As Vauchez points out, the Church, through the friars, "inaugurated the pastoral of the *stationes vitae*, the stations of life—or, more precisely, extended to the world of workers the same effort of adaptation that it had been extending toward the knightly class for more than a century. The warrior saints, exalted by the preaching and hagiography of the twelfth century, were joined by artisan and merchant saints" (103).

[23] Bornstein's introduction to Vauchez, xix. As Vauchez himself notes in explaining the evolution of the typology of sanctity at the end of the Middle Ages, "in this new ambience . . . entering a monastery no longer constituted the only means of arriving at Christian perfection. Among the laity themselves, the conviction began to take hold that it was possible to ensure one's salvation in any human condition, and that neither marriage nor involvement in worldly affairs constituted an obstacle to salvation. Thus, to use the apt expression of Father Chenu, a 'new equilibrium between nature and grace' took shape" (18).

[24] Kolve, 237.

[25] Kolve, 237.

[26] Gail McMurray Gibson and Clifford Flanigan suggest this kind of thinking when they speculate that "English vernacular drama had become a kind of active and popular liturgy, which performed essential ritual functions for a lay society separated by rood screens and philosophical abstractions from ... the 'alienated liturgy' of the altar" (Clifford Flanigan, "The Medieval English Mystery Cycles and the Liturgy," Paper delivered at the Seventeenth Medieval Studies Congress at Western Michigan University, Kalamazoo, Michigan, May, 1982, cited in Gail McMurray Gibson, *The Theatre of Devotion: East Anglian Drama and Society in the Late Middle Ages* [Chicago: University of Chicago Press, 1989], 41).

[27] Nitecki, 64.

[28] Nitecki, 66.

[29] As Stevens points out, the Marshall's play is a particularly good example of a moment when "the association of York and Bethlehem is made a vivid dramatic reality": "The obvious relationship is the provision of a horse by the Marshalls, who shod horses and provided veterinary services, to carry Mary out of Bethlehem at the end of the play. . . . [This] suggests that one of the Marshalls walking with the pageant actually brought a saddled horse along for use to convey Mary down the street to the next street" (33).

[30] Quotations from the mystery plays are from Richard Beadle's edition of *The York Plays* (London: Edward Arnold, 1982). Translations are suggested by the notes in Richard Beadle and Pamela King, *The York Mystery Plays: A Selection in Modern Spelling* (Oxford: Clarendon Press, 1984).

[31] Kolve, 248-49.

[32] Kolve, 252-53.

33 I am relying on Jeffrey Baerwald's definition of mystagogy, and in describing the interpretive function of the plays I want to point to the fact that even in the third century "the tone of the mystagogies are poetical and lyrical" (Jeffrey P. Baerwald, S.J., "Mystagogy," in *The New Dictionary of Sacramental Worship*, edited by Peter E. Fink, S.J. [Collegeville: The Liturgical Press, 1991], 881–83, at 881). Baerwald notes that "the patristic mystagogues perceive in the complex of baptismal symbols the watershed of salvation, recapitulated and unfolded *in hoc tempore*." The same perception seems true on the part of those who produced the mystery plays. In both cases, something more than catechesis is at stake. The emphasis is not so much on creedal formulas and doctrinal truths so much as it is on "images, metaphors and stories that reveal the significance and deeper meaning of . . . symbols" (883). Interestingly enough, Baerwald observes that "for all practical purposes the formal period of mystagogy . . . disappeared from the liturgical argot . . . during the Middle Ages." Perhaps it is the case that the plays assume some part of the role once played by these ancient rites.

34 Theresa Coletti, "Purity and Danger: The Paradox of Mary's Body and the En-gendering of the Infancy Narrative in the English Mystery Cycles," in *Feminist Approaches to the Body in Medieval Literature*, edited by Linda Lomperis and Sarah Stanbury (Philadelphia: University of Pennsylvania Press, 1993), 65-95, at 65.

35 Barry Unsworth, *Morality Play* (New York: Doubleday, 1995), 188.

IMAGES OF THE HOLY FAMILY IN THE RESTORED ROOMS OF ST. IGNATIUS IN ROME

Thomas M. Lucas, S.J.

Scripta manet, the proverb goes: what's written remains and gives us an idea of how people think. The writings of the saints show us their conceptual and theological frameworks, how their minds work, provide a kind of blueprint of their spiritual home. Trying to sketch out an individual's spiritual topography though—how and where he or she prayed and, more intriguingly, what moved him or her to prayer, is much more difficult, yet in some ways more interesting than studying spiritual writings. The private devotions of a saint reveal something very intimate: they give us a picture of the heart of the individual. They show us, as it were, how the saint furnished his or her spiritual home.

Although the spiritual writings of St. Ignatius never allude directly to the Holy Family, it is, of course, very much present in the contemplations of the second week of his *Spiritual Exercises*, when Ignatius invites the retreatant to visualize and to reflect upon the stories of Jesus' nativity and childhood as transmitted in the Gospels of Luke and Matthew. After rehearsing the Scripture passages, the retreatant is encouraged to make a "composition by imagining the place . . . to see the persons . . . to observe, consider, and contemplate what they are saying, what they are doing, for example, journeying and toiling, in order that the Lord may be born in greatest poverty . . . and reflect and draw some spiritual profit."[1]

Concretely, there are several exercises that include Jesus, Mary, and Joseph together: the contemplations of the nativity (110-117, 224), the shepherds (265), the presentation of the Infant Jesus (268), the flight into Egypt (269) and the return (270), the hidden life (271), and the finding in the temple (272). In all, the retreatant spends a considerable amount of time—up to five hours a day for four full days—in the company of the Holy Family, even to the point of "applying the senses" of

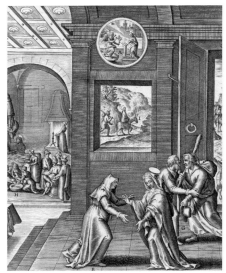

Figure 1
Hieronymus Wierix (Spanish Netherlands),
The Visitation (detail), engraving, late 16th c.

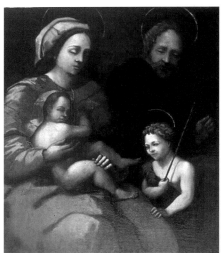

Figure 2
Anonymous (*Scuola Romana*),
The Holy Family with St. John the Baptist,
16th c. Altarpiece in the private chapel of
St. Ignatius Loyola, Casa Professa del Gesù, Rome.
Restored in 1990.

the imagination to smell, touch, hear, and see their surroundings (121-126). It is very interesting to note that after Ignatius' death one of his most trusted disciples and interpreters, Jerome Nadal (1507-1580), worked with Flemish engravers to produce a collection of 153 images illustrating the Gospels. This volume served as a devotional aid for young Jesuits in training.[2] Joseph appears in six of these plates, including an unusual inclusion in the Visitation scene (Figure 1).

St. Ignatius' devotion to the Blessed Virgin Mary is very well documented, both in his own *Autobiography* and in secondary sources. Significant physical evidence also survives. The Jesuit Archives in Rome has in its collection a small Italo-Byzantine icon of the Virgin and Child that belonged to Ignatius, and during his lifetime a fine gold-ground Madonna and Child painted on wood in the Umbrian style hung on the wall in his study-bedroom.

In the course of the restoration of the Rooms of St. Ignatius in Rome that I directed from 1988 to 1991, a great deal of our energy was devoted to returning the Rooms, insofar as possible, to their original integrity and simplicity. Over the course of more than four hundred years, this Ignatian sanctuary was sacked twice, passed out of Jesuit control three times, and was repeatedly—and often garishly—decorated according to rococo and neo-baroque sensibilities. The task we faced was daunting: we had to combine archival research, applied "urban archaeology" and analysis of oral and written traditions and artifacts, as we peeled away centuries of pious accretions. Our goal was to recreate within its original walls the apartment where Ignatius lived out the last twelve years of his life, and in so doing reveal something of the man who lived there to modern pilgrims.

The center of the sanctuary has always been the room in which Ignatius died on 31 July 1556. Documentary evidence establishes that he used the room both as a conference room and a private chapel. We know that in that room the first three General Congregations of the Society of Jesus took place.

Oral tradition as well as secondary sources held that what was (at the beginning of the restoration) an almost illegible painting of the Holy Family with John the Baptist hanging in the Rooms had been the altarpiece in Ignatius' chapel (Figure 2).

As we were studying how to adapt the chapel in such a way as to respect the original use and integrity of the room yet also make it appropriate for modern liturgical celebrations, I discovered an obscure painting in another chapel at the Gesù that cast light both on the original configuration of the room and validated the oral and documentary evidence on the painting of the Holy Family in the Rooms.[3] The painting shows the death of St. Ignatius, and accurately reflects the floorplan of the room.

That painting shows a small wooden altar surmounted by a painting of the Holy Family (Figure 3). The composition of the Holy Family image—a painting within a painting—is identical to the extant painting, the one that tradition says hung over Ignatius' altar. We had a perfect match: triangulation of oral tradition, secondary documentary evidence, and artifact. Once this work was restored (under the direction of Maestro Maurizio De Luca, director of restoration at the Vatican Museums), the original color and sweetness of this historic image reemerged.

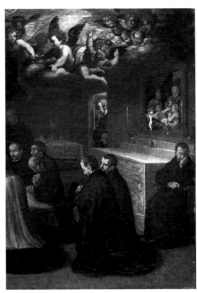

Figure 3
The Death of St. Ignatius Loyola (detail), early 17th c. The Farnese Chapel, Casa Professa del Gesù, Rome.

What makes this image important is emphatically not its artistic merit: objectively, it is a journeyman piece of central Italian *cinquecento* devotional art, not a great masterpiece of the Western tradition. Rather, it is significant because it is before this image that Ignatius repeatedly celebrated the Eucharist, experienced mystical visions, and wept so many tears of devotion that his physician forbade him under obedience to weep during Mass in order to preserve the saint's failing health.[4] Ignatius' *Spiritual Diary* testifies to the fact that he took many of the most difficult dilemmas he had to confront while composing the Constitutions of the Society of Jesus to this altar It is not much of an exaggeration to say that the Society of Jesus took flesh before this painting. In the restored Rooms, it still hangs above the altar as the focus for private prayer and liturgical action.

About fifty years after his death, the original Rooms of St. Ignatius were incapsulated into the much larger Casa Professa (the headquarters of the Order). Outside the Rooms, a barrel-vaulted corridor about four meters wide and five meters high was constructed to provide access to the Rooms for Jesuits and pilgrims. In the 1680s, the Jesuit artist Andrea

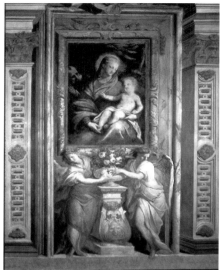

Figure 4
Andrea Pozzo, *The Holy Family*, ca. 1685.
Gallery outside the Rooms of St. Ignatius,
Casa Professa del Gesù, Rome.
This image was uncovered in 1990 during
the restoration of the Pozzo fresco cycle.

Figure 5
The Holy Family painting in the Pozzo Gallery
during the delicate work of recovery.

Pozzo was commissioned by the Superior General to decorate the corridor *in buon fresco*. Brother Pozzo did his work with a vengeance.

Pozzo, a master of *quadratura,* the painting of false perspective, created an immensely complicated fictive architectural gallery to enshrine large images of Ignatius' posthumous miracles. When read from the exact center of the gallery, the fiction is perfect: the low barrel vault becomes a lofty trabeated gallery. When read from anywhere else, the effect dramatically collapses.

The frescos of the gallery were cleaned during the project of the restoration of the Rooms. We had a number of startling surprises.

Fictive pilasters divided the south wall of the gallery into six fictive bays: Door-Miracle-Real Window-Miracle-Fictive Window-Miracle-Curtain. When cleaning began on the Curtain Panel, the first surprise emerged. The curtain was not a fresco like the rest of the corridor, but painted in tempera *a secco* on already dry plaster. As the cleaning progressed, so did the surprises. At last, two gloriously distorted anamorphic angels appeared under a fictive window. They read perfectly from the center of the room, but would have been most disconcerting to pilgrims entering from a doorway immediately across from them.

As the cleaning progressed, the plot thickened. The central fictive window also proved to be painted *a secco*, this time on a very thin (2mm.) coat of plaster under which traces of another image started to appear as the work very cautiously progressed. Softening the plaster with water and gently peeling it away with surgeons' scalpels, the restorers patiently opened small windows in the surface. What emerged were familiar faces, and a familiar family (Figures 4, 5).

There is no way to know for sure when or why this splendid image of the Holy Family was covered. A painstaking search in the Jesuit Archives failed to turn up any documents that could shed any light on this very strange occurence. The best we can do is to theorize that the anamorphic angels were considered too grotesque to greet pilgrims, and so were painted over with a false curtain. The Holy Family was covered

with a fictive window to replace the window covered with the curtain. A certain rhythm was maintained, at the cost of this splendid image.

Whatever the reason, the recent restoration gave us back Andrea Pozzo's tender image of the Holy Family that now dominates the Gallery. The Holy Family image is larger in scale than any other figures in the corridor, and the whole Gallery revolves around it and relates to it. I cannot help but think that Ignatius—who had worshipped before an image of the Holy Family on the other side of that same wall—would approve of the fact that his spiritual son Andrea Pozzo had made the Holy Family the most important image in a corridor celebrating Ignatius' sanctity.

The two images of the Holy Family in the Rooms of St. Ignatius in Rome—one a rustic devotional painting, the other a work of artistic and theological refinement—point to the incarnational optimism of Ignatius' spirituality, a spirituality that seeks to find God in all things. The Holy Family is the prototype of that search, and the icon of its discovery.

NOTES

[1] All references to the *Spiritual Exercises* are to George Ganss' *The Spiritual Exercises of Saint Ignatius: A Translation and Commentary* (St. Louis: Institute of Jesuit Sources, 1992). References to the standard paragraph numeration are given in parentheses.

[2] Nadal's *Evangelicae historiae imagines* was first published in Antwerp by Martin Nutius in 1593. For more on Nadal and this work, see *The Holy Family as Prototype of the Civilization of Love: Images from the Viceregal Americas*, exh. cat. (Philadelphia: Saint Joseph's University Press, 1996), 139-44.

[3] The painting, one of a series in the so-called "Farnese Chapel" of the Gesù residence, dates from the early seventeenth century. As such, it is the oldest, and indeed, only visual evidence about the early configuration of the chapel.

[4] *Fontes Narritivi de S. Ignatio de Loyola et de Societatis Iesu Initiis*, I (Rome: Monumenta Historica Societatis Iesu, 1943), 638-39.

"LIVING AMONG JESUS, MARY, AND JOSEPH": IMAGES OF ST. TERESA OF ÁVILA WITH THE HOLY FAMILY IN SPANISH COLONIAL ART

Christopher C. Wilson

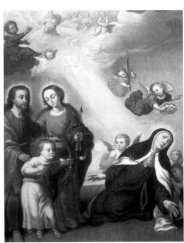

Included in the current exhibition at Saint Joseph's University, "The Holy Family as Prototype of the Civilization of Love: Images from the Viceregal Americas," is a mid eighteenth-century painting (Figure 1) attributed to Marcos Zapata (1710-1773), one of the most prolific artists of the Cuzco School of Peru.[1] It is a portrayal of a vision experienced by St. Teresa of Ávila, the sixteenth-century Spanish mystic and reformer of the Carmelite Order. Teresa describes the remarkable event, which occurred around 1560, in her autobiography, known as *The Book of Her Life*. She saw an angel at her left side, holding a large golden arrow with fire at its tip. The angel plunged the dart into Teresa's heart several times, causing her intense pain but leaving her "all on fire with great love of God."[2] This episode came to be known as the "transverberation," from the Latin *transverberare*, meaning "to pierce through," and is the event in Teresa's life most often represented in art.[3] During the seventeenth and eighteenth centuries, many of the most highly regarded artists working in the Spanish colonies produced depictions of this subject to adorn walls of convent and monastery churches, especially those associated with Teresa's Order, the Discalced Carmelites. The Mexican master Nicolás Rodríguez Juárez (1667-1734), for example, painted a depiction of the *Transverberation* in 1692 (Figure 2), which closely follows Teresa's own account of the event: the kneeling Carmelite saint, on the verge of

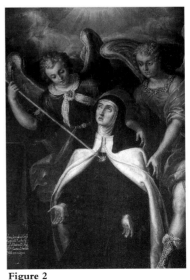

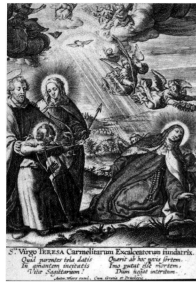

Figure 3
Anton Wierix (Spanish Netherlands),
*The Transverberation of St. Teresa of Ávila
with the Holy Family*, ca. 1615, copper engraving.

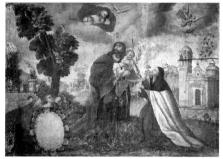

Figure 4
School of Cuzco (Peru),
The Mystical Marriage of St. Teresa of Ávila, 17th c.

completely falling over in ecstasy, is gently supported by two opulently-dressed angels, one of whom pierces her breast with the fiery tip of a large arrow.

Zapata's version of the subject, however, presents us with a significant rewriting of Teresian history. As in Rodríguez's painting, two angels prevent the collapsed figure of Teresa from falling backward, but neither of them is engaged in piercing the saint's heart. Rather, it is the Christ Child, standing at the left side of the composition, who shoots arrows at Teresa. One arrow is already embedded in Teresa's breast, and the young Jesus prepares to launch another. Christ's parents are His accomplices in this wounding: Mary holds the next arrow to be shot, while St. Joseph helps the Child to aim His bow. Zapata's painting is based on an early seventeenth-century Flemish engraving (Figure 3) by Anton Wierix (ca. 1552-1624), which bears an inscription emphasizing the Holy Family's collaboration in this project. Teresa, in the midst of an agony that is both delightful and painful, asks of Mary and Joseph, "Why, parents, do you give weapons? Why do you incite the Archer of Life against a loving person?"[4]

Though Wierix's print and Zapata's painting both take artistic license with Teresa's narrative, by showing the Holy Family, rather than an angel, as the instigators of her transverberation, this modification points to a fundamental truth about the saint's life: she was an ardent devotee of the Holy Family. Teresa attributed both her own spiritual progress, evidenced by such events as the transverberation, and the success of her Carmelite reform, to her intimate companionship with Jesus, Mary, and Joseph. By the early seventeenth century, when Wierix's print was produced, Teresa was perhaps as famous for her devotion to the Holy Family, particularly her insistence on the essentiality of St. Joseph, as she was for her extraordinary mystical experiences and her work of founding convents. In this paper I will examine Spanish Colonial paintings of Teresa with the Holy Family, investigating how these images were shaped by the saint's own written experiences of, and recommendations about, living intimately with Jesus, Mary, and Joseph. Within their original settings, such portrayals not only documented Teresa's close association with the Holy Family, but also presented her

experience as paradigmatic, encouraging the viewer, particularly Discalced Carmelite nuns and friars, to imitate her example of placing oneself in the company of Christ and His parents.

Teresa's Holy Family devotion developed and flourished in two realms, inextricably linked, both of which she chronicles in her writings: her own interior life and the world of her Carmelite reform. The saint's personal devotion to members of the Holy Family was awakened by crises in her early life. Teresa asserts that her mother, Beatriz de Ahumada, taught her as a child to be devoted to the Virgin Mary and to say the rosary. It was Beatriz's death, however, that incited the adolescent Teresa to reevaluate and intensify her relationship with Mary. She writes in her autobiography: "I remember that when my mother died I was twelve years old or a little less. When I came to understand what I had lost, I went, afflicted, before an image of our Lady and besought her with many tears to be my mother. It seems to me that although I did this in simplicity it helped me. For I have found favor with this sovereign Virgin in everything I have asked of her, and in the end, she has drawn me to herself."[5]

In her mid-twenties Teresa entered into another struggle that led her to adopt St. Joseph as her father, just as she had already taken the Virgin as her mother. Only a year after her formal profession at the Carmelite convent of the Incarnation in Ávila, she developed a painful illness that included fainting spells, chest pains, fever, and, eventually, a diagnosis of tuberculosis. The combination of illness and harsh medical treatment left her paralyzed for three years. Believing that if she were in better health she could serve God better, Teresa petitioned Joseph for a cure: "I took for my advocate and Lord the glorious St. Joseph and earnestly recommended myself to him. . . [and] he being who he is brought it about that I could rise and walk and not be crippled."[6] She emerged from this experience with a desire to persuade others to initiate, or to renew, their devotion to Joseph, whom she calls "this father and Lord of mine."[7] Teresa especially emphasizes the saint's remarkable intercessory powers, writing, "For with other saints it seems the Lord has given them the grace to be of help in one need, whereas with this glorious saint I have experience that he helps in all our needs and that the Lord wants us to understand that just as He was subject to St. Joseph on earth—for since, being the Lord's tutor, Joseph could give the Child commands—so in heaven God does whatever he commands."[8] Both in her writings and her work of reform, Teresa tirelessly promoted Joseph's cult. Her efforts were well rewarded, since it was largely as a result of her initiative that Joseph attained unprecedented popularity in Western Europe and Colonial Latin America.[9]

Teresa's emphasis on the many benefits she received from St. Joseph shaped the unusual iconography of a seventeenth-century painting by an unidentified artist of the Cuzco School of Peru (Figure 4). Set within an idyllic landscape, it depicts a pivotal moment in Teresa's spiritual life, the occasion in 1572 when she underwent a mystical marriage to Christ. She saw Christ appear before her, and as He presented her with one of the nails of His crucifixion, she heard Him say, "Behold this nail; it is a sign you will be My bride from today on."[10] In most artistic renditions of this event, it is the adult Christ, with long hair and beard, who takes Teresa as His bride. The Mexican master Juan Correa (ca. 1646-1716), for example, painted Christ appearing before Teresa as he often looks in depictions of the Resurrection (Figure 5): triumphant, in billowing drapery, holding a white banner as He places the nail in Teresa's hand. In the Peruvian painting, however,

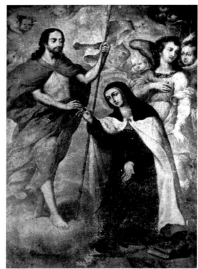

Teresa receives the nail from the Christ Child, who rests in St. Joseph's arms. Joseph has brought the Infant Jesus to Teresa, and as the bearer of her mystical spouse, he facilitates the spiritual marriage. Hovering above the scene are the figures of God the Father and the Holy Spirit, in the form of a dove. In the background is a church facade, presumably the exterior of one of Teresa's convents, from which a group of demons flee, pursued through the air by St. Michael the Archangel. This detail calls to mind Teresa's own descriptions of combating the demonic world. The saint's writings indicate that as she grew more proficient in prayer and became the recipient of supernatural phenomena, such as the mystical marriage, she also gained the ability to resist the assaults of the devil and various demons.[11]

While there is no previous tradition in Western painting of St. Joseph appearing before a certain saint while holding the Christ Child, there are many Baroque portrayals, both in Europe and Spanish America, of apparitions of Mary and the young Jesus to saints, such as Francis of Assisi, Bernard of Clairvaux, and Catherine of Alexandria. For the composition at hand, the Peruvian artist probably drew upon portrayals of the mystical marriage of Christ to St. Catherine of Alexandria. Such depictions commonly show the Virgin holding the Infant Christ as the Child places a ring on Catherine's finger. By adapting the iconography of Catherine's mystical marriage to show Joseph in place of the Virgin, and Teresa in place of Catherine, the artist has purposefully enlarged upon Teresa's narrative in order to communicate essential information about her life. Not only does the work convey the prominent role that Teresa assigned to Joseph, as her heavenly advocate who oversees all her needs, especially the spiritual, but also suggests that her relationship with Christ was intertwined with that which she enjoyed with His parents. The saint's writings provide a basis for this assumption. On one occasion, for example, she heard Christ verbally correct her for a mistaken notion she had once held. After describing the content of His reprimand, she indicates that it was prompted by the intervention of Mary and Joseph: "I understood that I had a great obligation to serve our Lady and St. Joseph; for often when I went off the path completely, God gave me salvation again through their

prayers."[12] For Teresa, experience of one member of the Holy Family often brought with it experience of the other members as well. She insists that thoughts of St. Joseph must inevitably accompany meditation on the lives of Christ and the Virgin: "For I don't know how one can think about the Queen of Angels and about when she went through so much with the Infant Jesus without giving thanks to St. Joseph for the good assistance he then provided them both with."[13] Similarly, in the Peruvian painting, Teresa cannot look upon the Infant Jesus without seeing St. Joseph, who has carried the Child to the site of the mystical marriage and holds Him during the course of the ceremony.

The personal devotion that Teresa felt for the members of the Holy Family found external expression in her program of Carmelite reform. The story begins in 1560, when Teresa, eager to be of more service to God, began to contemplate the idea of founding a strictly enclosed convent where a small group of nuns could live in solitude, poverty, and silence, like desert hermits, observing the primitive Carmelite rule, with all its rigors, instead of the mitigated rule kept in other Carmelite convents of the day.[14] Teresa's purpose in founding this first convent, and her subsequent reformed Carmelite communities, was missionary in nature. She believed that the nuns' lives of prayer and external austerity would assist the Church in rescuing souls being lost in Europe by the spread of Protestantism, and in the New World through ignorance of the Gospel.[15] From the beginning she received divine assurance of the Holy Family's advocacy of the project: "His Majesty earnestly commanded me to strive for this new monastery with all my powers, and He made great promises that it would be founded and that He would be highly served in it. He said it should be called St. Joseph and that this saint would keep watch over us at one door, and our Lady at the other, that Christ would remain with us, and that it would be a star shining with great splendor."[16] These words established for Teresa the model that her convent was to follow: it was to be the abode of the Holy Family, like the stable of Bethlehem and the House of Nazareth, where Joseph and Mary would watch over the house protectively, and where Christ would dwell among the small group of nuns.[17] Such a formula was confirmed when Teresa's friend and spiritual advisor, St. Peter of Alcántara, visited the new convent and exclaimed, "Truly this is a proper house of St. Joseph, because it seems to me like the little hospice of Bethlehem."[18]

While making preparations for the opening of St. Joseph's amidst bitter ecclesiastical and civil opposition, Teresa received a vision reassuring her of the Holy Family's protection of and participation in the project. The content of this vision became one of the most popular Teresian subjects in Spanish Colonial art. The finest example was painted by the Mexican artist Cristóbal de Villalpando (ca. 1645-1714) in the late seventeenth century and now hangs in the Church of La Profesa in Mexico City (Figure 6). Teresa writes that she saw Mary at her right side, and St. Joseph at her left, clothing her in "a white robe of shining brightness." The brilliance of the robe was beyond imagination, she says, since "everything here on earth in comparison is like a sketch made from soot." After being clothed, she saw Mary take her by the hands and tell her "that I made her very happy in serving the glorious St. Joseph, that I should believe that what I was striving for in regard to the monastery would be accomplished, that the Lord and those two would be greatly served in it. . . because they would watch over us, and that her Son had already promised He would be with us."

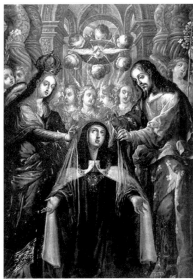

Figure 6
Cristóbal de Villalpando (Mexico),
St. Teresa of Ávila's Vision of the Virgin and St. Joseph,
late 17th c. Mexico City, La Profesa.

Figure 7
Gianlorenzo Bernini,
Baldacchino,
1624-1633, gilded bronze.
Vatican City, St. Peter's Basilica.

As a token of this promise, Mary presented her with a golden necklace, to which was attached a cross, made of "gold and stones [that] are incomparably different from earthly ones." At the end of the vision Teresa saw Joseph and Mary ascend to heaven accompanied by a "multitude of angels."[19]

Mindful of Teresa's statement that the quality of the robe cannot be grasped by the intellect, Villalpando painted it as a transparent, gossamer fabric, which Mary and Joseph gently drape across Teresa's shoulders. She wears a gold necklace, set with jewels, from which there hangs a medallion imprinted with a small cross and the monogram of Jesus. Crowded behind the three figures is the "multitude of angels" that Teresa describes. Also in the background is a group of four columns with twisted shafts. Solomonic columns were a popular architectural feature of Mexican Baroque architecture, thought to reproduce the design of columns that had once adorned Solomon's temple. The placement of the columns in a rectangle suggests that they support a canopy, and in this regard they seem related to the four spiral columns of Bernini's *Baldacchino* (1624-1633) over the high altar of St. Peter's in Rome (Figure 7). Like Bernini's seventeenth-century columns, those in the Mexican work imitate the ancient Solomonic prototype with their division into fluted segments and segments covered with vinescrolls. In fact, the entire architectural background of Villalpando's composition, with its piers and rounded arches, seems intended to suggest the apse of St. Peter's, as viewed through the *Baldacchino*, as if Teresa's vision is occurring just in front of that famous Baroque monument.

Teresa felt that the promises she had received in visions about her new Carmelite community came to fruition, since, despite many hardships along the way, the Convent of St. Joseph was successfully inaugurated on August 24, 1562 (Figure 8). Teresa emphasized the convent's identity as another Nazareth or Bethlehem through her placement of paintings and sculpture within the structure, setting a precedent for the decoration of subsequent houses of her reform.[20] Over the altar she hung a painting of St. Joseph and, recalling the Lord's promise that this saint would keep watch over the community at one door, and the Virgin at the other, she obtained two

wood and polychrome statues: one of the Virgin with the Christ Child (Figure 9), the other a dressed image of St. Joseph, holding a hat and his flowering staff (Figure 10). She put the image of the Virgin over the door of the convent, and the statue of Joseph, titular saint of the foundation, over the entrance of the church.[21] On the grounds behind the convent she constructed numerous hermitages, small one-room structures dedicated to a certain saint or Gospel episode, where individual members of the community could retire during the day for solitude and prayer.[22] One of these was the Hermitage of Nazareth (Figure 11), where there was placed a painting showing Joseph and Mary in a domestic interior; the Virgin is in prayer, while an angel informs Joseph, in a dream, that Mary shall give birth to the Messiah.[23]

Teresa's work of installing images of Holy Family members within houses of her reform is reflected in a seventeenth-century painting (Figure 12) by the Mexican artist Luis Juárez (ca. 1585-1639). The saint is shown levitating during Mass, which, according to an inscription at the bottom right of the painting, is taking place at the Convent of St. Joseph in Ávila. While suspended in the air, Teresa focuses her gaze on a statue of St. Joseph that stands in a niche above the altar. The viewer can assume that the Mother Foundress placed the image there herself, just as she had set up a statue of St. Joseph over a doorway prior to the convent's opening. Similarly, in a nineteenth-century Mexican *retablo* (devotional painting on tin), included in the current exhibition at Saint Joseph's University (Figure 13), Teresa is shown praying within a convent interior, where there hangs a picture of the Holy Family, again alluding to the saint's role as collector of images.[24]

Before her death in 1582, Teresa founded sixteen more convents, each based on the prototype of St. Joseph's at Ávila, each an intended replication of the House of Nazareth. She also initiated a branch of the Discalced Carmelites for friars. The Teresian reform soon expanded to the New World, where, by the early seventeenth century, houses of nuns and friars were established in many Colonial cities.[25] Following the Mother Foundress' example, the members of these religious communities structured their convents and monasteries as

Figure 8
Convent of St. Joseph, Ávila, Spain.

Figure 9
Anonymous (Spain),
The Virgin with the Infant Christ,
16th c., wood and polychrome.

Figure 10
Anonymous (Spain),
Dressed Statue of St. Joseph,
16th c., wood and polychrome.

Figure 11
Hermitage of Nazareth at the Convent of St. Joseph,
Ávila, Spain.

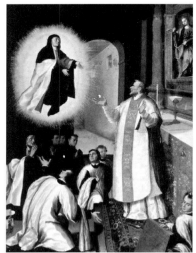

Figure 12
Luis Juárez (Mexico),
St. Teresa of Ávila Levitating during Mass, 17th c.
Mexico City, Church of the Carmen.

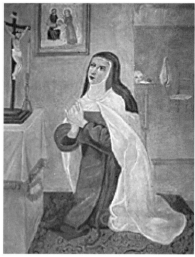

Figure 13
Anonymous (Mexico),
*St. Teresa of Ávila in Prayer
with an Image of the Holy Family*,
late 19th c. Private Collection.

houses of Nazareth. Placement of images of the Holy Family, some of them including the figure of Teresa, intensified this concept. No other work of art better conveys how New World Carmelites imitated Teresa's paradigmatic example of friendship with Jesus, Mary, and Joseph than an eighteenth-century Mexican painting, which can be entitled *The Carmelite Garden*, by an unidentified artist (Figure 14). Though the work is now housed in the Viceregal Museum in Tepotzotlán, its subject-matter reveals that it was originally created for a Discalced Carmelite convent. The composition is set within a paradisal garden, where, in the background, nuns wearing the Carmelite habit stroll among flower beds with watering cans, gather blooms into baskets, or draw water from a fountain. This garden appears to be situated within the enclosed grounds behind a convent, since the austere architecture of a monastic edifice can be seen in the background.

Clustered within the foreground are figures of the greatest importance to the Order. At the far left is the prophet Elijah, regarded as the Order's founder because of the eremetic way of life he instituted on Mount Carmel. He holds a banner with the inscription, "Peace be with all who follow this Rule." In the right half of the composition is the kneeling figure of Teresa, wearing the white Carmelite cape and holding a lily, a symbol of her chastity. Close by is St. John of the Cross, Teresa's friend and collaborator, with whom she instituted the Carmelite reform among the friars. He holds a cross and wears *alpargatas*, a poor type of sandal made from hemp, associated with the Order. In the center of the composition, below the dove of the Holy Spirit, is the Holy Family. Joseph stands holding his attribute of the flowering staff, while Mary, dressed as a Carmelite, supports the Christ Child on her lap. With her right arm, she embraces a female figure whose white veil identifies her as a novice. We are witnessing the moment when this Sister makes her religious profession, thereby becoming the spouse of Christ. An inscription at the bottom of the painting identifies the scene as the "marriage between Jesus Christ and the soul of a religious." The allegorical depiction of the novice's espousal incorporates elements of Teresa's own mystical experiences. The Christ Child pierces her heart, visible on the outside of her habit, in an action that calls to

mind Teresa's famous transverberation. He does this, however, not with an arrow, but with a nail, thus alluding to the nail He presented to Teresa as a token of her own mystical marriage. The presence of Christ's parents at the moment of profession indicates that this Sister can enjoy the same privileged relationship with the Holy Family that the Mother Foundress describes in her books.

The idyllic setting of the garden, replete with trees, flowers, and water, identifies the Teresian Carmel as an earthly paradise. In Patristic and medieval literature, the monastic life is characterized as a return to Eden: the monastery is a *hortus conclusus*, an enclosed garden, where the individual lives on intimate terms with God, as humankind did in the earthly paradise. Joseph F. Chorpenning has shown that Teresa thought along these same lines when describing convents of her reform.[26] She recounts hearing Christ tell her that the Convent of St. Joseph in Ávila "was a paradise of delight for Him,"[27] and reminds her nuns that "this house is a heaven, if one can be had on this earth."[28] Teresa felt that a beautiful garden enhanced the paradisal nature of her foundations. At St. Joseph's she provided her nuns with a walled garden that contained little hermitages for prayer, as already mentioned. Teresa describes the last convent she founded, in the city of Burgos, as "a paradise," explaining that "because of the garden, the view, and the water, the property is nothing else but that."[29]

What finally makes the Teresian Carmel a paradise, however, is the presence of God, since, as Teresa writes, "wherever God is, there is heaven."[30] Each convent attains paradisal status because, according to Teresa's writings, it is the dwelling place of Jesus, watched over by Mary and Joseph. As the abode of the Holy Family, like the house of Nazareth, it is a restoration of heaven on earth.[31] Biblical and patristic typology identified members of the Holy Family with the inhabitants of Eden. Christ is the new Adam, and Mary, the new Eve. By the end of the sixteenth century, when devotion to Joseph had begun to flower, he too was given an essential role in this scheme. The Discalced Carmelite friar Jerónimo Gracián de la Madre de Dios, for instance, wrote in his 1597 work *Summary of the Excellencies of St. Joseph* that Joseph "merited to be the guardian of the earthly paradise like the

Figure 14
Anonymous (Mexico),
The Carmelite Garden, 18th c.
Tepotzotlán, Museo Nacional del Virreinato.

Figure 15
José de Ibarra (Mexico),
Christ in the Garden of the Soul, 1728.
Tepotzotlán, Museo Nacional del Virreinato.

Figure 16
Anonymous (Mexico),
The Carmelite Garden (detail)

Cherubim because he guarded the sovereign Virgin, who is the paradise of delights with the tree of life, Christ Jesus, planted within her."[32] The Carmelite garden in the Mexican painting, therefore, is a terrestrial paradise because it is inhabited by the restorers of Eden, Jesus, Mary, and Joseph.

Teresa's writings indicate that in order for the convent to be fully transformed into an earthly paradise, each nun dwelling within it must restore the paradise of her own soul.[33] The nuns' activities in the Mexican painting allude to this process of individual spiritual development. Some of the nuns work as gardeners among flower beds, an activity which Teresa equates with cultivation of the virtues. She compares the soul of an individual who practices prayer to a garden, where God has removed weeds and has planted good seed. She writes: "And with the help of God we must strive like good gardeners to get these plants to grow and take pains to water them so that they don't wither but come to bud and flower and give forth a most pleasant fragrance to provide refreshment for this Lord of ours. Then He will often come to take delight in this garden and find His joy among these virtues."[34] The comparison of the soul to a garden is also evident in another eighteenth-century Mexican work (Figure 15), painted by José de Ibarra (1685-1756) in 1728. The allegorical composition shows Christ reclining in a bed of flowers, where the blooms are labeled as virtues, such as love, chastity, and purity. Like *The Carmelite Garden*, this composition implies that Christ comes to repose in the interior garden where such virtues are cultivated.

Two of the nuns in the painting of *The Carmelite Garden* draw water from a fountain (Figure 16), calling to mind Teresa's description of the four degrees of prayer, which she compares to four different ways of watering a garden.[35] Teresa likens the first degree of prayer, for example, when the individual practices meditation and places herself in Christ's presence, to drawing water from a well. The painting makes explicit the Teresian concept that through prayer, each nun waters the garden of her soul, making it a paradise in which Christ, accompanied by His parents, will take delight.

Standing next to St. Joseph in the painting is the figure of a nun, holding a basket of flowers she has gathered. Each time I

look at this detail I am reminded of a passage in a letter I recently received, with which I will conclude. It was written by Sister Matilde of the Holy Family, a Discalced Carmelite nun who resides at the Convent of St. Teresa in Madrid. We began our friendship when I visited her convent in 1990. She writes: "In our garden now we have many trees and flowers, which I use to decorate the church [since] I was elected to the office of sacristan. In silence and solitude, I occupy myself in preparing all related to the church. It is something very beautiful and a help for living interiorly among Jesus, Mary, and Joseph, as if in another little and simple Nazareth. I desire to imitate them in their love and faithfulness to God and to humankind." As this passage suggests, Discalced Carmelite nuns today still strive to preserve the Teresian model of intimacy with the Holy Family that is so beautifully evidenced by Spanish Colonial art.

NOTES

[1] For an iconographic analysis of Zapata's painting, in which I suggest that this composition, and the Flemish print upon which it is based, communicates the ideal of saintly martyrdom, see Christopher C. Wilson, "Catalogue No. 26: Attributed to Marcos Zapata, *The Transverberation of St. Teresa of Ávila with the Holy Family*," in *The Holy Family as Prototype of the Civilization of Love: Images from the Viceregal Americas,* exh.cat. (Philadelphia: Saint Joseph's University Press, 1996), 198-200.

[2] *Life*, 29.13. All references to Teresa's writings are from *The Collected Works of St. Teresa of Ávila, I: The Book of Her Life, Spiritual Testimonies, Soliloquies; II: The Way of Perfection, Meditations on the Song of Songs, The Interior Castle;* and *III: The Book of Her Foundations, Minor Works,* translated by Kieran Kavanaugh, O.C.D., and Otilio Rodríguez, O.C.D.(Washington, D.C.: Institute of Carmelite Studies, 1976-1985). Unless otherwise noted, references to the saint's writings are to chapter and section, e.g., 29.13 = chapter 29, section 13. In the case of the *Interior Castle*, references are to mansions, chapter, and section, e.g., III.1.5 = 3rd mansions, chapter 1, section 5.

[3] For a survey of artistic representations of the transverberation, see Laura Gutiérrez Rueda, "Iconografía de Santa Teresa," *Revista de Espiritualidad* 90 (1964): 5-168, especially 111-19. Another informative and well illustrated essay on Teresa's iconography that includes discussion of the transverberation is Elisa Vargas Lugo and José Guadalupe Victoria, "Theresia Magna," in *Juan Correa: Su vida y su obra,* 4 vols. (Mexico City: Universidad Nacional Autónoma de México, 1985-1994), vol. 4, part 2, 417-52. My forthcoming Ph.D. dissertation, *Mother of Carmel, Missionary, Martyr: St. Teresa of Ávila in Mexican Colonial Art*, deals extensively with images of the transverberation, by exploring their literary and artistic sources and considering reasons for the subject's popularity in art of New Spain.

[4] The entire inscription at the bottom of Wierix's print reads: "*Quid parentes tela datis/ In amantem incitatis/ Vitae Sagittarium?/ Quaerit ab hoc necis fortem/ Imo putat esse mortem/ Dum negat interitum.*" (Why, parents, do you give weapons, why do you incite the Archer of Life against a loving person? She asks from this point of death, but on the contrary she considers it to be a heroic death, while denying that it is her annihilation.) I owe special thanks to Susan Ford Wiltshire, Professor of Classics at Vanderbilt University, for her assistance in translating the Latin.

[5] *Life*, 1.7. Teresa's mother, Doña Beatriz de Ahumada, signed her last will on November 24, 1528, and it is believed that she died soon thereafter, at the age of thirty-three. Teresa, then, must have been about fourteen. See *Collected Works of St. Teresa of Ávila*, 1:287, n. 5. According to a long tradition, the statue which Teresa supplicated was a dressed image of *Our Lady of Charity*, housed in the Church of St. Lazarus in Ávila, near the river Adaja. In the nineteenth century, the statue was transferred to the Cathedral of Ávila, where it is venerated today. See Efrén de la Madre de Dios, O.C.D., and Otger Steggink, O. Carm., *Tiempo y vida de Santa Teresa* (Madrid: Editorial Católica, 1977), 47, n. 7.

[6] *Life*, 6.6-7.

[7] *Life*, 6.6.

[8] *Life*, 6.6.

[9] The classic study of Teresa's devotion to St. Joseph is Fortunato de Jesús Sacramentado, "Santa Teresa de Jesús y su espíritu josefino," *Estudios Josefinos* 7 (19. 3): 9-54. See also *Just Man, Husband of Mary, Guardian of Christ: An Anthology of Readings from Jerónimo Gracián's Summary of the Excellencies of St. Joseph (1597)*, translated and edited with an introductory essay and commentary by Joseph F. Chorpenning, O.S.F.S. (Philadelphia: Saint Joseph's University Press, 1993), 29-33, 239-49, and Christopher C. Wilson, "St. Teresa of Ávila's Holy Patron: Teresian Sources for the Image of St. Joseph in Spanish American Colonial Art," in *Patron Saint of the New World: Spanish American Colonial Images of St. Joseph,* exh.cat. (Philadelphia: Saint Joseph's University Press, 1992), 5-17.

[10] *Spiritual Testimonies*, no. 31.

[11] See *Life*, ch. 31.

[12] *Spiritual Testimonies*, no. 26.

[13] *Life*, 6.7.

[14] Jodi Bilinkoff provides an excellent analysis of Teresa's reform in its social and religious context, paying close attention to the reasons some municipal and ecclesiastical officials resisted the founding of her first convent, St. Joseph's in Ávila: see her *The Ávila of St. Teresa: Religious Reform in a Sixteenth-Century City* (Ithaca: Cornell University Press, 1989), 108-51. The same author has also written a concise essay surveying Teresa's reform: "Teresa of Jesus and Carmelite Reform," in *Religious Orders of the Catholic Reformation: In Honor of John C. Olin on His Seventy-Fifth Birthday*, edited by Richard L. DeMolen (New York: Fordham University Press, 1994), 165-86.

[15] See *Way*, ch. 1, and *Foundations*, 1.7-8.

[16] *Life*, 32.11.

[17] See Christopher C. Wilson, *Saint Joseph in Spanish American Colonial Images of the Holy Family: Guardian of an Earthly Paradise* (Philadelphia: Saint Joseph's University Press, 1992), 17-21, and Joseph F. Chorpenning, O.S.F.S., "Icon of Family and Religious Life: The Development of the Holy Family Devotion," in *The Holy Family as Prototype of the Civilization of Love,* 7-10.

[18] Quoted in Madre de Dios and Steggink, 216.

[19] *Life*, 33.14.

[20]Michel Florisoone pioneered the scholarly consideration of Teresa's artistic tastes by surveying the images she acquired for houses of her Carmelite reform. See his *Esthétique et mystique d'après Sainte Thérèse d'Avila et Saint Jean de la Croix*, (Paris, 1956), 49-86, and his article, "Estética de Santa Teresa," *Revista de espiritualidad* 22 (1963): 482-88.

[21]P. Silverio de Santa Teresa, O.C.D., *Historia del Carmen Descalzo en España, Portugal y América*, 15 vols. (Burgos: Monte Carmelo, 1935-1949), 2: 138. Silverio de Santa Teresa points out that both statues were later moved from St. Joseph's in Ávila to the sacristy of the monastery of Discalced Carmelite friars of San Hermenegildo in Madrid. He cites a passage written by P. Jerónimo de San José, author of a seventeenth-century chronicle of the reform (*Historia del Carmen Descalzo*, Madrid, 1637) that describes the appearance of the two statues as "two small wooden sculptures, one of the most holy Virgin, with her precious Child in her arms, all gilded, not dressed in cloth garments; the other of her glorious husband St. Joseph, adorned with clothing and hat in his hand, of silk, and his flowering staff; both very devotional..." (my translation).

[22]For information on Teresa's hermitages, mostly drawn from testimonies of early nuns of St. Joseph's at Ávila, see Madre de Dios and Steggink, 243-47.

[23]For a photograph of the interior of the Hermitage of Nazareth, with its painting of the *Dream of St. Joseph*, see Tomás Álvarez, O.C.D., et al, *Avanti con Dio: Fondazoni e Viaggi di S. Teresa di Gesù* (Genova, 1982), 24.

[24]For an iconographic analysis of this *retablo*, see Christopher C. Wilson, "Catalogue No. 37: *St. Teresa of Ávila in Prayer, with an Image of the Holy Family*," in *The Holy Family as Prototype of the Civilization of Love*, 222-23.

[25]For the history of the Discalced Carmelites in Colonial Latin America, see Alberto de la Virgen del Carmen, *Historia de la reforma teresiana (1562-1962)* (Madrid: Editorial de Espiritualidad, 1968), 537-47; Ethel Correa Duró and Roberto Zavala Ruiz, *Recuento mínimo del Carmen Descalzo en México* (Mexico City: Instituto Nacional de Antropología e Historia, 1988); and Josefina Muriel, *Conventos de monjas en la Nueva España* (Mexico City: Editorial Santiago, 1946), 353-434.

[26]In his superb study of Teresa's four major prose works, Joseph F. Chorpenning analyzes Teresa's characterization of her convents as the restoration of heaven on earth: see his *The Divine Romance: Teresa of Ávila's Narrative Theology* (Chicago: Loyola University Press, 1992), 67-70, 124-32.

[27]*Life*, 35.12.

[28]*Way*, 13.7.

[29]*Foundations*, 31.39.

[30]*Way*, 28.2.

[31]See Wilson, "St. Joseph in Spanish American Colonial Images of the Holy Family," 3-9, 17-21.

[32]*Just Man*, 260.

[33]For analysis of Teresa's descriptions of the soul as paradise, see Chorpenning, *The Divine Romance*, 61-63, 87-91, and 93-116

[34]*Life*, 11.6.

[35]According to Teresa, the four ways of watering a garden, which correspond to the four degrees of prayer, are: manually drawing water from a well (meditation); turning the crank of a bucket-type water wheel (the prayer of quiet); diverting a river or spring to irrigate the garden (the prayer of the sleep of the faculties); and rain from heaven (the prayer of union). See *Life*, chs. 11-22. Chorpenning observes that "the watering allegory of chapters 11-22 is a virtual rewriting of the story of the Garden of Eden in Genesis 2-3," calling attention to several parallels between the two texts: see *The Divine Romance*, 62-63. Teresa often makes references to water in her writings, pointing out that "I don't find anything more appropriate to explain some spiritual experiences than water; and this is because . . . [I] am so fond of this element that I have observed it more attentively than other things" (*Castle*, IV. 2.2). One of her favorite Gospel passages was the story of the encounter and dialogue between Christ and the Samaritan woman at the well. She reveals that from the time of her childhood, she used to beg Christ to give her the living water about which He told the Samaritan woman (*Life*, 30.19).

"THE GUIDANCE AND EDUCATION OF HIS DIVINE INFANCY": THE HOLY FAMILY'S MISSION IN ST. FRANCIS DE SALES

Joseph F. Chorpenning, O.S.F.S.

"Family values" is perhaps the most used but ill defined term in late twentieth-century America. This will only become more evident as the 1996 Presidential election campaign moves into high gear. By contrast, there is no such lack of clarity about the meaning of "family values" in the Catholic Church's teaching on the family. For example, throughout his pontificate, Pope John Paul II has reminded humanity that the family's identity and mission are inseparable. The family is "to become more and more what it is," namely, an "'intimate community of life and love,'"[1] and "an eloquent and living image" of "the eternal loving communion of the three persons of the Most Holy Trinity."[2] The family's identity and mission are achieved by its appropriation and practice of the values of "heartfelt acceptance, encounter and dialogue, disinterested availability, generous service and deep solidarity."[3] While particularly suited to the family, these values also provide the foundation for "broader community relationships marked by respect, justice, dialogue and love," as well as are "the most effective means for humanizing and personalizing society."[4]

Since emergence of its cult in the late Middle Ages, the Holy Family has been regarded as the prototype of the values which should be the hallmark of every family. In his 1892 apostolic brief on devotion to the Holy Family (*Neminem Fugit*), Pope Leo XIII put it this way: "a unique Family, divinely constituted, in which all peoples might contemplate the most accomplished model of family community and of full virtue and holiness."[5] In our own day, John Paul II often appeals to the example of the Holy Family of Nazareth. As the pope constantly points out, this family, molded for the birth and education of the Son of God, is at the same time a human family which underwent many of the same experiences that families do today: uncertainty about the future, homelessness, the threat of violence, being refugees in an alien and hostile country, the struggle to preserve a stable home environment, the loss of a child. In short, "all that we can say of every human family, its nature, its duties, its difficulties, can be said also of this sacred Family."[6]

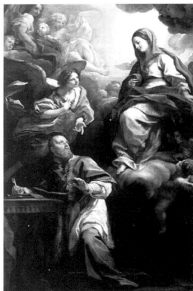

Figure 1
Carlo Maratta (1625-1713),
The Virgin Mary Appearing to St. Francis de Sales.
Forlì, Pinacoteca e Musei Comunali.

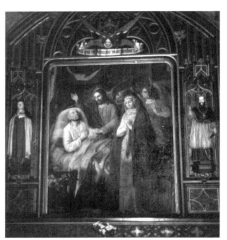

Figure 2
St. Joseph's Altar, St. Peter's Cathedral,
Annecy (France).

Recognition by modern popes of the Holy Family as a model for all families is rooted in and anticipated by a vigorous and venerable tradition of theological reflection on the familiar life of Jesus, Mary, and Joseph which has evolved since the late medieval period. Among the contributors to this tradition, St. Francis de Sales (1567-1622), the early seventeenth-century bishop of Geneva and Doctor of the Church, clearly merits a place of prominence (Figure 1). While Francis' theology of St. Joseph has been studied by scholars,[7] his equally rich and well developed theology of the Holy Family, which is a natural outgrowth of his theology of Joseph, has not received comparable attention.

The pattern which is observable throughout the history of devotion to the Holy Family is that it is always based on a strong, positive appreciation of the person and mission of St. Joseph in the mystery of the Incarnation. The reason is simple: Joseph must be seen as an active, full-fledged participant in the Holy Family before it is possible to consider Jesus, Mary, and Joseph as forming an integral and credible family unit.[8] As if to underscore this principle, most of Francis' reflections on the Holy Family occur in contexts in which he exalts the person of St. Joseph, specifically in the dedicatory prayer and Book 7, chapter 13, of his masterwork *Treatise on the Love of God* (1616) and in the sermons which the bishop preached on the Solemnity of St. Joseph (March 19).[9] For his manifold contributions to the burgeoning post-Tridentine cult of St. Joseph in Western Europe, Francis is traditionally accorded a place of honor alongside St. Teresa of Ávila, another Doctor of the Church of the period who vigorously promoted devotion to Joseph.[10] For example, in St. Peter's Cathedral in Annecy (where, during Francis' lifetime, the bishop of Geneva resided in exile because his see city was occupied by the Calvinists), St. Joseph's altar consists of a nineteenth-century painting of the Death of St. Joseph flanked by statues of Teresa and Francis (Figure 2). Likewise, in the crypt church of St. Joseph's Oratory in Montreal, the largest shrine in the world dedicated to the saint, the Italian sculptor A. Giacomini's magnificent Carrara marble statue of St. Joseph is flanked by statues of the Mother of Carmel and bishop of Geneva.

In this paper, I will examine the principal themes of

Francis' theology of the Holy Family. These touch on topics such as the marriage of Mary and Joseph, Joseph's special role in the Holy Family, the qualities of the Holy Family's relational life, and the mutuality of relations within this divinely constituted family. Where appropriate, these remarks will be illustrated with French devotional paintings and engravings of the post-Tridentine period. Scholars have appealed to Francis' writings on St. Joseph and the Holy Family to explain the iconography of several of these images.[11]

Figure 3
Nicolas Poussin (1594–1665),
Sacrament of Marriage, 1647–1648.
Duke of Sutherland Collection, on loan to the
National Gallery of Scotland.

A DIVINELY ORDAINED MARRIAGE AND A HUMAN FAMILY FOR THE SON OF GOD

The communion between husband and wife in the covenant relationship of marriage is the origin of the community of persons in the family. So too in the case of the Holy Family. Without the marriage of Mary and Joseph, there would be no Holy Family (Figure 3). As the angel reveals to Joseph in Matthew 1:21, the purpose of his marriage to Mary was to provide a human family for the Son of God, to receive and to rear Jesus Christ (Figure 4). Francis reflects this perspective in his statement, in the dedicatory prayer to Mary and Joseph in the *Treatise*, about the nature of this marriage and the origin of the Holy Family. In Francis' view, both the marriage of Joseph and Mary and the Holy Family essentially consist of a union of hearts. This echoes the teaching on marriage of St. Augustine and St. Thomas Aquinas,[12] but it also has special poignancy since the Salesian spiritual world is, as Wendy M. Wright has described it, a "world of hearts."[13] Francis writes: "Mother all-triumphant, who can cast his eyes on you in majesty without seeing at your right hand him whom your Son, out of love for you, willed so often to honor with the title of father? He it was whom Christ Jesus united to you by the heavenly bond of a completely virginal marriage, so that he might be your helper and coadjutor in the guidance and education of His divine infancy" (Figure 5).[14]

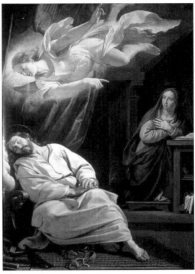

Figure 4
Philippe de Champaigne (1602–1674),
The Dream of St. Joseph, ca. 1638.
London, The National Gallery.

Note how Francis says this marriage and the Holy Family come into existence. Jesus and Mary are so completely united with one another that they "had but one soul, but one heart, and but one life."[15] Through the indissoluble union that Jesus establishes between Joseph's heart and Mary's heart, Jesus draws

Figure 5
Guy François (1578?-1650),
The Holy Family in St. Joseph's Workshop, 1608-1613.
Hartford, Wadsworth Atheneum,
The Ella Gallup Sumner
and Mary Catlin Sumner Collection.

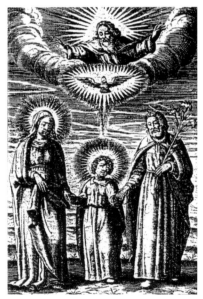

Figure 6
The Heavenly and Earthly Trinities,
engraving by Picart, from Étienne Binet, S.J.,
Le tableau des divines faveurs faites à saint Joseph . . .
(Paris: Sebastien Cramoisy, 1634).

the saint into union with His own divine heart. Jesus was "the dear Child of [Joseph's] heart," and Joseph was Jesus' "great friend and His beloved father."[16] Jesus, Mary, and Joseph are so closely united that Francis cannot look at one without thinking of the others. This union of the hearts of Jesus, Mary, and Joseph is both the source and the fruit of the special mission of the Holy Family which is "the guidance and education of [the] divine infancy" of Christ the Redeemer. In fulfilling its mission, the Holy Family represents to us, in Francis' words, "the mystery of the most holy and adorable Trinity. . . . it was a trinity on earth representing in some sort the most holy Trinity. Mary, Jesus, and Joseph—Joseph, Jesus, and Mary—a trinity worthy indeed to be honored and greatly esteemed!"[17] Thus, the Holy Family becomes the model for every family to follow in realizing its identity and mission (Figure 6).

THE HIDDEN GRANDEUR OF THE VICAR AND LIEUTENANT OF GOD THE FATHER

In Francis' theology, the Holy Family's mission is inseparable from the divine election of St. Joseph as "the guardian of Our Lord" and "the husband of His most holy Mother."[18] In the sermon for the Solemnity of St. Joseph which Francis preached in 1622, the year of his death, he declares: "If earthly princes consider it a matter of so much importance to select carefully a tutor fit for their children, think you that the Eternal God would not, in His almighty power and wisdom, choose from out of the whole of His creation the most perfect man living to be the guardian of His divine and most glorious Son, the Prince of heaven and earth? There is, then, no doubt at all that St. Joseph was endowed with all gifts and graces required by the charge which the Eternal Father willed to commit to him, over all the domestic and temporal concerns of Our Lord, and the guidance of His family. . . ."[19]

The bishop of Geneva stands at the head of a multitude of seventeenth-century theologians, preachers, and devotional authors who regarded St. Joseph as the surrogate of God the Father on earth. Poussin would illustrate this idea in his painting *The Holy Family on the Steps* (1648) by placing in

St. Joseph's hands a compass, which is God the Father's attribute as Creator (Figure 7).[20] In the outline of a sermon for 19 March 1612, Francis observes of the saint: "St. Joseph was the vicar and the lieutenant designated by God the Father, in charge of His family and guarding over the Son of God and the Mother of God. . . . There is no doubt that Joseph was placed over this house; it was to him alone, in fact, that the Angel brings the message of the flight [into Egypt] and of the return [from Egypt]. And St. Luke (2:51) explicitly says of Christ that He was obedient to [him]. The Old Testament Joseph was called 'savior of the world' (Genesis 41:45 in the Vulgate), ours was the savior of the Savior of the world."[21] A passage in the first redaction, but omitted in the final version of the *Treatise*, Book 7, chapter 13, expresses exactly what Francis thought: [St. Joseph] was the "deputy-Father of Our Lord, in lieu of the eternal Father. . . ."[22]

The notion that St. Joseph was divinely endowed with the talents and gifts necessary for his mission was, in Francis' day, commonplace. However, what most intrigues Francis is the hiddenness of the grandeur, dignity, and charisms granted the saint: "There is no doubt. . . that St. Joseph was more valiant than David and wiser than Solomon; nevertheless, seeing him so humbly working in his carpenter's shop, who would have imagined (unless enlightened supernaturally) that he was endowed by God with such marvelous gifts, so closely and carefully did he keep them concealed!"[23] This unidealized, down-to-earth image of Joseph would become especially popular among seventeenth-century tenebrist painters, such as Georges de La Tour, as his *Christ with St. Joseph in the Carpenter's Shop* (ca. 1635-1640) attests (Figure 8).[24] Francis imagines throngs of angels coming to Joseph's carpenter shop to admire his humility: "Truly, I doubt not that the Angels, wondering and adoring, came thronging in countless multitudes to that poor workshop to admire the humility of him who guarded that dear and divine Child, and labored at his carpenter's trade to support the Son and the Mother, who were committed to his care."[25] These reflections partake of the Salesian spirit's deep appreciation for the significance of little things and insistence on the hiddenness of authentic spiritual growth and greatness.[26]

Figure 7
Nicolas Poussin (1594-1665),
The Holy Family on the Steps, 1648.
The Cleveland Museum of Art,
Leonard C. Hanna, Jr., Fund.

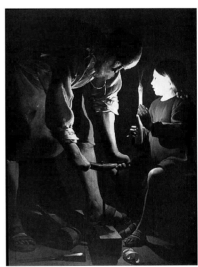

Figure 8
Georges de La Tour (1593-1652),
Christ with St. Joseph in the Carpenter's Shop,
ca. 1635-1640.
Paris, Musée du Louvre.

Gentleness and Humility: The Environment of the Growing Son of God

Francis is fond of dwelling on the specific ways in which the Holy Family lived out its union of hearts and communion of love. In his most well-known and best-selling book, *Introduction to the Devout Life* (1609), Francis advises married people that "mutual support must be so great that they will never be angry with each other at the same time, and hence quarrels or disputes will never be seen between them. . . . [T]he Holy Spirit [cannot] remain in a home where there are quarrels, recriminations, and the echoing sounds of scolding and strife."[27] Francis' reflections on the relational life of Jesus, Mary, and Joseph reveal that he regarded the mutual respect and reverence that should govern family relationships to be present in an exemplary manner in the Holy Family of Nazareth.

Like all families, the Holy Family experienced stress. As Francis comments, in a sermon for the Octave of the Feast of the Holy Innocents, unexpected and troubling events "occurred even in the family of Our Lord, in which abode constancy and steadfastness itself in the person of Our Lord."[28] As examples of such events, Francis cites Joseph's distress and perplexity at the mystery of Mary's pregnancy, the danger posed to the Christ Child's life by the murderous Herod, and the necessity of fleeing to an alien and pagan land which was hostile to Israelites. With regard to Joseph's affliction when "he knew that the glorious Virgin was with child and not by him," Francis remarks: "Yet, in spite of all, [Joseph] never complained, he was never harsh or ungracious towards his holy Spouse, but remained just as gentle and respectful in his demeanor as he had ever been."[29]

Historically, there have been three principal interpretations of Joseph's conduct when he learned of Mary's pregnancy: first, that he actually suspected her of adultery; second, that he surmised that she was the mother of the Messiah, and he wished to withdraw in humility; and, third, that he was subject to agonizing perplexity.[30] While Francis firmly rejects the first interpretation (in the *Introduction*, Part 3, chapter 28, on rash judgment, and in his conference on the spirit of humility, he cites Joseph's refusal to judge Mary's behavior[31]), he repeats both the second and third interpretations. As we have just seen, Francis refers to Joseph's perplexity, which was eventually alleviated by the angel's revelation, in order to exalt the saint's gentleness. Moreover, the bishop approvingly cites St. Bernard's formulation of the second interpretation to extol Joseph's humility. "[St. Joseph's] humility . . . , as St. Bernard explains, was the cause of his wishing to quit Our Lady when he saw that she was with child; for St. Bernard says that he spoke thus to himself: 'Ah! what is this? I know that she is a virgin, for we have together made a vow to keep our virginity and purity intact—a vow which nothing would induce her to break; yet I see that she is with child. How can it be that maternity is found in virginity, and that virginity does not hinder maternity? O my God! must not this be that glorious Virgin of whom the Prophets declare that she shall conceive and be the Mother of the Messiah? Oh, if this is so, God forbid that I should remain with her—I, who am so unworthy of such an honor! Better far that I should quit her secretly on account of my unworthiness, and that I should dwell no longer in her company.'"[32]

St. Joseph's gentleness and humility toward Jesus and Mary is reciprocated by their humble submission to the will of God as it is made known to them by the saint. Apropos of the flight into Egypt, Francis remarks: "Our Lord would not govern Himself, but suffered Himself to be carried by whoever wished to carry Him, and wherever they wished to carry Him. It seemed as if He did not

consider Himself wise enough to guide Himself or His Family. . . . [S]ee what rank is observed in the Holy Family! . . . Who could doubt for a moment that Our Lady was much superior to St. Joseph, and that she had more discretion and qualities more fit for ruling than her spouse? . . . Yet Our Lady . . . is not in the least offended because the Angel addresses himself to St. Joseph; she obeys quite simply, knowing that God has so ordained it."[33]

The primary Salesian virtues of humility toward God and gentleness toward neighbor are the hallmarks of relationships within the Holy Family. Mary and Joseph worthily serve as parents to Jesus, who, in Matthew 11:29, Francis' favorite Scriptural quotation, invites all: "[L]earn from Me, for I am gentle and humble in heart."[34]

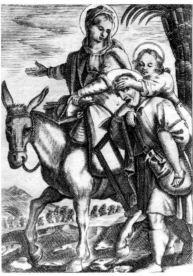

Figure 9
Christophorus Blancus
(active late 16th c./early 17th c.),
The Return of the Holy Family from Egypt,
engraving, from
Jerónimo Gracián de la Madre de Dios,
Sommario dell'eccellence del glorioso S. Josef . . .
(Rome: Luigi Zannetti, 1597).

PARENTAL RESPONSIBILITY AND PATERNAL AFFECTION

In his instructions on parenting in the *Introduction*, Francis stresses that both parents are responsible for the religious and moral education and rearing of children.[35] This point is echoed in the *Treatise* when Francis speaks of Joseph as Mary's "helper and coadjutor in the guidance and education of [Jesus'] divine infancy." Joseph and Mary were "chosen to perform the most tender and loving duties that ever were or ever shall be done in behalf of the Son of God."[36] Francis delights in enumerating the services which Joseph and Mary rendered the Christ Child. When Jesus came down from heaven to earth, Joseph received Him into his house and family. At the moment of His birth, Joseph received Jesus into his arms.[37] "Ah, how much sweetness, charity, and mercy did this good foster father show towards the Savior when He was born into the world as a little child!"[38] Moreover, "[w]hile our Savior was still a little child, the great St. Joseph, His foster father, and the most glorious Virgin, His Mother, . . . carried Him many times, especially on the journey they made from Judea into Egypt and then from Egypt back to Judea" (Figure 9).[39] Joseph also "toiled with the most affectionate zeal for the support of his little family."[40]

Francis is also fond of dwelling on the bond of deep mutual affection which unites the members of the Holy Family. He especially singles out the warm and tender

Figure 10
Pierre Le Tellier (17th c.),
St. Joseph Holding the Christ Child, 1665.
Rouen, Couvent des Cordeliers.

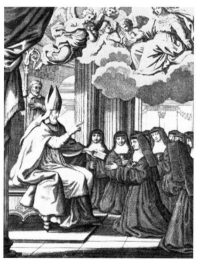

affectionate relationship which existed between Joseph and Jesus (Figure 10). For example, in a letter written in March 1609, to his protégé Jean-Pierre Camus (1584-1652), who had requested that Francis serve as the principal consecrator at his ordination as bishop of Belley (Figure 11), Francis confesses: "I find nothing sweeter to my imagination than to see little Jesus in the arms of this great saint, calling him Daddy thousands of times in childlike words and with an absolutely filial and loving heart."[41] The following year, in a letter, dated 30 June 1610, to St. Jane Frances de Chantal (1572-1641), with whom he co-founded the Order of the Visitation of Holy Mary (Figure 12), Francis says that this privileged relationship between Jesus and Joseph commenced while Christ was still in the womb of His virgin mother. Siding with those theologians who argued that Joseph must have accompanied the Virgin on her visit to her cousin Elizabeth (Figure 13), Francis states that during this journey the Redeemer in the womb "by secret rays, touches [Joseph's] heart with a thousand extraordinary affections. And just as wines kept in cellars imperceptibly give forth the fragrance of vines in blossom (Song of Songs 2:13), so the heart of this holy Patriarch unconsciously experiences the fragrance, vigor, and strength of the little Infant who blossoms within his beautiful vine."[42] Francis comes back to this favorite theme in the *Treatise*'s dedicatory prayer: "Great St. Joseph, most beloved spouse of the Mother of the Beloved, ah, how many times have you borne in your arms the love of heaven and earth! All the while, inflamed by the sweet embrace and kiss of that divine Child, your soul was dissolved in joy. All the while—O God, how sweet it was!—He spoke tenderly into your ears and told you that you were His great friend and His beloved father."[43]

The member of the post-modern family who is most often absent is the father. Our own country has recently been described as "fatherless America." Pope John Paul II, as well as many commentators on contemporary society, have called attention to the importance of the father in the family and to the psychological difficulties in family relationships caused by his absence.[44] Recently, John Paul has stressed that "it is essential that the husband should recognize that the motherhood of his wife is a gift: This is enormously important for the entire

process of raising children. Much will depend on his willingness to take his own part in this first stage of the gift of humanity and to become willingly involved as a husband and father in the motherhood of his wife."[45] Contemporary emphasis on the irreplaceability of the father in the family is anticipated by Francis' insistence on the responsibility of both parents for child rearing, as well as by his casting into relief the strong affective bond between Joseph and Jesus, Joseph's gracious acceptance of the mystery of Mary's motherhood, and the generous gift of self which Joseph made in the service of the Incarnation by surrendering himself to the demands of the Messiah coming into his home. In short, Francis' presentation of St. Joseph proffers him as a model for husbands and fathers of every period in human history, especially fatherless America on the eve of the third millennium.

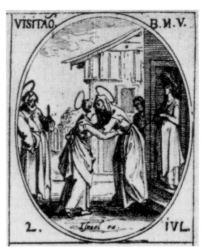

Figure 13
Jacques Callot (1592-1635),
The Visitation,
engraving from *Les images de tous les saincts et saintes de l'année* (Paris: Israel Henriette, 1636).

The Impact of the Christ Child on His Parents

Parents are the first teachers of children, and the family is the first school of social life. However, the educational process which takes place within the family is not one-way. Rather, it is mutual, involving a reciprocal giving and receiving between parents and children. Parents are teachers of humanity for their child, who, in turn, gives them the newness and freshness of the humanity which it has brought into the world.[46] For Francis, the Holy Family epitomizes this mutuality (Figure 14). The bishop not only speaks of the humility, gentleness, generous service, and parental affection of Mary and Joseph, but also describes the impact of the Christ Child on His parents.

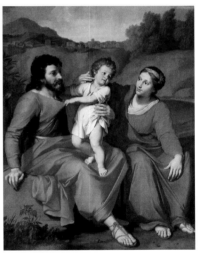

Figure 14
Reynaud Levieux (1613-1699),
The Holy Family, 1651.
Villeneuve-lès-Avignon,
Musée Pierre-de-Luxembourg.

In his 1622 sermon for the Solemnity of St. Joseph, Francis observes that, by virtue of the marriage of Joseph and Mary, the "Good of eternal goods, Our Lord Himself, belonged to St. Joseph as well as to Our Lady. This is not true as regards the nature which He took in the womb of our glorious Mistress, and which had been formed by the Holy Ghost of the most pure blood of Our Lady; but is so as regards grace, which made him participate in all the possessions of his beloved Spouse, and which increased so marvelously his growth in perfection; and this through his continual communication with Our Lady."[47] Later in the

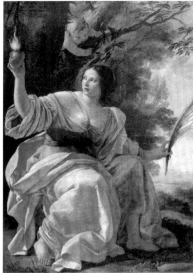

Figure 15
Simon Vouet (1590-1649),
Allegory of Charity.
Paris, Musée du Louvre.

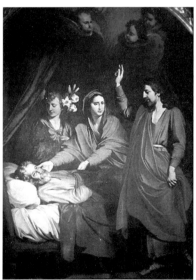

Figure 16
Reynaud Levieux (1613-1699),
The Death of St. Joseph, ca. 1656.
Sérignan, Église Saint-Étienne.

same sermon, Francis more fully explains this process of sanctification by specifying the precise impact of Jesus on Mary and of Jesus and Mary on Joseph. "[St. Joseph] never allowed himself to be conquered or subdued by dejection of mind, which yet, no doubt, constantly attacked him, but always increased and grew in more perfect submission [to the will of God], as in all other virtues. So, too, it was with Our Lady, who day by day gained an increase of virtues and perfections from contact with her all-holy Son, Who Himself being unable to grow in any perfection—since He was, from the moment of His conception what He is and will be eternally—bestowed upon the Holy Family, of which He deigned to be a member, this grace of continual growth and advance in perfection. Our Lady drew hers from His own divine Goodness, and St. Joseph received it, as we have said, through the intervention of Our Lady."[48] Francis' highlighting Mary's role as mediatrix in the process of Joseph's sanctification, which is the fruit of not only her prayer but also her love, foreshadows insistence on this point in later seventeenth-century spiritual authors and preachers, such as St. Claude La Colombière (1641-1682).[49]

THE HOLY FAMILY'S BOND
OF MUTUAL AFFECTION ON EARTH AND IN HEAVEN

Late medieval advocates of devotion to St. Joseph and the Holy Family, such as Jean Gerson (1363-1429) and St. Bernardine of Siena (1380-1444), both of whom Francis greatly esteemed, emphasized that the Holy Family's bond of mutual affection was so strong that it enabled them not only to endure many trials together in this world, but also to be reunited in heaven.[50] As Bernardine put it, "just as this holy family—Christ, the Virgin, and Joseph—lived together in laborious life and affectionate grace on earth, so do they now rule in affectionate glory in heaven with body and soul."[51] Thus, the Holy Family models how the communion of persons in the family on earth is to be a preparation for the communion of saints in heaven.[52]

As the *Treatise*, Francis' biography of a little-known saint, "Holy Charity," attests, the saint esteemed love as preeminent among all the virtues (Figure 15). From his student days in Paris, when he attended the lectures of the Benedictine

Scripture scholar Gilbert Génébrard on the Song of Songs, Francis was unable to conceive of the spiritual life as anything except the most beautiful of love stories between human and divine persons.[53] The aim of Francis' entire ministry was to inflame souls with magnanimous love of God and neighbor. He intended the Order of the Visitation to be a small "kingdom of charity" where the sisters were to make the gentle, humble Jesus of Matthew 11:29 come to life and which was to radiate holiness to the whole Church.[54] At the outset of the *Treatise*, Francis makes it clear that the Holy Family is the model par excellence of charity, of magnanimous love, of the bond of love which was to unite the Visitation, as well as married people and families in the world. Mary is "the mother of charity"; Joseph, "the father of heartfelt love"; and Jesus, love incarnate, "that divine Child who is the Savior of those who love and the love of those saved."[55]

Love so consumed the members of the Holy Family that each, according to Francis, died of love. For example, Francis recounts of Joseph's death (Figure 16): "A saint who had loved so much in this life could not die except from love. His soul could not sufficiently love his own dear Jesus amid all the distractions of this life, and he had already performed the services required of him during the childhood of Jesus. What remained, then, but for him to say to the eternal Father, 'O Father, I have accomplished the work which You have given me to do,' and then to the Son, 'O my Child, as Your heavenly Father placed Your tender body in my hands on the day You came into the world, so do I place my spirit in Your hands on this day of my departure from this world.'"[56] Like Gerson and Bernardine, Francis was also convinced that the Holy Family is reunited, in body and soul, in heaven. In fact, the *Treatise*'s dedicatory prayer alludes to this reunion as Francis envisions Mary and Joseph together in heavenly glory: "Mother all-triumphant, who can cast his eyes on you in majesty without seeing at your right hand him whom your Son, out of love for you, willed so often to honor with the title of father?"[57] The source of this reunion is Jesus' filial love. Francis proposes that Jesus granted both His parents the favor of bodily resurrection and assumption into heaven as an expression of His filial gratitude for their parental love.[58]

CONCLUSION

During Francis' lifetime, the idea that the Holy Family was the nascent Church was being popularized. For example, this idea was disseminated by books, such as *Summary of the Excellencies of St. Joseph*, by the Spanish Discalced Carmelite friar Jerónimo Gracián de la Madre de Dios (1545-1614), who was St. Teresa of Ávila's religious superior, spiritual director, and closest friend and collaborator in the dissemination of the reformed Carmel. The *Summary* continued the Teresian apostolate of propagating Joseph's veneration and made a major contribution to fulfilling Teresa's dream of widespread devotion to the saint. Francis may have been familiar with the *Summary*, which was first published in 1597 in Spanish and in Italian. Between 1597 and 1622, the year of Francis' death, there were five more Spanish and three more Italian editions of Gracián's treatise; it was also translated into German (Augsburg, 1615) and French (Paris, 1619).[59] One of the *Summary*'s principal points is that Mary and Joseph were the first Christians, because, Gracián explains, "the Christian is one who knows, believes in, serves, and glorifies Christ after His coming into the world. . . . St. Joseph was the first who, after the Virgin Mary, knew and adored Christ incarnate."[60] In a letter,

dated 19 March 1614, to Jane de Chantal, Francis echoes this idea, referring to Joseph as "[Jesus'] first adorer, after his divine Spouse."[61] Moreover, the preceding examination of Francis' theology of the Holy Family amply documents the role of Mary and Joseph as the first Christians, who knew, believed in, served, and glorified the Word made flesh.

This study of Francis' theology of the Holy Family has also brought to light another essential point: that Francis regarded the Holy Family as enfleshing, indeed as the prototype, of the major themes of his own spiritual doctrine, specifically the significance of little things, the hiddenness of authentic spiritual growth and greatness, and making the humble, gentle heart of Jesus come to life in human relationships—in this case, married and family life. Historians of spirituality maintain that devotion to the Holy Family truly comes into its own when Jesus, Mary, and Joseph are reflected upon not individually but in relationship to one another.[62] This is precisely the perspective of Francis, who focuses on the Holy Family's triple bond of love: the spousal love of Mary and Joseph, the filial and paternal love of Jesus and Joseph, and the filial and maternal love of Jesus and Mary. On the eve of the third millennium, Pope John Paul II urges the world's families to find in the Holy Family of Jesus, Mary, and Joseph "their sure ideal and the secret of their vitality."[63] Francis' reflections on the familiar life of Jesus, Mary, and Joseph are of invaluable assistance in responding to the pope's invitation because they help us to access this ideal and to unlock this secret.

NOTES

[1] Second Vatican Council, *Gaudium et Spes*, Pastoral Constitution on the Church in the Modern World (7 December 1965), n. 48, quoted in John Paul II, *Familiaris Consortio*, Apostolic Exhortation on the Role of the Christian Family in the Modern World (22 November 1981), n. 17.

[2] "Yours must be a witness of love," *L'Osservatore Romano*, Eng. ed. (12 October 1994): 2, and *The Wisdom of John Paul II: The Pope on Life's Most Vital Questions*, compiled by Nick Bakalar and Richard Balkin, with an introduction by Father John W. White (San Francisco: Harper, 1995), 32.

[3] John Paul II, *Familiaris Consortio*, n. 43.

[4] John Paul II, *Familiaris Consortio*, n. 43.

[5] Leo XIII, *Neminem Fugit*, in Charles L. Stoeber, S.F., *The Holy Family Association: Statutes and Documents* (Silver Spring: Holy Family Publications, 1993), 30-34, at 30.

[6] John Paul II, "Love and respect for nascent life," General Audience Address, 3 January 1979, in *The Family: Center of Love and Life. Pope Paul VI, Pope John Paul I, Pope John Paul II*, compiled by the Daughters of St. Paul (Boston: St. Paul Editions, 1981), 109-114, at 110.

[7] See, e.g., Francis L. Filas, *Joseph: The Man Closest to Jesus. The Complete Life, Theology, and Devotional History of St. Joseph.* (Boston: St. Paul Editions, 1962), 108, 173, 248-52, 398, 427-28, 548-49; Louis Comte, *Saint Joseph, maître de vie spirituelle, d'après les oeuvres de saint François de Sales* (Paris: P. Lethielleux, 1967); André Doze,, "Les intuitions de S. François de Sales sur le mystère de saint Joseph," *Cahiers de Joséphologie* 37 (1990): 211-23; Joseph F. Chorpenning, O.S.F.S., "Just Man, Husband of Mary, and Guardian of Christ: St. Joseph's Life and Virtues in the Spirituality of St. Francis de Sales," in *Patron Saint of the New World: Spanish American Colonial Images of St. Joseph*, exh. cat. (Philadelphia: Saint Joseph's University Press, 1992), 19-29.

[8] See Irenée Noye, S.S., "Famille (Dévotion à la Sainte Famille)," *Dictionnaire de spiritualité*, vol. 5 (Paris: Beauchesne, 1964), 84-93, especially 85.

[9] In the seventeenth century, the Solemnity of St. Joseph, as well as the liturgical season of Christmas and some feasts of Our Lady, offered the most appropriate opportunity for preachers to speak of the Holy Family since, except in the Diocese of Quebec, there was no Feast of the Holy Family in the liturgical calendar. In 1893, Pope Leo XIII formally instituted the Feast of the Holy Family, which was granted to any diocese which petitioned to celebrate it. On 26 October 1921, Pope Benedict XV extended this feast to the Universal Church. See Noye, "Famille (Dévotion à la Sainte Famille)," 92, and "La Sainte Famille vue par les prédicateurs et auteurs spirituels français jusqu'au XVIII^eme siècle," in *La Sagrada Familia en el siglo XVIII: Actas del Tercer Congreso Internacional sobre la Sagrada Familia, Barcelona/Begues, 6-10 de septiembre de 1996* (Barcelona: Hijos de la Sagrada Familia/ Nazarenum, 1997), 633-44.

[10] See, e.g., Henri Rondet, S.J., *St. Joseph*, translated and edited by Donald Attwater (New York: P. J. Kenedy & Sons, 1956), 28-30; Roland Gauthier, C.S.C., "Joseph (saint) dans l'histoire de la spiritualité," *Dictionnaire de spiritualité*, vol. 8 (Paris: Beauchesne, 1974), 1308-1316, especially 1311-12; Andrew Doze, *St. Joseph: Shadow of the Father*, translated by Florestine Audett, R.J.M. (New York: Alba House, 1992), 10, 13, 15-18, 30-46. St. Teresa adopted Joseph as her father after she was healed from a crippling illness through his intercession, and henceforth she "had the desire to persuade all to be devoted to him" (*Book of Her Life*, ch. 6). Teresa included an encomium of the saint in her autobiography (ch. 6), named for him twelve of the seventeen monasteries she founded, and "personally installed his image in her foundations. On Joseph's presence in Teresa's life and Carmelite reform, see Fortunato de Jesús Sacramentado, O.C.D., "Santa Teresa de Jesús y su espíritu josefino," *Estudios Josefinos* 7 (1953): 9-54; the special double issue of *Estudios Josefinos*, entitled *San José y Santa Teresa*, 18 (1964); Christopher C. Wilson, "St. Teresa of Ávila's Holy Patron: Teresian Sources for the Image of St. Joseph in Spanish Colonial Art," in *Patron Saint of the New World*, 5-17. On the question of Teresa's influence on Francis' personal devotion to St. Joseph and promotion of his cult, see Pierre Serouet, O.C.D., *De la vie dévote à la vie mystique: Ste. Thérèse d'Avila, St. François de Sales*, Études Carmélitaines (Paris: Desclée de Brouwer, 1958), 352-54.

[11] See, e.g., Michel Hilaire, "Reynaud Levieux (1613-1699), *The Holy Family* (1651)," in *Century of Splendor: Seventeenth-Century French Painting in French Public Collections* (Paris: Réunion des Musées Nationaux/Montreal: Montreal Museum of Fine Arts, 1993), 294-95, and Barry Wind, "Poussin and St. Francis de Sales: The *Sacrament of Marriage* for Chantelou," *Gazette des beaux-arts* 126 (October 1995): 95-98.

[12] See John Paul II, *Redemptoris Custos/Guardian of the Redeemer*, Apostolic Exhortation on the Person and Mission of St. Joseph in the Life of Christ and of the Church (15 August 1989), n. 7.

[13] "It is virtually impossible to turn to a page of Francis' or [St. Jane de Chantal's] writing which does not contain some reference to the human heart or the heart of God or of Jesus or which does not use affective language associated with the image of the heart. ... [T]he Salesian spiritual world ... is, in fact, a world of hearts" (Wendy M. Wright, "'That Is What It Is Made For': The Image of the Heart in the Spirituality of Francis de Sales and Jane de Chantal," in *Spiritualities of the Heart: Approaches to Personal Wholeness in Christian Tradition*, edited by Annice Callahan, R.S.C.J. [New York: Paulist Press, 1990], 143-58, at 144).

[14] *Treatise on the Love of God*, translated by John K. Ryan, 2 vols. (1963; Rockford: Tan Books, 1974-1975), 1:34.

[15] *Treatise*, 2:49 (Bk. 7, ch. 13)

[16] *Treatise*, 2:48 (Bk. 7, ch. 13), 1:34 (Dedicatory Prayer), respectively.

[17] *The Spiritual Conferences of St. Francis de Sales*, translated by F. Aidan Gasquet, O.S.B., and Henry Benedict Mackey, O.S.B. (1906;

Westminster, Maryland: Newman Press, 1962), 373-74. This edition of the *Conferences*, like those before it, includes as Conference 3 a sermon delivered by Francis on the Octave of the Feast of the Holy Innocents (29-53), and as Conference 19 a sermon which the saint preached on the virtues of St. Joseph, in 1622, on the Solemnity of St. Joseph (364-85). More recent critical editions of the *Conferences*, such as that by André Ravier, S.J., and Roger Devos (see note 22 below), do not include these texts because they are sermons, rather than conferences.

[18] *Spiritual Conferences*, 372-73.

[19] *Spiritual Conferences*, 373.

[20] See Joseph F. Chorpenning, O.S.F.S., "The Enigma of St. Joseph in Poussin's *Holy Family on the Steps*," *Journal of the Warburg and Courtauld Institutes 60* (1997): 276-81.

[21] *Oeuvres de St. François de Sales, Édition complète*, 27 vols. (Annecy: J. Niérat et al., 1892-1964), 8:86-87. I am grateful to my confrère Fr. William N. Dougherty, O.S.F.S., for his kind assistance with the translation of this passage.

[22] Quoted in translation in Doze, 46; for the French original, see St. François de Sales, *Oeuvres*, edited and annotated by André Ravier, S.J., and Roger Devos, Bibliothèque de la Pléiade (Paris: Gallimard, 1969), 1534.

[23] *Spiritual Conferences*, 373.

[24] Philip Conisbee, "An Introduction to the Life and Art of Georges de La Tour," in *Georges de La Tour and His World*, exh. cat. (New Haven: Yale University Press, 1996), 14-147, especially 127.

[25] *Spiritual Conferences*, 373.

[26] See, e.g., Wendy M. Wright and Joseph F. Power, O.S.F.S., "Introduction," to Francis de Sales, Jane de Chantal, *Letters of Spiritual Direction*, translated by Péronne Marie Thibert, V.H.M., The Classics of Western Spirituality (New York: Paulist Press, 1988), 9-90, especially 62-63.

[27] Translated by John K. Ryan (Garden City: Image Books, 1972), 226 (Part 3, ch. 38).

[28] *Spiritual Conferences*, 39.

[29] *Spiritual Conferences*, 49, 379.

[30] Francis L. Filas, S.J., "Joseph, St.," *New Catholic Encyclopedia*, 1967.

[31] *Introduction*, 199, and *Spiritual Conferences*, 72, note 8.

[32] *Spiritual Conferences*, 374-75. For a thorough discussion of this interpretation of Matthew 1:19, see Ignace de la Potterie, S.J., *Mary in the Mystery of the New Covenant*, translated by Bertrand Buby, S.M. (New York: Alba House, 1992), 37-56.

[33] *Spiritual Conferences*, 43-45.

[34] On the centrality of the image of the gentle, humble Jesus of Matthew 11:29 in Salesian spirituality, see Wendy M. Wright, *Francis de Sales, Introduction to the Devout Life and Treatise on the Love of God*, The Crossroad Spiritual Legacy Series (New York: Crossroad, 1993), 78-79, and "The Ignatian-Salesian Imagination and Familied Life," in the present volume, 116-21, especially 117-18.

[35] *Introduction*, 224-25 (Part 3, ch. 38).

[36] *Treatise*, 2:49 (Bk. 7, ch. 13).

[37] *Spiritual Conferences*, 383-84.

[38] *Treatise*, 2:48 (Bk. 7, ch. 13).

[39] *Treatise*, 2:48 (Bk. 7, ch. 13).

[40] *Spiritual Conferences*, 382.

[41] Quoted in Doze, 43.

[42] *Oeuvres de St. François de Sales, Édition complète*, 14:324. I thank Sr. Jeanne Charlotte Johnson, V.H.M., of the Philadelphia Visitation, for her help with the translation of this passage. On the theme of Jesus' embryonic and fetal life in Mary, see John Saward, *Redeemer in the Womb: Jesus Living in Mary* (San Francisco: Ignatius Press, 1993). Two principal arguments were put forth for Joseph's presence at the Visitation: first, that, according to Oriental custom, a woman never travelled alone; and, second, that Luke omits mentioning that Joseph accompanied Mary because, given the aforementioned custom, this was assumed. It is hardly surprising that Francis concurred with the view that Joseph accompanied Mary on her visit to Elizabeth considering the prominence which the bishop ascribes to Joseph as the guardian and protector of Mary and Jesus, as well as of the Order of the Visitation (Canon Jean-Baptiste Gard's deposition, given in 1656, as part of the canonical process for Francis' beatification and canonization, testifies that in 1610 Francis dedicated to Joseph the first monastery of the Visitation [Serouet, 353]; Francis also wished the saint to be the Order's special patron and the particular protector of each monastery and of all entrusted to its care [*Année sainte des religieuses de la Visitation Sainte-Marie*, 12 vols., Annecy: Charles Burdet/Lyon: P.-N. Josserand, 1867-1871, 3:446, and *The Visitation Manual: A Collection of Prayers and Instructions Compiled According to the Spiritual Directory and Spirit of St. Francis de Sales, Founder of the Religious Order of the Visitation of Holy Mary*, New York: George Grady Press, 1955, 414]). Joseph is regularly included in artistic representations of the Visitation after the Council of Trent as his cult becomes more popular and widespread. The earliest illustration of Joseph's presence at the Visitation is found in a manuscript of the Pseudo-Bonaventure's *Meditations on the Life of Christ* (ca. 1300). See *Meditations on the Life of Christ: An Illustrated Manuscript of the Fourteenth Century* (Paris, Bibliothèque Nationale, Ms. Ital. 115), translated by Isa Ragusa and completed from the Latin and edited by Isa Ragusa and Rosalie B. Green (Princeton: Princeton University Press, 1961), 22, 407; Joseph Ignatius Vallejo, S.J., *The Life of St. Joseph* (this is an English translation of Vallejo's

biography of St. Joseph, which was first published in Spanish in 1774) (New York: Thomas Kelly, 1856), 81-83; Louis Réau, *Iconographie de l'art chrétien*, vol. 2, part 2 (1957; Millwood, New York: Kraus Reprint, 1988), 202; Gertrud Schiller, *Iconography of Christian Art*, translated by Janet Seligman, 2 vols. (Greenwich: New York Graphic Society, 1971-1972), 1:56.

43 *Treatise*, 1:34 (Dedicatory Prayer).

44 See, e.g., John Paul II, *Familiaris Consortio*, n. 25; Barbara Dafoe Whitehead, "Dan Quayle Was Right," *The Atlantic Monthly* (April 1993): 47-84; David Blankenhorn, *Fatherless America: Confronting Our Most Urgent Social Problem* (New York: Basic Books, 1995).

45 *Letter to Families* (2 February 1994), n. 16.

46 John Paul II, *Letter to Families*, n. 16.

47 *Spiritual Conferences*, 367-68.

48 *Spiritual Conferences*, 383.

49 Noye, "La Sainte Famille vue par les prédicateurs," 637.

50 See David Herlihy, "The Making of the Medieval Family: Symmetry, Structure, and Sentiment," *Journal of Family History* 8 (1983): 116-30, especially 128, *Medieval Households* (Cambridge: Harvard University Press, 1985), 128, and "The Family and Religious Ideologies in Medieval Europe," *Journal of Family History* 12 (1987): 3-17, especially 13.

51 Quoted in Filas, 426.

52 Cf. John Paul II, *Letter to Families*, n. 14.

53 Wright, *Francis de Sales*, 134-36.

54 See Wright, "'That Is What It Is Made For,'" 152, and *Francis de Sales*, 130; Ravier, "Preface," to his and Roger Devos' edition of St. François de Sales *Oeuvres*, ix-cix, especially xlvi-xlvii.

55 *Treatise*, 1:49 (Preface).

56 *Treatise*, 2:49 (Bk. 7, ch. 13).

57 *Treatise*, 1:34.

58 See *The Sermons of St. Francis de Sales on Our Lady*, translated by Nuns of the Visitation and edited by Lewis S. Fiorelli, O.S.F.S. (Rockford: Tan Books, 1985), 15-16; *Treatise*, 2:48-49 (Bk. 7, ch. 13); *Spiritual Conferences*, 383-84. Of course, the Church has no defined or obligatory doctrine on the bodily resurrection and assumption of St. Joseph. Advocates of this teaching—which, in addition to Francis, include Gerson, Bernardine of Siena, St. Vincent Ferrer, and Francis Suárez—propose it as a probable theological opinion. It should be noted, however, that, on 26 May 1960, in his homily for the Solemnity of the Ascension, Pope John XXIII, who was greatly devoted to both St. Joseph and St. Francis de Sales, stated that the assumption of St. Joseph is acceptable in pious belief. See Rondet, 29, 32-33; Filas, 421-29; *Acta Apostolicae Sedis*, 52 (1960): 455-56.

59 José Antonio Carrasco, O.C.D., "Fray Jerónimo Gracián de la Madre de Dios y su *Summario de las excelencias del glorioso S. Joseph, esposo de la Virgen María o Josefina* (1597)," *Cahiers de Joséphologie* 25 (1977): 295-322, especially 300-301.

60 *Just Man, Husband of Mary, Guardian of Christ: An Anthology of Readings from Jerónimo Gracián's Summary of the Excellencies of St. Joseph (1597)*, translated and edited with an introductory essay and commentary by Joseph F. Chorpenning, O.S.F.S. (Philadelphia: Saint Joseph's University Press, 1993), 254-55. Moreover, according to Gracián, at Nazareth the Holy Family conversed about the foundation of the Church and "St. Joseph was the advisor for the building of the Church because, as a carpenter, he helped to draw up the model, plans, and design of the new Jerusalem" (*Just Man*, 257). On subsequent elaborations of the theme of the Holy Family as the nascent Church by spiritual authors, artists, and modern popes, see Joseph F. Chorpenning, O.S.F.S., "The Earthly Trinity, Holy Kinship, and Nascent Church: An Introduction to the Iconography of the Holy Family," in *The Holy Family as Prototype of the Civilization of Love: Images from the Viceregal Americas*, exh. cat. (Philadelphia: Saint Joseph's University Press, 1996), 41-56, especially 50-51, 54.

61 St. Francis de Sales, *Letters to Persons in Religion*, translated by Henry Benedict Mackey, O.S.B. (New York: Burns & Oates, 1909), 420.

62 See, e.g., Noye, "Famille (Dévotion à la Sainte Famille)," 90. This point has special poignancy in Salesian spirituality, which is profoundly relational. Human relationships are neither inimical nor marginal to this spirituality, which gives priority to relational virtues, such as charity, gentleness, humility, patience, diligence. Devotion, actualized by the practice of the relational virtues, strengthens and enhances married and family life. See, e.g., Wright, *Francis de Sales*, 49, 73-99, 129-30.

63 "The Christian family is a vocation to love," *L'Osservatore Romano*, Eng. ed. (6 January 1993): 9.

"THE EARTHLY HOME OF THE ETERNAL FATHER": THE HOLY FAMILY IN THE SPIRITUALITY OF THE FRENCH SCHOOL

John Saward

For the French, the seventeenth century is the "great century," *le grand siècle*. These are years lived by France on the grand scale, the age of *grandeur* and *excellence*, of classicism and absolutism. The culture seems to soar to a glorious summit. With Corneille, Molière, and Racine, the French theater enters its golden age; and on the stage of the world stride players of Promethean power—Richelieu, Mazarin, and the Sun King, Louis XIV. In the palaces of Hardouin-Mansart and the operas of Lully, the same pomp and circumstance is seen and heard. Seventeenth-century France might truly be hailed, had the title not been adopted elsewhere, as the "land of hope and glory."

For the Catholic, the seventeenth century is great with the only true and lasting greatness, the *grandeur* of the saints, who are "first" only because, like their divine Master, they have become the last and least of all (see Matthew 20:26). In every age, God raises up saints in His Church, but in the seventeenth century, especially in France, He showered the graces of heroic holiness with prodigal liberality. In the revised universal calendar of the Roman Church, there are more saints of this century than of any other after the first and fourth. These are holy men and women who not only shaped the life of the religious congregations which they founded or to which they belonged, but also left an indelible imprint on the spirituality of the whole Latin Church. It is in the seventeenth century, and in France, that devotions, already deeply rooted in the Tradition, come to full and permanent flowering: the Hearts of Jesus and Mary, the Holy Infancy, St. Joseph, and the Holy Family.

In this paper, I want to show how the seventeenth-century French School of holiness and spiritual doctrine gave the last of these, devotion to the Holy Family, its decisive impetus. My theme is a paradox. In the very years when the princes of this world parade their glittering greatness, the Bride of Christ honors the hidden life of the King of Kings. There is a breathtaking

divine wisdom at work here. As the world swells with pride before the splendors of Versailles, the Church kneels before the humilities of Nazareth.

1. The French School: More Family Than School

The French School is a school of spirituality, a movement of missionary endeavor, a climate of reforming zeal. It prolongs and extends the work of the Council of Trent through ascetical and mystical theology, through evangelizing effort at home and abroad, and through bold new initiatives in the formation of priests, religious, and the laity. School, movement, climate: more than any of these, the French School is itself a kind of *family*.[1] Its influences, as in a natural family, are communicated as much through example and quiet encouragement as through institutional structures and formal teaching. The "nuclear family" of the French School is composed of the founding fathers and their sons. The fathers are Cardinal Pierre de Bérulle (1575-1629), the founder of the French Oratory, his disciple in the Oratory, Charles de Condren (1588-1641), and Condren's disciple, Jean-Jacques Olier (1608-1657). Their sons, those directly influenced or inspired by them, include St. Vincent de Paul (ca. 1580-1660), St. John Eudes (1601-1680), and St. Louis de Montfort (1673-1716), "the last of the great Bérullians."[2] But then there is a wider circle, an "extended family" which embraces most of the orthodox[3] Catholic spirituality of seventeenth-century France. Here we find, among others, the charismatic Jesuit Lallemant (1587-1635), the Dominican Passion-mystic Chardon (ca. 1596-1651), the golden-mouthed Bishop Bossuet (1627-1704), and the saintly archdeacon Boudon (1624-1702). The French School in this broader sense lives on in all the saints and great spiritual writers of France, right up to the twentieth century: the Curé of Ars, St. Thérèse of Lisieux, Blessed Elisabeth of the Trinity, Charles de Foucauld, and many others. It is an impressive school record, a noble family tree.

In what follows, I shall be examining the theological roots of devotion to the Holy Family in both the inner and outer circle—in Bérulle and his sons in the French Oratory, and in the school of Louis Lallemant in the Society of Jesus. Between these two men, we shall observe striking resemblances in doctrine and devotion (Lallemant has been described as a "Bérullian Jesuit"), but we shall also not fail to notice large differences in personality and career. Bérulle was what Cardinal Newman would have called an "outdoors" man, a master of the interior life, but also the agent of major external works: founding the French Oratory, establishing the reformed Carmel in France, securing a dispensation for Henry IV's daughter to marry the future Charles I of England.[4] By contrast, Lallemant spent his priestly life in the Society of Jesus on quiet "indoor" jobs as a teacher and a master of novices. Then again, Bérulle was a prolific author, while Lallemant wrote very little; we know him only thirdhand, through the re-editing of the notes of his students by a priest, Father Pierre Champion, who never met him. There is little doubt, however, that these two men had a tremendous and similar impact on their respective communities and on the French Church in general. Lallemant's disciples include the exorcist of Loudun, Jean-Joseph Surin, the apostle of Brittany, Blessed Julien Maunoir, and the North American missionary-martyrs, St. Isaac Jogues and Paul Ragueneau.[5]

2. The Christ-Centeredness of the French School: A "Copernican" Revolution

Pope Urban VIII called Bérulle the "Apostle of the Word Incarnate." The accolade is justly deserved. Bérulle effected a kind of "Copernican" revolution in spiritual theology. He is emphatic that the fiery star at the core of the universe is the Lord Jesus Christ, true God and true man in one person: "One of the outstanding minds of our times [Copernicus] maintains that the sun, and not the earth, is at the center of the world . . . Jesus is the true center of the world, and the world must be in continual movement towards Him. Jesus is the sun of our souls, from whom they receive all graces, lights, and influences."[6]

Father Bourgoing, third General of the Oratory, in his preface to the works of Bérulle, compares him to St. John the Baptist. His mission was "to point out Jesus Christ, to make Him known in the world, and not only His mysteries, His actions, His words, His miracles and sufferings, but also His person, His adorable states and grandeurs, to make Him revered, served, worshipped, and loved, and to form in us the living image of His life."[7]

The "States" of the Word Incarnate: A Relational Christology

Bérulle is Christocentric, not "Christomonistic." He does not isolate the Word made flesh. His is a Trinitarian, Marian, Ecclesial, Eucharistic Christocentricity. He always contemplates the incarnate Son in His several "states" and thus in His respective relations, divine and human: in the bosom of the heavenly Father, in the womb of the Holy Virgin, in the Blessed Sacrament of the Altar, in the hearts of the saints. The word "state" (*état*) is characteristic of Bérulle's age, and the concept the word signifies is the hallmark of Bérulle's spirituality. It enables him to draw on the rich theology of the "mysteries of the life of Jesus" inherited from the Fathers and living on in the Tradition up to and including St. Thomas Aquinas.[8] Bérulle argues that in some mysterious way, through the permanence of the wounds in the risen body of Jesus, all His earthly human actions and experiences, though concluded as events, remain as models and specific sources of grace for His members.[9] We are able to have communion with these mysteries, by the working of the Holy Spirit, in the liturgy of the Church, above all in the Holy Sacrifice of the Mass. In the Holy Eucharist, says Bérulle, Christ is given to us "in the plenitude of all His states and mysteries."[10] "We must, therefore, treat the things of Jesus and His mysteries not as past and dead, but as living and present, indeed eternal, from which we too should reap fruit that is present and eternal."[11]

Jesus is the eternal Word of the Father, and so His every human action and experience, even the silent months in the Virgin's womb, are revelatory, speak to us of the Father and His love. Bérulle follows St. Thomas in holding that, from the first moment of His Incarnation in the Blessed Virgin's womb, the Son of God was offering up His human will to the Father, thereby meriting grace for us.[12] Moreover, since the incarnate Son is the "Head of human nature,"[13] somehow united to every person, it follows that in Him every stage of our human life is raised up to a fresh dignity and given a marvelous new destiny.[14] There is nothing in the life of Christ that is in vain or futile. In His every mystery, He is indeed "full of grace and truth" (John 1:18).

We find in Father Lallemant the same grounding of spirituality in the Church's Christological dogma, especially as expounded by St. Thomas, together with a similar preoccupation with the "states" of Christ. Father Champion, his biographer and editor, speaks of him thus: "His great devotion was the Word incarnate. All the powers of [Lallemant's] soul were filled with [Christ's] adorable Person, with His states and with His mysteries ... All his practices of piety concerned the God-Man or related to Him, and the love of Our Lord was the foundation of all his conduct."[15]

Self-Abasement

In an age so triumphalistic and self-glorifying, it is wonderful to see a theology built so firmly on the humility and self-emptying of God incarnate. Bérulle uses the verb *s'anéantir* ("to make onself nothing") to describe the kenotic modality of the Incarnation. Without change in His divine nature, without diminution of His infinite divine richness, the Son of God unites to Himself hypostatically, in the womb of the Virgin, our poverty, a created human nature, a nature which, like everything created, is out of nothing. He makes Himself nothing, then, in this sense: by assuming our nothingness, our lowliness.[16]

In one of his *élévations*, Bérulle explains how the Incarnation involves two kinds of abasement for God the Son: first, through the assumption by a Divine Person of a created nature; secondly, through the voluntary assumption of our human nature in the condition of poverty and passibility: "O great and wonderful Jesus, despite your grandeurs, I see You in the state and form of a servant, and I see that You have taken this form and state in two ways. The first way is by taking our human nature through the mystery of the Incarnation, thereby lowering the infinite and supreme being of Your divinity to the nothingness of our nature. The second way is by taking the abject condition of Your mortal life, a weak and pitiful life, and lowering this same humanity, which is united to the Word, into the state and mystery of Your mortal, pilgrim life, an unknown and suffering life. . . ."[17]

The same doctrine is found in Lallemant: "One can say that the divinity in a way made itself nothing (*s'est anéantie*) in the mystery of the Incarnation by uniting itself in person to a nature drawn from nothing."[18] It would have been an abasement for the Creator of the universe to have united Himself hypostatically to the nature of the highest of the Seraphim; how much more then for Him to assume the nature of man, poor clod of earth. Moreover, had He wished, the divine Word could have formed a human nature for Himself in adult form, as He did for Adam, but He chose not to. He wanted to begin the human journey, as we do, in the lowliness of the womb.[19] The Son of God freely and lovingly decided to be "mothered" into human nature, to be conceived and born of the Virgin Mary, the Virgin betrothed to Joseph.

3. The Doctrine of the Holy Family

Through their spirituality of the mysteries of Christ, Bérulle and Lallemant, working independently in the same historical period, are setting the stage for a new veneration of the infancy and hidden life of Christ, His family life, those precious yet silent years when He is enfolded in the love of Mary and Joseph.

Connecting the Mysteries

Bérulle loves to connect the mysteries, to set out the likenesses and unlikenesses of the various states of Christ. So, for example, as St. Bonaventure did before him, he compares and contrasts the "three births" of Christ: the first birth is in His divinity, His eternal generation by God the Father; and the second and third births are in His humanity—His birth (i.e., conception) *within* the Virgin's womb in Nazareth (cf. the *quod in ea natum est*, Matthew 1:20), and His birth *from* the Virgin's womb in Bethlehem. Of the last of these, Bérulle says that it takes place "with noise and commotion" in the sense that "the angel proclaims it to the shepherds, the angel to the Kings, the Kings to Judea, and the capital of Judea is roused." By contrast, "the interior birth [the conception] takes place without noise and commotion; it takes place between the Holy Spirit, the angel, and the Virgin, in the intimacy of her heart, in the secrecy of her womb, in a closed room in Nazareth." Now it is here, as he meditates on the virginal conception, that Bérulle speaks of St. Joseph. His point is that, at the moment of this "interior birth," the whole world, including St. Joseph, is ignorant of the great and mighty wonder. On a superficial reading, Bérulle's words appear to be faint praise, but, on closer examination, they open up the beauty of St. Joseph's mission in the Holy Family: "Joseph . . . [is] the guardian of the Son, the husband of the Mother, the head of the Family and House of the eternal Father on earth . . . He was established by God with power and principality, His lieutenant in the noblest part of His state and empire, for the noblest empire of the eternal Father is Jesus and Mary, and Joseph has power over the one as over the other, by the will of the Father. Even so, this angel, this prince, this husband, this guardian of the Son and of the Mother of God is not called to the secret of this interior birth of Jesus, the secret which adores the secret of the eternal birth, just as the intimate dwelling of the Son in the Mother by this interior birth adores the intimate dwelling of the Son in the Father through the divine birth."[20]

This typically Baroque, very Bérullian sentence makes two important assertions: first, that the chaste husband of the Virgin acts *in loco Patris aeterni* in the Holy Family (the "head of the Family and House of the eternal Father on earth"); and secondly, that St. Joseph's way of discipleship is the way of silent, humble, uncomprehending obedience. These insights will be taken up by Bérulle's disciples.

Father Lallemant, too, connects the mysteries, contemplating and worshipping the God-Man in all His relations, to the Father and the Holy Spirit in His divinity, and to the virgin mother and the chaste guardian in His humanity. "All that bears the character of the Son of God, all that has a link with Him and touches Him, was infinitely precious to [Father Lallemant]; and for this reason He felt an inconceivable tenderness toward the Blessed Virgin and St. Joseph . . . He had an extraordinary grace for inspiring in everyone devotion to St. Joseph. He advised those persons who wanted to enter the spiritual way to take as their model of humility Jesus Christ; as their model of purity the holy Virgin; and as their model of interior life St. Joseph. It was by these models that he worked on his perfection, and one could see how he had happily expressed these models in himself."[21]

The Mysteries of the Hidden Life

Lallemant considers the various states of Christ's life that can be called "hidden." The obscurity of Nazareth is part of a pattern. The humble everyday work, prayer, joy and sorrow, of the Holy

Family's life reveals the permanent attitude, so to speak, of the Father's eternal Son. Moreover, we are called to share in His hiddenness: "We cannot conceive how Our Lord loves the hidden life. He hides Himself in all His states. He is hidden in the bosom of His Father, in the womb of His Mother, in His birth, in His childhood, in His exile in Egypt, in His dwelling in Nazareth, in the course of His ordinary life, in the ignominy of His Death, in the world after His Resurrection, in heaven after the Ascension, in the Holy Eucharist, which one can call the great mystery of His hidden life. When one loves Jesus Christ, one loves to stay with Him. 'Your life is hidden in God with Jesus Christ' (Colossians 3:3)."[22]

The Hidden Life in Nazareth, at the hearth of the Holy Family, is a contemplative life, the foundation of the mixed life of action and contemplation which characterizes the Public Ministry. "Our Lord gave thirty years to the contemplative life, and only three or four to the life that is called 'mixed,' because it is a mixture of action and contemplation. One can offer two reasons for this conduct: 1. He did not want to teach before the time prescribed by the Law. 2. He wanted to instruct by His example the Blessed Virgin and St. Joseph, who on their own were more important to Him than all other creatures."[23]

The Hidden Life of Jesus in Nazareth is one of poverty, says Lallemant. "Wanting to become man, He chose a poor Mother. He is born in the womb of poverty [cf. Ignatius Loyola, *Spiritual Exercises*, n. 116]. The cave in Bethlehem and the crib are proofs of this poverty. Poverty always accompanied Him throughout the whole course of His life. He lived for thirty years by His own work, and by that of the Blessed Virgin and St. Joseph."[24]

Meditating on the Mystery

In Lallemant, we find the rudiments of an explicit devotion to the Holy Family. It flows spontaneously from his admiration for St. Joseph. We are told that he performed four exercises each day in honor of the Guardian of the Redeemer, two in the morning, two in the evening. In the first, he sees St. Joseph as the model of sanctification of daily work, "harmonizing perfectly the interior life with his exterior occupations." In the second exercise, he looks at how he is measuring up to St. Joseph's standard. In the third, he accompanies "St. Joseph in spirit as husband of the Blessed Virgin," reflects on "the wonderful knowledge he had of her virginity and maternity," and encourages himself "to love St. Joseph for the love of his most holy spouse." Finally, in a typically Ignatian way, he pictures to himself "the worship and homage of love and gratitude that St. Joseph gave to the Holy Infant Jesus, and to ask for a share in it, in order to worship and love this divine Infant with the sentiments of the most profound respect and of the tenderest love of which he was capable."[25] Here are the seeds of a true devotion to the Holy Family: Lallemant contemplates the interdependent relationships of Jesus with Mary, Mary with Joseph, and Jesus with Joseph.

The Mystery of Israel

One striking feature of Lallemant's theology of the hidden and family life of Jesus in Nazareth is its positive appreciation of the Jewish tradition. For example, all the ritual purifications of the Old Testament are seen as a preparation for the Immaculate Virgin and her divine Son, for "it was

necessary that the people from which the Man-God was to be born should be purified in so many ways and sanctified by such a great number of sacred ceremonies."[26]

Bérulle likewise speaks of the Jews in a spirit of genuine reverence: "For His Son, God wanted to prepare not just individual persons, not just prophets and patriarchs, but an entire people, a state and an empire, in order to announce and welcome Him into the world. Thus, the whole state of the Jews is prophetic—foretelling, announcing, making public the world's salvation to the world."[27]

This reverence for the Jewish people (which does not disguise the tragedy of its failure to accept Christ) is a direct consequence of Bérulle's and Lallemant's relational Christology: for them, every state of the incarnate Son, everything relating to Him, is to be venerated and loved. Something similar will reappear in French Catholic culture, in the years following the Dreyfus case, in the writings of Leon Bloy, Charles Péguy, and the Maritains. As Bloy said in 1910, "Anti-Semitism . . . is the most horrible slap in the face suffered in the ever-continuing Passion of Our Lord: it is the most stinging and the most unpardonable because He suffers it on His Mother's face, and at the hands of Christians."[28]

In the same spirit of "adoration of the states of Jesus," St. Vincent de Paul and St. Louis de Montfort will serve the poor. They see the poor in relation to Christ: they serve Him in them. "What is a poor man?," asks St. Louis.

> It is written
> That he is the living image,
> The lieutenant, of Jesus Christ,
> His most beautiful heritage.
> To speak more truly,
> The poor are Jesus Christ Himself.
> This supreme Monarch
> Is helped or refused in them.[29]

Jesus, Mary, and Joseph: Our Teachers

In his "Practice for Honoring in Solid Fashion the Word Incarnate, the Blessed Virgin, and St. Joseph," Lallemant argues that the Son of God, in the self-abasement of His Incarnation, is a model of self-disregard (literally "self-contempt," *mépris de nous-mêmes*); the Blessed Virgin is a model of purity; and St. Joseph our practical guide in both the exterior and interior life. To him "God the Father entrusted the direction and government of the exterior actions of His Son and of the Blessed Virgin," in which He "had a more exalted employment than if He had had the government of all the angels and the direction of the interior life of all the saints." It follows, therefore: "We must . . . address ourselves to [St. Joseph] in our functions and duties, and ask him constantly for his guidance, not only for what is interior, but also for what is exterior; for it is certain that this great saint has a particular power to help souls in interior ways, and that one receives from him much help to enable us to act well in what appears to be external."[30]

Twenty-five years after Lallemant's death, his Jesuit disciple, Father Surin, continues to preach the same doctrine. Writing to a Carmelite nun, he speaks thus of St. Joseph as model and guide for the interior life: "He was in the most secret familiarity that one can have with Jesus and Mary, and he had with them communications and privacies that no one has ever had or will ever have. That is why he is the father of the interior life and the true protector of the souls that have the courage to detach themselves from everything in order to be wholly absorbed in the enjoyment of the divine mysteries."[31] Surin compares St. Joseph to a store, filled with the graces of Jesus and Mary, at which "souls who want to give themselves to the interior life can find what they need to enrich them." This is the treasury from which St. Teresa of Ávila drew so abundantly, and which she left as an heirloom to her daughters.[32]

4. DOCTRINE EXPRESSED IN DEVOTION

Although he does not give much explicit teaching on devotion to the Holy Family, Bérulle laid the dogmatic foundations upon which others will build. He performs a similar service for St. John Eudes in his theology of the Hearts of Jesus and Mary and for St. Louis de Montfort in his "true devotion to the Blessed Virgin." Condren and Olier will likewise apply the riches of Bérullian theology to the sanctification of priestly life. Similarly, the hints and suggestions of Lallemant, who died in 1635, will be extended and developed by his disciples and applied practically in the mission field.

It is, in fact, at about the time of Bérulle's death in 1629 that we see what some historians have called an "explosion" of devotion to the Holy Family both in Old and New France. In the spirit of Bérulle, who likes to connect the mysteries and to contemplate Christ in relationship, preachers, spiritual directors, and spiritual writers begin to recommend the invocation of the three names of Jesus, Mary, and Joseph. Associations, confraternities, and religious communities are dedicated to the Holy Family. From the beginning, a pastoral purpose is evident. In 1633, Canon Dognon of Verdun published a meditation on the marriage of Our Lady and St. Joseph with the goal of strengthening the purity of married and family life. He recommends that the invocation "Jesus, Mary, Joseph" be repeated three times after the twelve *Aves* of the "Little Crown of the Blessed Virgin" and before each hour of the Little Office of St. Joseph.[33]

Jérôme Le Royer de La Dauversière (1597-1659), the founder of Montreal and one of the foremost promoters of the Holy Family devotion, was indebted, it would seem, to both the Bérullian and Jesuit traditions.[34] In 1630, he consecrated himself with his wife and children to the Holy Family. A few years later, to support his projects in New France, he organized a confraternity of the Holy Family "under the name and invocation of the glorious confessor St. Joseph."[35] In 1635, while in Paris to make plans for the North American adventure, Monsieur de La Dauversière was blessed with a vision of the Holy Family. In the *Annales de Moulins*, Mother Peret tells the story: "Having received Holy Communion, he went to pray at the feet of Our Lady. As if outside himself, he saw quite distinctly Jesus, Mary, and Joseph, and he heard Our Lord speaking to the Most Blessed Virgin: 'Where can I find a faithful servant?' He repeated 'faithful servant' three times. The Blessed Virgin replied: 'Here, Lord, here is that faithful servant,' and taking Monsieur Le Royer by the hand, she presented Him to her dearly beloved Son. Our Lord received him with kindness and said:

'Henceforth you will be My faithful servant. I will clothe you with strength and wisdom. You will have your guardian angel to guide you. Work hard for me. My grace is sufficient for you and will not fail you.'"[36] Finally, on 2 February and 15 August 1642, the infant colony of Montreal, "Ville-Marie," was consecrated to the Holy Family of Jesus, Mary, and Joseph.[37]

By the 1660s, Lallemant's disciple, Father Surin, is proposing the Holy Family as a model for both religious communities and families in the world. He describes the Ursuline monastery of Mère des Anges in Loudun as the "house of St. Joseph, Mary, and Jesus."[38] Just before Christmas 1663, he writes to a married layman, Monsieur Du Sault of Bordeaux, showing how his whole household can share the joy of Our Lord's birthday with the Blessed Virgin and her Spouse: "Little Du Sault [the Du Saults' son] will make a point of looking for wood to make a fire for the Holy Child Jesus, and, in the hope of making himself altogether spiritual, he will make provision for lighting the fire of divine love in his heart." The servants are drawn into the service of the Holy Family: "Anne [probably the chambermaid] will be charged with the service of the whole Family and see to it that the table of the Blessed Virgin and St. Joseph is served according to their merits. . . ."[39]

CONCLUSION: THE STRUGGLE OF TWO CULTURES

It may have been *le grand siècle*, but to Bérulle and Lallemant and their disciples, it was *le pauvre siècle*. Like all times, it was the best of times and yet the worst of times. The French School keeps alive the evangelical tradition of non-conformity to the *saeculum*, to the world as it presently is, organized by the Prince of this World in opposition to Christ and His Church. The Holy Family is seen as the perfect realization of what the Popes of our time call the "civilization of love" and, therefore, in prophetic opposition to the culture of the world. Jesus, Mary, and Joseph, says Father Surin, "were extremely remote from all that the world esteems, and the life they lived on earth is the condemnation of the worldly life." He admits that there are certain proprieties that "persons of quality" must preserve outwardly, but "inwardly they must have a holy contempt for all the vanities of the world," otherwise they will be unable to avoid the "subtle venom of pride and haughtiness that the advantages of birth and fortune discharge in people's souls." Such a temptation can only be overcome "by the love and pursuit of what is lowly, abject, and of least consequence in the eyes of men and most opposed to the spirit of the world and its maxims."[40] Surin's biographer, Henri-Marie Boudon, Archdeacon of Evreux, in similar fashion, commends devotion to the Holy Family to all who want to share the hidden life of Jesus and distance themselves from those who "want to amuse us with the esteem of created things and arrest us with the thought of what to think and say." Devotion to these lovable persons, who were "in such a holy way separated from the world (*siècle*)," "fills the soul with heavenly lights and a divine power, enabling it to penetrate the excellences of the hidden life and thus enter its solid and faithful practice."[41]

If we put down Surin's *correspondance* and take up Madame de Sévigné's, we shall appreciate the force of the French School's social criticism. In "society," the medieval virtue of courtesy (which presupposed charity and the moral virtues) has degenerated into *préciosité*. Refinement of manners prevails over reform of morals. Marriage is widely seen as a bore. Adultery is not condemned as long

as dignity and discretion are maintained. And, of course, until Madame de Maintenon exerted her influence, the life of Louis XIV's court was one of orchestrated licentiousness. There was need, urgent need, for the Christian renewal of family life. Devotion to the Holy Family met that need.

There is nothing negative about the French School's *mépris du monde*. On the contrary, Bérulle and his sons see it is a condition of the Christian's positive love. The believer cannot cooperate with the Son's mission of saving the world unless he cooperates with the Holy Spirit's mission of convincing the world of its sin. Since the world lives by *cupiditas*, conformity to the world destroys *caritas*. That indefatigable missionary and apostle of Christian hope, St. Louis de Montfort, has left us a vigorous cantique of Christian resistance to the spirit of the age, "Adieu to the Insane World." It is militant, not morbid, an act of defiance, not defeatism.

> Sin, you say, is gallantry.
> Virtue you treat as bigotry.
> In your mind, gentleness
> Is cowardliness; humility
> Is servility.
> Saying prayers rusticity,
> Fearing Hell infirmity.
>
> We want, O Master,
> To march under your banner
> Against this enchanter,
> Though he may growl and mutter.
> Oh how glorious,
> Oh how sweet it is, sweet it is, good Master,
> To have you as our leader
> To combat this traitor.[42]

This good-humored Gospel radicalism is very different from the joylessness of Port-Royal. As Father Deville has shown, the Jansenist *contemptus mundi* was "promoted in reaction against the commitment 'to the world' advocated by the Bérullians, priests and laypeople alike."[43] It was precisely because they wanted to save and transfigure the world that the Bérullians opposed its false values. Port-Royal wanted just to escape. The missionaries of the French School saw that the newness of Christ cannot transform a culture if His servants surrender to the culture's *vanités* and *bassesses*. What nowadays is called "inculturation," i.e., the penetration and transformation of a culture by the Gospel, can only take place through purgation of the culture's defilement and the illumination of its darkness.

Two generations ago, Christopher Dawson showed in connection with another century, the twelfth, that the "dualism of Church and world" was "the principal source of that dynamic element which is of such decisive significance for Western culture."[44] It was precisely during what now we

would call the "Christian centuries" of the Middle Ages that the faithful were made most acutely aware of the Pauline challenge to be unconformed to the world. To us, the twelfth century seems a golden age of Christian culture, but to people of the time it was "dark with the threat of the coming doom."[45] Cultures are transformed by the unworldly, by those who bring them, at whatever the cost, the salt, light, and leaven of Christ. That is why the blood of the martyrs is the seed of the Church. Through their wounds, Christian faith and charity are poured out anew to water the wasteland of the world.

Our Holy Father, Pope John Paul II, calls us both to cooperate with the Holy Spirit in building up the civilization of love, the culture of life, and also to be bold in the same Spirit in resisting the civilization of use, the culture of death. In his *Letter to Families* (1994), he has spoken of how the ever-virgin Mother of God and her chaste Spouse are the "first models" of that "fairest love" which alone can transfigure the earth.[46] Like the great doctors of the French School, the Holy Father sees the Holy Family as a pattern for cultural renewal. His prayer is that of Bérulle and Lallemant: "May the Holy Family, icon and model of every human family, help each individual to walk in the spirit of Nazareth. May it help each family unit to grow in understanding of its particular mission in society and the Church by hearing the Word of God, by prayer and by a fraternal sharing of life. May Mary, Mother of Fairest Love, and Joseph, Guardian of the Redeemer, accompany us all with their constant protection."[47]

The *siècle* can only be truly great when Nazareth provides the social norm.

NOTES

[1] The word "family" is often used in the Oratorian tradition as a synonym of "confraternity" or "association of the faithful": see Irénée Noye, "Famille (Dévotion à la Sainte Famille)," *Dictionnaire de spiritualité*, vol. 5 (Paris, 1964), 84-93, especially 86-87.

[2] See R. Deville, *L'École Française de spiritualité* (Paris, 1987), ch. 9.

[3] By "orthodox," I mean non-Jansenist and non-Quietist. The spirituality of the French School, together with that of St. Francis de Sales, was a God-given remedy for the Jansenist and Quietist maladies. One has only to think of the healing balm provided later in the century by St. Margaret Mary and St. Louis de Montfort.

[4] See *Lettres III*, n. 244; *Oeuvres complètes de De Bérulle*, new edition (Paris, 1856), 1606-1607. All references henceforth will be to this edition according to column number.

[5] On the Lallemant school's interest in the theme of "folly for Christ's sake," see my book *Perfect Fools: Folly for Christ's Sake in Catholic and Orthodox Spirituality* (Oxford, 1980), 104-184.

[6] Bérulle, *Oeuvres*, 161.

[7] Bérulle, *Oeuvres*, 97.

[8] More recently, this beautiful traditional Christology, which is rooted in the Gospels, has been opened for us in *The Catechism of the Catholic Church* (nn. 512ff).

[9] They are "past with regard to performance, but they are present with regard to power" (Bérulle, *Oeuvres*, 1052). Father Bourgoing writes: "The Resurrection of the Savior was the perfection, consummation, and, as it were, the sanctification of all the other mysteries that He accomplished on earth" (*Les veritez et excellences de Jésus-Christ nostre Seigneur*, part 1, vol. 2 (Paris, 1639), 14.

[10] Bérulle, *Oeuvres de piété*, 83, 1; 1064.

[11] Bérulle, *Opuscules de piété*; 1053.

[12] Bérulle, *Vie de Jésus*, 27; 487ff. Cf. St. Thomas Aquinas, *Summa Theologiae* 3a 19, 3 (on the merit of Christ); 34, 3 (on Christ meriting from His conception).

[13] Bérulle, *Oeuvres de piété*, 16, 5; 939.

[14] Bérulle says that all the "states and conditions of our nature" have been honored by the "divine subsistence," that is to say, made His very own by the divine hypostasis of the Word and in Him "restored, sanctified, and deified" (*Oeuvres de piété*, 17, 2; 940).

[15] Pierre Champion, S.J., *La vie et la doctrine spirituelle du Père Lallemant*, new edition (Paris, 1959), 53-54. All references henceforth will be to this edition according to page number. On the "states" of Christ, see 284ff.

[16] Cf. Bérulle, *Grandeurs de Jésus*, 2, 3; 162.

[17] Bérulle, *Élévation II à la Saint Trinité, sur l'Incarnation*, 12; 518-19.

[18] Champion, 276.

[19] Champion, 276.

[20] Bérulle, *Grandeurs de Jésus*, 11, 12; 382-83.

[21] Champion, 54.

[22] Champion, 285-86.

[23] Champion, 286.

[24] Champion, 317-18.

[25] Champion, 54-55.

[26] Champion, 321.

[27] Bérulle, *Vie de Jésus*, Préambule, 21; 425.

[28] Cited in J. Maritain, "The Mystery of Israel," in *Redeeming the Time*, English translation (London, 1943), 153.

[29] *Cantique 17*; *Oeuvres complètes de Saint Louis-Marie Grignion de Montfort*, new edition (Paris, 1966), 1004.

[30] Champion, 333.

[31] Letter 296 (to Mother Jeanne de la Conception, Carmelite in Bordeaux, end of March 1660; *Correspondance*, new edition [Paris, 1966], 939-40).

[32] Letter 224 (to Mother Jeanne de la Conception; *Correspondance*, 761-62).

[33] R. Dognon, *Modèle du ménage heureux en l'histoire du mariage de saint Joseph* (1633), passim.

[34] See Camille Bertrand, *Monsieur De La Dauversière* (Montreal, 1947), 98ff.

[35] Bertrand, 56.

[36] Bertrand, 63.

[37] Bertrand, 126-27.

[38] Letter 571 (December 23, 1664; *Correspondance*, 1636).

[39] Letter 516 (written between December 22 and 25, 1663; *Correspondance*, 1496-97).

[40] Letter 475 to Madame de Pontac (July-August 1662; *Correspondance*, 1407).

[41] *La vie cachée avec Jésus en Dieu* 2; *Oeuvres complètes de Boudon*, new edition, vol. 1 (Paris, 1856), 602-603.

[42] *Adieu au monde insensé* (*Cantique 107*); *Oeuvres complètes*, 1454.

[43] R. Deville, "The French School of Spirituality" in *Jesus Living in Mary: Handbook of the Spirituality of St. Louis-Marie de Montfort* (New York, 1994), 455.

[44] *Religion and the Rise of Western Culture*, new edition (New York, 1958), 68.

[45] Dawson, 204.

[46] *Letter to Families*, n. 20.

[47] *Letter to Families*, n. 23.

DEVOTION TO THE HOLY FAMILY IN SEVENTEENTH-CENTURY CANADA

Roland Gauthier, C.S.C.

Historians of spirituality are well aware that devotion to the Blessed Virgin Mary, to St. Joseph, and to St. Ann was vigorous in Canada from the beginnings of the French colony. It is also well known that St. Joseph was proclaimed, in 1624, "patron of the country and protector of the growing Church."[1] Moreover, one has only to read attentively the early chronicles of the history of New France, as Canada was called during the Colonial period, in order to realize that devotion to the Holy Family spread very rapidly in that vast territory.

THE BEGINNINGS OF THE HOLY FAMILY DEVOTION

A listing of facts is very revealing; even an incomplete list is significant. In 1634, the Notre-Dame-de-Recouvrance Chapel, in Quebec City, received a gift of a small copper picture representing Our Lady, St. Joseph, and the Infant Jesus in the center.[2] In 1635, Blessed Marie of the Incarnation was living at the Ursulines in the town of Tours, France. God then revealed to her that she had a special vocation as a missionary in New France, and asked her to build a house where Jesus, Mary, and Joseph would be honored.[3] During the winter of 1636-1637, a widespread epidemic broke out among the Hurons. On 30 November 1636, St. Jean de Brébeuf, superior of the mission, and each of his Jesuit companions promised to celebrate three Masses: the first Mass in honor of Our Lord, another in honor of the Virgin Mary, and a third Mass in honor of St. Joseph. By springtime, the sickness had gradually disappeared.[4] Devotion to the Holy Family also had more official manifestations. On 1 May 1637, the governor of the country, Monsieur de Montmagny, had a large tree planted in front of the church of Quebec where the names of Jesus, Mary, and Joseph were inscribed.[5] This was the origin of the "May Tree," a tradition that was to be maintained in New France for a great many years.

Another event deserves special mention. In March 1639, the layman Monsieur Jérôme Le Royer de La Dauversière met with Father Jean-Jacques Olier, the future founder of the Society of St. Sulpice, and together they decided to establish the Notre Dame Society which would eventually be responsible for the foundation of Montreal. All the members of this Society (twenty-seven men and eight women) met at Notre-Dame of Paris on 27 February 1642, and "they consecrated the Island of Montreal to the Holy Family of Our Lord, Jesus, Mary, and Joseph, under the special protection of the Blessed Virgin."[6] This was the origin of the name of Ville-Marie that was given to the city of Montreal; however, we must not forget that the consecration of the island had been made to the Holy Family.

Other special traits of devotion to the Holy Family in New France merit consideration. First of all, the chapter of the Ursuline Sisters of Quebec, on 31 July 1647, adopted the new text of their Constitutions and Rules drawn up by the Jesuit Father Jérôme Lalemant. In this text, the Sisters were invited to imitate, as they took their meals, the intentions and virtues of each of the three persons of the Holy Family.[7] Almost ten years later, on 25 May 1656, Monsieur Jean de Lauzon, the fourth governor of the country, "in the name of Jesus, Mary and Joseph" set the first stone of the Ursuline church.[8] That same year the building of St. Joseph's chapel of the Hôtel-Dieu of Montreal began, and the text inscribed on the lead plaque that marked the placing of the cornerstone ended with the three names of Jesus, Mary, and Joseph.[9] The following year, a poor young girl (Antoinette Hyacinthe du Tartre) was graciously received, without dowry, in the monastery of the Augustinian Sisters of the Hôtel-Dieu of Quebec, "in order to honor the Holy Family of Jesus, Mary, and Joseph."[10]

I conclude this introductory section of my paper by recalling the case of Blessed Catherine of St. Augustine, a religious of the Hôtel-Dieu of Quebec. It is common knowledge that during her life she was granted the grace of several visions and ecstasies. In 1657, she had a vision of Our Lord and St. Joseph, who clearly indicated the place that was chosen in the celestial court for her, a place where she would easily see Jesus, Mary, and Joseph. A few weeks later, on the Vigil of the Solemnity of the Assumption, at the moment when Catherine was preparing herself for the reception of the Sacrament of Confirmation, "the Blessed Virgin and St. Joseph presented her to Our Lord, to receive the sacred unction from the Lord's hand."[11]

How impressive and revelatory is this list of facts! It is quite evident that, in the spirituality of the first pioneers of Canada, a very special place was reserved for the three members of the House of Nazareth. According to those hardy souls, what God had united should never be separated (cf. Matthew 19:6, Mark 10:9).

THE CONFRATERNITY OF THE HOLY FAMILY

We will now speak of a major event in the religious annals of Canada, namely, the foundation of the confraternity in honor of the Holy Family. Important information about this event is disclosed in the autobiography of Father Pierre Joseph Chaumonot (1611-1693), one of the most illustrious Jesuit missionaries in New France, who labored there from 1639 to 1693.[12] First of all, it is clear that Father Chaumonot had a lively devotion to the Holy Family before his arrival in

Quebec. He had been cured in Italy, ca. 1632, from a chronic violent headache, thanks to the intercession of Jesus, Mary, and Joseph; he expressed his gratitude by making a pilgrimage to the Holy House of Loreto, which he usually called the House of the Holy Family.[13] When he landed in Quebec on 1 August 1639, he quickly became the spiritual father of the Hurons, and he also frequently spoke to them of the three holy people in the House of Nazareth.

On 2 June 1662, Chaumonot left Quebec City and went to Montreal, in order to accomplish a special mission. In Montreal, he met Madame Barbe d'Ailleboust, a woman of exceptional virtue who had the soul of an apostle. They decided to find a practical way of promoting the Holy Family as a model for all Christian homes. Father Chaumonot had the brilliant idea of establishing an association under the title of the Holy Family. His project won the approval, in July 1663, of the most prominent citizens of Montreal: the parish priest of Ville-Marie, the Sulpician Father Gabriel Souart, Madame d'Ailleboust, the superior of the Hôtel-Dieu of Montreal, Mother Judith Moreau from Brésoles, and, finally, Mother Marguerite Bourgeois.[14]

This association had barely begun in Montreal when, in late August or early September 1663, Father Chaumonot was recalled to Quebec by his superior, Father Jérôme Lalemant. For her part, Madame d'Ailleboust also decided to return to Quebec. They wanted to avail themselves of the opportunity to secure the official approval of the Confraternity of the Holy Family from the bishop of New France, Blessed François-Xavier de Montmorency-Laval (1623-1708), who initially gave provisional approval. Subsequently, the bishop gave his complete approval, expressing his great interest in this project by erecting an authentic confraternity by means of patent letters dated 14 March 1664. Laval testified that what he wanted, above all, was "to imprint in the heart of each and everyone a sincere love and just as strong a devotion toward the most saintly and sacred family of Jesus, Mary, and Joseph, and to the holy angels."[15] But, while reading the official charter, our attention is drawn to the fact that this confraternity was set up exclusively for women ("a few meetings of women and girls"), because, according to Father Chaumonot, this confraternity was not to detract in any way from the Marian Congregation that had been established at the Jesuit College in Quebec on 14 February 1657, and was reserved exclusively for men and boys.[16]

Bishop de Laval also requested Father Chaumonot to write to his confrère Father Paul Ragueneau, who was then in Paris, in order to obtain from Rome indulgences, and even plenary indulgences.[17] In fact, two bulls (rescripts) were received in Quebec. The first one, dated 22 January 1665, granted a plenary indulgence on certain occasions to deceased members of the confraternity; the second, dated January 28 of the same year, granted in perpetuity many indulgences to living members.[18]

After the reception of those bulls, Bishop de Laval published specific and detailed rules for the confraternity, rules that he had composed himself. He explained the purpose and the spirit of this association, the qualities required for membership, the pious practices to be carried out, the mode of reception and the reasons for exclusion, the role of the officers and of the councillors.[19] On the other hand, Bishop de Laval did not fear to show openly his personal devotion toward this "trinity on earth." For example, he placed the Seminary of Quebec under the patronage of the Holy Family. He also reserved one of the chapels in his cathedral for the meetings of the confraternity, and

dedicated this chapel and its altar to the Holy Family. Moreover, he chose the Holy Family as "patron of the parish."[20] Likewise, he dedicated several new parishes in his diocese to the Holy Family, such as those on the Island of Orleans in 1666, of Boucherville in 1668, and of Cap-Santé in 1679.[21] There is also the Holy Family chapel and fort for the Tamarois, near Cahokia (Illinois), inaugurated in 1699 by a group of priests from Quebec.[22]

There is another episode which clearly shows the unlimited confidence of Bishop de Laval in the Holy Family of Nazareth. Leaving Boston with a flotilla of thirty-two ships transporting more than 2,000 soldiers, the British admiral William Phips arrived in the port of Quebec City on 16 October 1690. His intention was to conquer the town and even the country. Bishop de Laval asked the Ursuline Sisters for the loan of the painting of the Holy Family that they had venerated for some years. The bishop had decided to display this image on the top of the steeple of the cathedral, in order to make it known that the defense of the city was entrusted to the patronage of the Holy Family. The English artillery tried several times, unsuccessfully, to knock down this standard. They finally gave up and eventually retreated.[23]

THE MANUAL OF THE CONFRATERNITY

Because of the exceptional attractiveness of this confraternity and the notable increase in the number of its members, it became necessary to publish an official manual, in order to ensure unity of mind and of action. This manual was first published at Paris in 1675, with the title, *The Solid Devotion to the Very Holy Family of Jesus, Mary, and Joseph, with a Catechism That Teaches How to Practice Their Virtues*.[24] The first section of the book indicated in detail the order to follow in the monthly meetings of the members: an opening prayer, the recitation of the rosary of the Holy Family, an exhortation or instruction of about a half-hour given by the spiritual director, the litanies of the Holy Family, and a concluding prayer.[25]

Two pious practices of the confraternity deserve our attention. The rosary of the Holy Family was made up of three decades only. On the three large beads, the "Our Father" was recited, and the "Glory Be" was added at the end of each decade. And, on the thirty small beads, the following invocation was to be repeated in Latin: "Jesus, Mary, Joseph, Joachim and Anna, help us! Blessed Trinity, only one God, have pity on us!" This was a means of recalling the thirty years that Jesus, Mary, and Joseph lived together.[26]

The text of the Litanies of the Holy Family was printed only in Latin. The three persons of the Holy Family were not grouped under one single invocation. Rather, there were three successive invocations, one for each of the three persons. The following translation of the first two series of invocations serve as an example: "Jesus, Son of the Living God, have mercy on us. Holy Mother of God, pray for us. Spouse of the Virgin Mary, pray for us. / Jesus, O lily of virgins, have mercy on us. Holy Virgin of Virgins, pray for us. Blossom of virginity, pray for us."[27]

The second part of the book was titled: "Catechism of the Holy Family of Jesus, Mary, and Joseph."[28] It was a real catechism in question-and-answer format which presented an exposition of devotions and family virtues to be practiced. It was divided into three parts. The first part focused on the sublime holiness of the Family of Nazareth; the second set forth the exterior practices

whereby one could honor the Holy Family; the third specified the duties of the different members of the confraternity.

THE FEAST, OFFICE, AND MASS OF THE HOLY FAMILY

Bishop de Laval also wanted this confraternity to be properly established. Therefore, at the outset he decreed that the official feast of the association be celebrated at a set date, that is, the Second Sunday after Epiphany. At the time of the confraternity's establishment, the text of the Office and of the Mass was borrowed from the Feast of the Annunciation of the Lord, but, shortly thereafter, the bishop asked four priests from his diocese to compose a text to be used exclusively for this solemn celebration. When the first draft of this work was completed, the four priests submitted their composition to a poet and well-known French liturgist, Jean-Baptiste Santeul, a canon regular of the Abbey of St. Victor in Paris.[29]

The bishop of Quebec spoke again of the Feast of the Holy Family in his mandate of 4 November 1684. He indicated that henceforth this feast be a double first class with an octave, "such as it was practiced for several years." Moreover, he determined that in the future, this feast would be celebrated at a time of the year when the weather would be more favorable. Therefore, he transferred it from the Second Sunday after Epiphany to the Third Sunday after Easter, in order to encourage the faithful to go to church to celebrate this great feast in an appropriately solemn manner.[30]

This was one of Bishop de Laval's last official acts, as his resignation was accepted in 1685. Father Jean-Baptiste de St.-Vallier was appointed as his successor. The new bishop arrived in Quebec City on 31 July 1688. The annual celebration of the Feast of the Holy Family continued to take place with great solemnity. The director of the confraternity, Father Charles Glandelet, wished, however, that the text of the Office and Mass be printed. He made this request several times to Father Henry-Jean Tremblay, who was procurator of the Seminary of Quebec in Paris. The latter asked Father Simon Gourdan, another poet of the Abbey of St. Victor in Paris, to compose four hymns and a long prose piece in honor of the Holy Family. This new Office was printed in 1701 and sent at once to Quebec.[31]

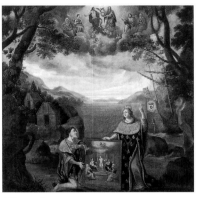

Figure 1
France Bringing the Faith to the Hurons of New France, ca. 1670.
Quebec City, Ursuline Monastery.

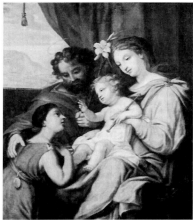

Figure 2
Claude François, called Frère Luc (France),
The Holy Family with a Huron Girl, ca. 1671.
Quebec City, Ursuline Monastery.

Figure 3
[Gregory Huret?],
The Holy Family,
engraving, 17th c.

THE ICONOGRAPHY OF THE HOLY FAMILY IN SEVENTEENTH-CENTURY CANADA

Just a few words on this topic. We must remember that New France was still a young country at this period. Life was harsh and dangerous. Generally speaking, the pioneers were unable to devote much time to producing works of art. They had to toil to clear the land that had been granted them and to do so as quickly as possible. They also had to defend themselves against Indian attacks. Consequently, it is not at all surprising that there are very few seventeenth-century works of art depicting the Holy Family. Of those that were produced, even fewer have survived, the rest being destroyed in various fires.

Two such extant images are discussed in the essay on the iconography of the Holy Family in the catalogue of the exhibition "The Holy Family as Prototype of the Civilization of Love: Images from the Viceregal Americas."[32] Consequently, I will only briefly mention them. *France Bringing the Faith to the Hurons of New France* (Figure 1), executed ca. 1670 and presently in the Monastery of the Ursulines in Quebec City, was for many years thought to be the work of the French artist Claude François (1614-1685), who, after entering the Franciscan Recollects in 1644, took the name Frère Luc. Today this painting is no longer attributed to this artist, who spent fifteen months in Quebec City (Summer 1670 to October 1671). *The Holy Family with a Huron Girl* (Figure 2), illustrating one of the many visions of Blessed Marie of the Incarnation, is also in the Ursuline Monastery in Quebec. It was probably painted ca. 1671. Although unsigned, it is attributed to Frère Luc. I would like to call attention to three additional surviving images of the Holy Family.

The first image is an engraving of the Holy Family, signed Huret (perhaps Gregory Huret [1606-1670]), which adorns the frontispiece of the *Manual of the Confraternity of the Holy Family* (Figure 3). The artist wished to illustrate the exceptional value of the intercession of the Holy Family. He sought to explain why the wife would not refuse the supplications of her spouse, and the Son, the prayers of His mother. Huret depicted this symbolism by putting on the lips of each member of the Holy Family a characteristic sentence. Joseph says to Mary: "Show yourself a mother." Mary says to Jesus: "Remember, my

Son, Your Congregation (Confraternity)." Jesus answers: "Mother, your sons are My brothers." Although the meaning of this image is readily intelligible, it is not, in my opinion, an artistic masterpiece.

The second example is a painting, by an anonymous French artist, representing the Holy Family in the traditional style (Figure 4). This image was given by the Sulpician priest Gabriel Souart to Sister Marguerite Bourgeoys between 1663 and 1676. The Child Jesus is about five or six years of age, His right hand is raised to heaven, and He stands in the center. Mary is at His right, and Joseph at His left; both are kneeling and, apparently, are deep in meditation. This painting survived three fires and five movings. It is kept as a precious souvenir at the Motherhouse of the Sisters of Notre Dame in Montreal.

The final example is a large painting of the Two Trinities which hangs in the Hôtel-Dieu of Montreal (Figure 5). According to a manuscript note, the Sisters of this hospital, the Hospitallers of St. Joseph, bought this tableau in France in 1708. This painting was probably executed in France at the end of the seventeenth century, or at the very beginning of the eighteenth. The symbolism of this picture requires no special explanation. However, an historical event linking an American girl with this canvas is of the greatest interest. The American general Ethan Allen, who died in 1789, had a daughter named Frances Margaret. One day, at the age of twelve, Frances Margaret was walking alone along the Connecticut River (near Westminster, Vermont), when she suddenly saw an animal with the appearance of a monster coming out of the water. She was paralyzed with fear. But, at the same moment, she saw an old man clothed with a brown cloak, who touched her arm and said: "Little girl, go back home immediately. Run, run!" Frances Margaret converted to Catholicism in Montreal in 1807, and, a year later, became a novice at the Hôtel-Dieu of Montreal. When she entered the chapel there and saw the painting of the Two Trinities hanging above the main altar, she immediately said to the other sisters: "Look at the face of St. Joseph. He is really the mysterious old man who appeared to me earlier and saved my life." This episode is attested to by both Canadian and American historians.

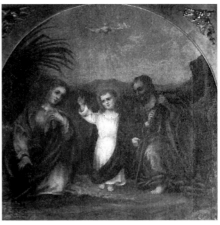

Figure 4
French School,
The Holy Family, 17th c. Montreal,
Motherhouse of the Sisters of Notre Dame.

Figure 5
French School,
The Heavenly and Earthly Trinities,
ca. 1700. Montreal, Hôtel-Dieu.

CONCLUSION

The data presented in this paper amply documents that devotion to the Holy Family was an integral part of popular piety in New France. During the seventeenth century, this devotion did not spread with such rapidity and fervor in any other country in the world, nor with such great care taken to celebrate the liturgical feast of the Holy Family conveniently and solemnly. One can affirm, and with good reason, that the meticulous organization of the Confraternity of the Holy Family in Canada, as well as its prodigious growth, were "a world spiritual success."[33]

NOTES

[1] See John J. O'Gorman, "Canada's Patron Saint," *Catholic Historical Review* 7 (1928): 646-57.

[2] "Catalogue des bienfaiteurs de Notre-Dame-de-Recouvrance de Kébec," in *The Jesuit Relations and Allied Documents: Travels and Explorations of the Jesuit Missionaries in New France, 1610-1791*, edited by Reuben Gold Thwaites (Cleveland, 1891-1901), 42:270.

[3] Marie de l'Incarnation, *Relation de 1654*, in *Écrits spirituels et historiques*, edited by Dom Albert Jamet (Paris-Québec 1930), 2:323-24.

[4] *Jesuit Relations*, 13:158-62.

[5] *Jesuit Relations*, 12:166-69.

[6] *Jesuit Relations*, 22:208. On Jérôme Le Royer, see Henri Béchard, S.J., *Jérôme Le Royer de La Dauversière, His Friends and Enemies (1597-1659)* (Bloomingdale [Ohio], 1991).

[7] *Constitutions & Reiglemens des Ursulines de Québec*, ms., Ursuline Monastery, Quebec City, fol. 114r.

[8] Mother Saint-Joseph Barnard, O.S.U., "Un pèlerinage des Ursulines de Québec dans le domaine de Saint Joseph," *Cahiers de Joséphologie* 13 (1965): 5-86, especially 43.

[9] Sister Maria Mondoux, R.H.S.J., "La dévotion à S. Joseph dans la Congrégation des Religieuses Hospitalières de S.-Joseph," in *Le patronage de Saint Joseph* (Montréal-Paris 1956), 424.

[10] Text from the Archives of the Congregation, quoted by Dom Albert Jamet, in *Les Annales de l'Hôtel-Dieu de Québec* (Québec, 1939), 94, note 2.

[11] The text of these visions is quoted by Adrien Pouliot, S.J., "L'extraordinaire dévotion de la Nouvelle-France envers saint Joseph," in *Le patronage de Saint Joseph*, 381-82.

[12] There are three editions of this autobiography: New York 1858, Poitiers 1869, and Paris 1885. I use the last one: *Autobiographie du Père Chaumonot de la Compagnie de Jésus et son complément, par le R.P. Félix Martin* (Paris: H. Oudin, 1885).

[13] *Autobiographie du Père Chaumonot*, 31-33.

[14] *Autobiographie du Père Chaumonot*, 162-67.

[15] See the complete text of Bishop de Laval in *Mandements, lettres pastorales . . . des évêques de Québec* (hereafter *MEQ*) (Québec, 1887), 1:51-53.

[16] *Autobiographie du Père Chaumonot*, 171.

[17] *Autobiographie du Père Chaumonot*, 170.

[18] For the text of these two bulls, see *MEQ*, 1:53-56.

[19] For the text of these Rules, see *MEQ*, 1:56-66.

[20] Noël Baillargeon, *Le Séminaire de Québec sous l'episcopat de Mgr de Laval* (Québec, 1972), 55-64.

[21] Hormisdas Magnan, *Dictionnaire historique et géographique des paroisses, missions et municipalités de la province de Québec* (Arthabaska, 1925).

[22] Joseph P. Donnelly, S.J., "The Founding of the Holy Family Mission . . . ," in John Francis McDermott (editor), *Old Cahokia* (St. Louis: Historical Documents Foundation, 1949), 55-92.

[23] See *Les Ursulines de Québec,* 2nd edition (Québec, 1878), 1:440, 263; Sister Marie Morin, R.H.S.J., *Histoire simple et véritable: Les Annales de l'Hôtel-Dieu de Montréal, 1659-1725,* édition critique par Ghislaine Legendre (Montréal, 1979), 264; *Annales de l'Hôtel-Dieu de Québec*, edited by Dom Albert Jamet (Québec, 1939), 252.

[24] *La solide dévotion à la Très-Sainte Famille de Jésus, Marie et Joseph. Avec un catéchisme qui enseigne à pratiquer leurs vertus* (Paris: Florentin Lambert, 1675).

[25] *La solide dévotion*, 9-58.

[26] *La solide dévotion*, 42-43, 127-29.

[27] *La solide dévotion*, 47-53.

[28] *La solide dévotion*, 59-192.

[29] See [Mother Sainte-Hélène], *de la dévotion à la Sainte Famille, du temps et de la manière dont la fête et la confrérie ont été etablies,* 5. This manuscript of eighteen pages is kept at the Hôtel-Dieu of Québec.

[30] This document of Bishop de Laval is published in *MEQ*, 1:133-35.

[31] *Officium Sanctissimae Familiae, duplex primae classis, cum octava* (Paris, 1701).

[32] See Joseph F. Chorpenning, O.S.F.S., "The Earthly Trinity, Holy Kinship, and Nascent Church: An Introduction to the Iconography of the Holy Family," in *The Holy Family as Prototype of the Civilization of Love: Images from the Viceregal Americas*, exh. cat. (Philadelphia: Saint Joseph's University Press, 1996), 41-56, especially 51, 54.

[33] For further details on the subject of the Holy Family devotion in seventeenth-century Canada, see my extensive study of this same topic, published in French, in *La Sagrada Familia en el siglo XVII: Actas del Segundo Congreso Internacional sobre la Sagrada Familia, Barcelona/Begues, 7-11 de septiembre de 1994* (Barcelona: Hijos de la Sagrada Familia/Nazarenum, 1995), 359-98. This study has also been published separately as a booklet: *La dévotion à la Sainte Famille en Nouvelle-France au XVII^e siècle* (Montréal: Oratoire Saint-Joseph, 1996).

THE HOUSE OF DAVID, TREE OF JESSE, AND ORIGINAL DOMESTIC CHURCH: IMAGES OF SACRED FAMILIES, PARENTING, AND CHILDHOOD IN THE DEVOTIONAL ART OF THE VICEREGAL AMERICAS

Barbara von Barghahn

From the late Gothic age to the Renaissance, European devotion to St. Anne was central to the cultural construction of gender in society. This essay seeks to address several related aspects of this phenomenon: the flourishing cult of the spiritual matriarch Anne in Spain; the manner in which Anne's domestic household was associated with the royal court of Queen Isabel of Castile; and Anne's importance in viceregal Peru, where Jesuit humanism had permitted a grafting of her persona to the Inca queen and the goddess Pachamama.

I.

The Gospels of Matthew and Luke trace the ancestry of Christ only through the male line. Beginning in the eleventh century, Jesus' agnastic lineage was represented in art by a symbolic Tree of Jesse, an image derived from Isaiah 11:1: "And there shall come forth a rod out of the root of Jesse; and a flower shall rise up out of his root." Writing in the second century, Tertullian (160-225) had identified the prophetical *virga*, or rod, as the Virgin Mary, and his opinion was endorsed by St. Augustine a century later. Accordingly, as Marian devotion accelerated during the late thirteenth century, another genealogy of Christ emerged, one which was decidedly matrilineal and centered on St. Anne.

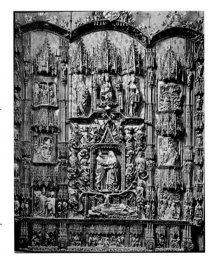

Figure 1
Gil de Siloe and Diego de la Cruz,
Tree of Jesse, ca. 1483.
Burgos, Chapel of the Conception
in the Cathedral. (F. Checa)

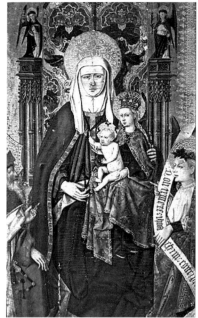

Figure 2
Jaime Jacomart,
Santa Ana Triple,
Altarpiece of of St. Anne, ca. 1450.
Játiva, Collegiate Church.

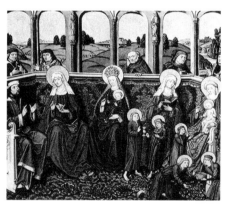

Figure 3
Gert van Lorn,
The Holy Kinship Altarpiece (central panel),
ca. 1510–1520.
Munich, Westfälischer Kunstverein.

Illustrative of this elevated image of Mary's mother is the Spanish *Altarpiece of St. Anne and the Tree of Jesse* at the cathedral of Burgos (Figure 1). Created about 1483 by the lower Rhenish masters Gil de Siloe and Diego de la Cruz, the retable in the Chapel of the Conception includes the kings of Israel in branches around a Messianic portal. The carvings accentuated Mary's direct lineage to the House of David.[1] The embrace of Anne and Joachim before the "Golden Gate" of Jerusalem had been interpreted by medieval theologians as a theme signifying the mystical conception of Mary. But the subject also magnified the late Gothic viewpoint that Anne shared equal stature with Joachim.

The glorification of Anne as *mater genetrix* reached a zenith during the Renaissance, when she was venerated in Florence as a special patron of seamstresses and cloth merchants and represented within a triadic grouping called *Anne Metterza*.[2] Literally meaning "herself making a third," the subject is called *Anna Selbstdritt* in Germany, and *Santa Ana Triple* in Spain. The Trinitarian theme typologically pairs Mary's mother with God the Father, the first person of the heavenly Trinity. Spanish devotion to St. Anne was especially strong in Aragon, a kingdom which sustained close commercial contact with Florence due to the silk and wool trade. A convent dedicated to St. Anne had been established at Valencia by King Jaime in 1239, and by 1305 the city's cathedral contained a chapel in her honor.[3] Dated about 1450, an *Altarpiece of St. Anne* by the Valencian Jaime Jacomart was commissioned by the future Spanish Pope Calixtus III (reigned 1455–1458) for the collegiate church of Jativa (Figure 2). The work contains a prophet and a sibyl, traditional figures of Messianic prognostication. The floral patterns of the cloth of honor behind St. Anne intimate the concept of paradise on earth and suggest that a female line existed in the mind of God from the Creation.

The diagramatic theme of the Holy Kinship, Christ's extended family, had emerged in northern Europe with late Gothic vernacular translations of the non-canonical *Protoevangelium of James* (Figure 3). This apocryphal text had defined Anne's role as a matriarch by introducing her triple marriages. The Holy Kinship evolved as a way of reconciling New Testament references to the "brothers of Christ"

(Matthew 12:46; John 2:12, 7:10) with a belief in the immaculate nature of Mary's conception. To buttress theological arguments concerning the perpetual chastity of Jesus' mother, ecclesiastics fostered Anne's image as a generative female of sacred progeny. United in one lineage, the three daughters of Anne by her husbands Joachim, Cleophas, and Salome produced seven holy children. By contrast with the agnatic or male lineage of the Tree of Jesse, the nuclear units of Anne's multigenerational family, called the *trinubium*, were depicted simultaneously not sequentially. When Joachim died, the Virgin Mary was still a young child. Mosaic Law dictated that the brother of the deceased was bound to marry a surviving widow (Deuteronomy 25:5-6). Anne's second husband, therefore, was Joachim's brother Cleophas. Their daughter, Mary Cleophas, wed Alpheus and bore four children: James the Minor, Joseph the Just, Simon, and Jude. Anne's third husband was named Salome. Their daughter, Mary Salome, wed Zebedee and bore James the Greater and John the Evangelist.

Following the translation by Crusaders of Anne's alleged relics from the Holy Land to France and Germany, the *trinubium* had been championed most ardently by the Franciscans and Carmelites. John Gerson (1363-1429), theologian and chancellor of the Sorbonne, not only was a proponent of the doctrine of the Immaculate Conception, but also a defender of the *trinubium*. In a Marian sermon, *Anna tribus nupsit*, Gerson praised Anne's three marriages in mnemonic verse.[4] While Anne's feast day was originally celebrated as the Feast of the Virgin's Conception, 8 December, the first to observe the date of 26 July were the Carmelites, who wove Anne's *vita* and the Holy Kinship into the history of their Order. In 1479, a Brotherhood of St. Anne—a confraternity of laymen, merchants, and humanists of the urban middle class—was established in Frankfurt. Toward the end of the fifteenth century, this group commissioned an anonymous painter from Brussels to execute two wings of a *Holy Kinship Altarpiece* (Figure 4).[5] The sixteen paintings encapsulize late Gothic emphasis on Anne as a focal point of sacred lineage. Prior to arranging a marriage with Joachim, Emerentina had introduced her daughter Anne to the hermits of Mt. Carmel. Because Mt. Carmel was only three miles from Nazareth, Anne

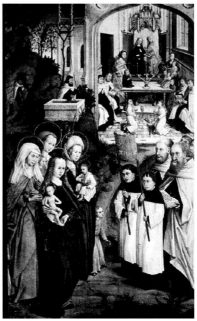

Figure 4
German School,
St. Anne and the Three Marys Visit Mt. Carmel,
from the *St. Anne Altarpiece*, ca. 1490-1500.
Frankfurt am Main, Historisches Museum.

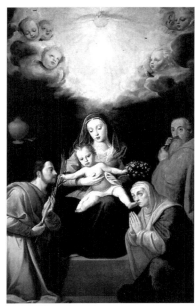

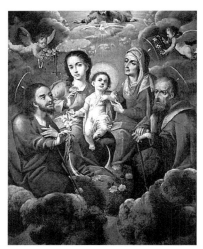

also brought her three daughters to the holy community at the time of their betrothals. As late as the eighteenth century, paintings of the Virgin Mary's marriage typically include Anne, Mary Cleophas, and Mary Salome.

Characterized by mutual love and charity to the poor, the home of Anne and Joachim was an original domestic church. But in the aftermath of the Council of Trent, which eschewed apocryphal legends, the concept of the *trinubium*, or Anne's three marriages, was de-emphasized. Moreover, the Protestant reformers had redefined gender roles in Christ's family to negate the prominence of the Virgin Mary and Anne.[6] Perhaps in response to the Reformation's emphasis on the *pater* as the authoritative head of the household and the *mater* as submissive helper, the Tridentine Church elected to redefine the traditional role of St. Joseph. With this recasting of Joseph's image from an elderly, sometimes buffonish, background figure (an image of the saint derived from the apocryphal gospels and often reflected in medieval art and literature) to the youthful and vigorous protector and educator of the Christ Child, paintings of the nuclear "Holy Family of Nazareth" increased in popularity throughout Catholic Europe as the subject of the Holy Kinship diminished. Baroque Spain followed the new trend of magnifying Joseph's image (Figure 5).[7] Yet the cult of St. Anne had been firmly embedded in Spanish culture. Not only did early seventeenth-century Sevillian masters like Antonio Mohedano continue to glorify the Virgin Mary's mother, but also the concept of the Holy Kinship resurfaced in Viceregal Peru (Figure 6). The longevity of the Holy Kinship theme in Spain and Peru may be attributed to two factors: first, the sustained fame of Isabel of Castile as the ideal matriarch of a dynastic household; and, second, the persistent memory of the Inca queen who played a commanding role in her empire's agrarian society.

II.

As wife, mother, and sage, Anne was a polyvalent symbol of a perfect woman. Yet her sister Esmeria was also extolled as a founder of a cadet familial branch. Esmeria's daughter was St. Elizabeth. Queen Isabel of Castile was named for the mother of St. John the Baptist, because her conception had

been regarded as a miracle. In the hope of bearing a child, Isabel of Portugal (1428-1496), the wife of King Juan II of Castile, had made a barefoot pilgrimage to the Shrine of Santa María de la Vega near Toro. The young Isabel spent her childhood at Arévalo, where she was tutored by learned Franciscan Immaculists. However, she was raised not by her infirm mother, but by her Portuguese maternal grandmother, the intellectual Isabel de Barcelos (died 1465), Duchess of Beja. In tribute to her mother and grandmother, and to honor her father, Isabel of Castile gave the name of Juan to her only son by Ferdinand of Aragon. Juan's birth on 30 June 1478, nearly coincided with the Feast of the Birth of John the Baptist (24 June). To mark the occasion, a *canción* by Antón de Montoro compared the Annunciate Mary and Isabel of Castile: "High and sovereign Queen/if you had been the daughter of St. Anne/from you the Son of God/would have received flesh."[8] The chronicler Fernando de Pulgar was equally enthusiastic in a letter sent to the jurist Rodrigo Maldonado de Tavera. He described the newborn prince as "a very special gift from God" bestowed at the "end of such a long wait," adding: "He has to be the most welcome prince in the world, because all those who are born desired are friends of God, as were Isaac, Samuel, and St. John." Pulgar's alliterative expression "God's chosen Tribe of Isabel" reveals the courtly image of Queen Isabel as a woman who had conceived by divine intervention.[9]

Soon after his appointment as court painter in 1496, Juan de Flandes executed an impressive *Altarpiece of the Life of St. John the Baptist*. Created to honor the patron saint of the heir-apparent to the united thrones of Castile and Aragon, the retable was probably commissioned following the death of Queen Isabel's mother in late autumn of 1496. Isabel of Portugal had been nursed by her daughter during her last months. A realistic portrait of Queen Isabel is included within the panel of *The Birth and Naming of St. John the Baptist* (Figure 7).[10] Depicted as an attendant to St. Elizabeth, she holds a pewter plate of red berries. Her offering serves as a token of her conquest of Moorish Granada, a city which derived its name from *mangrana*, meaning "pomegranate." Traditionally linked with Eden and Messianic destiny, the fruit

Figure 7
Juan de Flandes,
The Birth and Naming of St. John the Baptist,
ca. 1496. Cleveland Museum of Art.

Figure 8
Francesco Niculoso "Pisano,"
Visitation Oratory of the Catholic Kings, ca. 1504.
Seville, Alcázar.

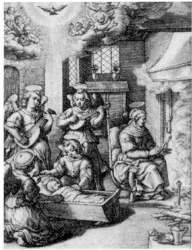

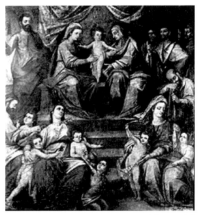

was added to the royal escutcheon after 1492.[11] On 3 April 1497, Prince Juan married Margaret of Austria, the daughter of Maxmilian I and Mary of Burgundy.[12] As a note of irony, royal succession did not continue with Prince Juan, who died at age eighteen, on 4 October 1497, only six months after his marriage. The family tree of Queen Isabel was extended only by her daughters: Isabel, Juana, María, and Catarina.

The concept of an "Isabelline Holy Kinship" is suggested in a ceramic altar of *The Visitation* created for the oratory of the Catholic Monarchs in the Alcázar of Seville (Figure 8). Created in 1504, the year of Queen Isabel's death (22 November), the altar by the Italian Francesco Niculoso "Pisano" includes female companions, whose secular attire draws an analogy between the royal family and the Holy Kinship.[13] In imitation of St. Anne, who was venerated as the wise teacher of the young Virgin Mary, Queen Isabel had personally supervised the education of her children. Learned priests and nuns had served as their tutors in theology, and Italian humanists introduced them to classical literature and philosophy. The princesses became proficient in several languages, composed songs, and played the clavichord and harp. Like their brother Juan, the sisters were destined to form significant dynastic alliances with the royal houses of the Holy Roman Empire, Portugal, and England.

III.

Due to Isabel of Castile, the exaltation of Anne as the founding parent of a matriarcal household was firmly implanted in the artistic lexicon of Renaissance Spain. Despite the Tridentine Church's disapproval of the *trinubium*, the cult of the Holy Kinship was transported to Viceregal Peru by Immaculist missionaries of the Franciscan, Carmelite, and Augustinian Orders. St. Anne's cultural role in Andean society was as considerable as it had been in late medieval Europe. As illustrated in Flemish prints, published by the Plantin-Moretus press in Antwerp under the aegis of the Jesuits, the domestic household of Anne and Joachim was angelic (Figure 9). The devotional theme of the Heavenly and Earthly Trinities abound in eighteenth-century Andean art. When Anne and Joachim were included to form a "Trinitarian Holy Kinship,"

the purpose was to trace Christ's Davidic heritage not only to His legal father Joseph, but also to His maternal grandparents. The absence of examples of the subject of the Holy Kinship, which affirms the *trinubium* in later Colonial art, does not prove that this theme was disfavored, as earthquakes and fires have resulted in the loss of many early Andean altarpieces. A rare *Holy Kinship* survives in the Bolivian Museo Colonial de San Francisco at Sucre (Figure 10). This painting was created by the influential Roman master Angelino Medoro (1567-1631), who emigrated to Colombia from Seville in 1587. Although Medoro returned to Spain in 1628, the scope of his creative activity after 1592 encompassed Quito and Lima. Commissioned by the Friars Minor, his *Holy Kinship*, dated about 1600, is ususally identified as "The Holy Family with Saints."[14] However, the central figures of the Virgin Mary, Christ, and Anne are bracketed by St. Joseph on the left and Anne's three husbands on the right. The families of Mary Cleophas and Mary Salome appear in the foreground.

Because Anne was the root of the tree from which sprang the branch of the mystical Eucharistic grape, she continued to be extolled in the Andes as the patroness of woodcarvers, viniculturalists, and miners. Anne was invoked in Colonial households and convents as the special protector of seamstresses, lacemakers, and embroiderers. Andean paintings of *St. Anne Educating the Young Virgin* typically show Mary contemplating the Scriptures with her mother or learning to sew (Figures 11, 12). Either rendition of Mary's instruction by her mother dovetails with the subject of Mary's Presentation in the Temple of Jerusalem. According to the *Protoevangelium*, Joachim and Anne brought their three-year-old daughter to the Temple of Jerusalem with offerings. Without assistance, the child ascended the staircase—fifteen steps known as the "Psalms of Ascent" (Psalms 120-134)—separating the women's court from the men's. Mary then remained in the Temple where she received her daily food from an angel. Contrary to the *Protoevangelium*, Andean artists preferred to depict Mary as a child of about eight years at her Presentation (Figure 13).

Paintings of *The Young Virgin with a Distaff* drew a pertinent analogy between Mary, the Temple-Maiden, and the Inca "Chosen Women," called *acllakuna* (Figure 14). Selected from

Figure 12
Leonardo Flores (Bolivia),
The Education of the Virgin, ca. 1700.
Denver Art Museum.

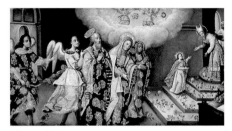

Figure 13
School of Charcas (Bolivia),
The Presentation of the Virgin Mary, ca. 1725-1760.
La Paz, Museo de la Casa de Murillo
(from a series of 14 works originally in
the Carmelite Cloister of La Paz).

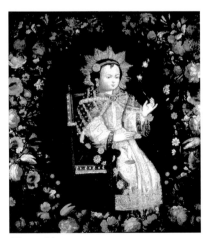

Figure 14
Melchor Pérez Holguín (Bolivia),
The Virgin with a Distaff, ca. 1699.
Buenos Aires, Museo de Arte Hispanoamericano,
Colección Isaac Blanco.

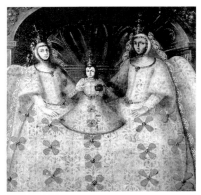

Figure 15
School of Seville,
Santa Ana Triple, ca. 1680.
Seville, Museo de Bellas Artes.

Figure 16
Master of the "Corpus Christi Series of Santa Ana"
(Juan Basilio de Santa Cruz Pumacallao
and his Workshop?),
The Last Supper Altar, ca. 1674–1678.
Cuzco, Archepiscopal Museum.

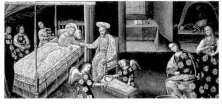

Figure 17
School of Charcas (Bolivia),
The Birth of the Virgin Mary, 1725–1760.
La Paz, Museo de la Casa de Murillo
(from a series of 14 works originally in
the Carmelite Cloister of La Paz).

their families when they were about eight or nine years old, these imperial virgins were sequestered in a complex near Cuzco's temple precinct known as the *Korikancha* or "Fence of Gold." Trained under elderly matriarchs, the *mamakuna*, they wove fine tunics of *vicuña* wool (*cumbi*) only for royalty. The brides of the sun god Inti also prepared sacred bread for solstitial feasts.[15]

At the age of fourteen, Mary was one of seven virgins of the House of David selected to weave a new curtain for the Ark of the Covenant.[16] Her assigned task was to spin the true royal, or purple, threads. Jacobus de Voragine's *Golden Legend* (ca. 1260) recounts that Mary devoted herself to alternate periods of prayer and weaving. Yet the *Protoevangelium* mentions the Annunciation in the context of Mary's domestic work in her mother's household. She first heard a voice while drawing water from a well, and trembling, returned home. Archangel Gabriel then greeted her while she was praying. Colonial artists often represented the Immaculate Virgin attired in a pristine white robe. Inspired perhaps by an Andean painting exported from Peru to the motherland, a Sevillian *Santa Ana Triple*, ca. 1680, portrays the holy triad as sharing the same white garment (Figure 15). The unique imagery provides a patent reference to Christ's seamless tunic woven by Mary which apparently grew with him. Mentioned in John the Evangelist's Passion narrative (19:23), this linen robe, which symbolized the fulfillment of Davidic prophecy (Psalm 22:18), was the subject of a late medieval French poem. Although the Gallic verses extol Mary as a seamless tunic enveloping the Word made flesh, Joachim is designated as the one who provided the pure silk for Anne, who "set up the warp without break."[17]

Anne's image as a teacher of the young virgin contributed to the flowering of her cult in the Andes. But the nexus of blood relations she provided was particularly important to a society familiar with the kinship-structured inheritance of the Inca state. With respect to the Inca royal house, there were parallel transmissions of lines of descent.[18] A prince would inherit property from a line of male rulers originating with the genitor Manco Cápac, and a princess would claim wealth from a matrilineal line established by the genetrix Mama Ocllo. This

symmetrical system characterized the households of the nobility, as well as the clans composing the fabric of the Inca Empire. Besides Anne's rank as preeminent matriarch of Christ's family, her hagiography affirms an association with water. While she was hailed as the fertile root whence sprang the bough of the Eucharistic vine, the Carmelites had equated Mary's conception with Elijah's vision of the cloud that produced showers and ended a drought (1 Kings 18–22). Because of this mystical prefigurement, Anne was invoked by Andean farmers during the dry season.[19]

Throughout the Viceroyalty of Peru, and especially in Bolivia, St. Anne was linked to Pachamama, a telluric goddess whose replenishment of the land was constantly celebrated, notably at the June and December solstices.[20] As the matriarch of the Empire, the *coya* (queen) officiated at state ceremonies pertaining to the most important goddesses of the Inca pantheon. Yet she also played a paramount role in matters of horticulture. The *coya* experimented with seeds, choosing the best for planting in a rite known as *muju akklay*, and instructing a select body of female administrators to review the maturation of crops.[21] Held at the winter June solstice in homage to the young sun, Punchao-Inti, the solemn feast of Inti Raymi occurred after the May harvesting of maize. During this important period of the agricultural cycle, corn seeds were selected for the *sara tarpuy* (time for sowing) in August and September. Inca queens, therefore, presided over the solstitial offering of sacrifices to Pachamama and other female goddesses in the *Korikancha's* silver-plated "Temple of the Moon" and "Temple of the Stars." After the Conquest, and the replacement of Inti Raymi by the Feast of Corpus Christi, the legacy of Pachamama may be discerned in a series of seventeen paintings collectively known as *The Corpus Christi Procession in Cuzco*.[22] Commissioned by the bishop of Cuzco, Don Manuel Mollinedo y Angulo, and completed between 1674 and 1678, these large works were destined for the parish church of Santa Ana, illustrated in the oldest plan of Cuzco (1631). *The Last Supper Altar* is the only painting of the cycle which contains a group of "Holy Virgins," and specific saints may be identified: Agnes, Catherine, Barbara, Ursula, Lucy, and Casilda (Figure 16). While St. Anne had three daughters, Pachamama had seven, each of whom was a prismatic reflection of their mother's regenerative powers.[23] Pachamama's progeny were conflated with virgin martyrs whose lives exemplified a sisterhood of suffering conforming to the perfection of Mary.

A popular subject in Viceregal Peruvian convents, the Birth of the Virgin Mary was customarily depicted with several females attending Anne (Figure 17). The annual observance of the Feast of Mary's Nativity at the September equinox marked the Inca festival month for honoring the Empire's queen. Named perhaps for Qoyllur, the Morning Star (Venus), the Inca feast of Coya Raymi celebrated the planting of seed and beginning of a new agricultural cycle. The Colonial commemoration of the Immaculate Conception on 8 December, however, dovetailed with the Inca summer solstitial rites of Cápac Raymi, which glorified the powers of the mature sun, Apu-Inti. Initiations of warriors were conducted during this solemn feast, and illustrious ancestors (*mallkikuna*) were remembered in ceremonies held at a second "Temple of the Sun" located near the defense walls of Sacsahuaman. Early December marked the sowing of potatoes (*oca*) and the commencement of the rainy season. During this month, the Empire's *coya, ñustakuna* (princesses), and *pallakuna* (noblewomen) paid tribute to their female ancestors, and made offerings to

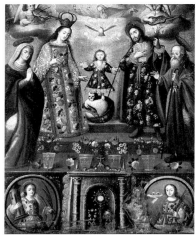

Figure 18
School of Cuzco (Peru),
The Holy Kinship with SS. Barbara and Lucy,
ca. 1700-1750.
Washington, D.C., Osuna Gallery.

Figure 19
The Sanctuary of Copacabana,
late 17th c. (G. Rueda)

Pachamama and her daughters, especially Quilla, the lunar spouse of the sun and "queen of the stars." As the "brides of Inti," the acllakuna prepared bread (*cança*) and *chicha* (fermented corn drink) for the sacred rites of Cápac Raymi. Their memory is evoked in an anonymous cuzqueño *Holy Kinship*, dated ca. 1700-1750 (Figure 18). Medallions of the patrician saints Lucy and Barbara are shown to the sides of a Eucharistic monstrance. The feast days of Barbara and Lucy, 4 December and 13 December respectively, occurred during the month of Cápac Raymi, and their hagiographies verify their exclusive association with the moon goddess Quilla. In the post-Conquest blending of cultures, Quilla was equated with the apocalyptic "Planet Woman" who is "clothed with the sun, and the moon under her feet, and on her head a crown of twelve stars" (Revelation 12:1). Lucy's name, derived from the Latin word for light, *lux*, and her attribute of two eyes on an offering plate, are relevant to the Inca designation of the constellations as "shining eyes." Lucy's native Sicily was evocative of Lake Titicaca's sacred "Island of the Queen," where the moon and stars (*chaskakuna*) supposedly were created. The Viceregal Andes also linked St. Barbara with Quilla's nocturnal illumination. Invoked to prevent lightening, she was venerated as the special protector of the artillery due to the homophonic association between Dioscurus, her evil father, and the Dioscuri, Jupiter's twin sons. Patrons of the ancient Roman equites, the constellations of Castor and Pollux were regarded as propitious stars by sailors.

Copacabana, a preeminent Christian pilgrimage shrine on the shores of Lake Titicaca, was located near the Inca empire's most sacred *huaca*, or shrine bonded with nature's phenomena.[24] The site had a commanding view of two islands to the northeast worshipped by the Inca as the cosmic *pakkarina* (birthplace) of Inti the sun and Quilla the moon. At the islands, the supreme Viracocha created eight Ayar brothers and sisters, the progenitors of the Andean peoples. Tupac Inca Yupanqui (1471-1493), the tenth king of the empire built a luxuriant palace at Copacabana, which was kept constantly furnished, providing lodgings for pilgrims who were obliged to make offerings and to be purified before they could sail by totora reed boats to Lake Titicaca's "Island of the Sun," a land

mass almost six miles long with steep cliffs rising from the water.[25] The *Historia del Nuevo Mundo*, completed in 1653 by the Jesuit Bernabé Cobo (1580-1657), documents Tupac Inca Yupanqui's visit to the ancient shrine located on the northwest tip of the island. Situated at the farthest point from Copacabana, the rock for centuries had been revered as the place where the sun first rose in the sky. Upon the ruler's orders, the stratified rock was covered by a curtain of fine *cumbi* cloth on its convex side, and its concave face enclosing an altar was plated in gold. The ruler constructed a larger temple about forty yards to the east of the rock. Its niches were adorned with copper, silver, and gold statues of humans, llamas, and birds.[26]

The esplanade of Pilco Caima overlooked the Copacabana peninsula to the right and the Illampu mountain on the left. In between, and distanced by about three miles, was the "Island of the Moon." Cobo called the island "Coata," a name which derived from the Inca title for queen (*Coya*), and he states that its temple contained a silver statue.[27] Cobo also relates that Tupa Inca Yupanqui's wife Guayro traveled throughout the Inca kingdom with her husband.[28] She would have visited the two-storied "nunnery" on the northeast shore of Coata with its six apartments for "Chosen Women" and *mamakunas* dedicated to serving the shrine of Quilla. Impersonating the sun's spouse, the main oracle of Coati communicated frequently with the chief *huatuc* (wise man) of the "Island of the Sun." Rafts plied the waters between the two islands and the chanting of love songs (*haravi*) to the melodic resonances of flautists conjured a paradisal realm of mutual love. After the Spanish conquest of the Andes, the Dominicans and the Friars Minor first preached Christianity in the Audiencia de Charcas (present-day Bolivia). Because of the persistence of Quilla's memory, many churches along the southern shores of Lake Titicaca were dedicated to the Virgin Mary.

None of the Marian shrines, however, surpassed the grandeur of the Sanctuary of Copacabana (Figure 19). Begun in 1552 as a small parish dedicated to St. Anne, the church stands on the former site of Tupac Yupanqui's palace. In February 1582, when inclement weather threatened the newly sprouted maize plants, the Indians of Santa Ana inaugurated a confraternity dedicated to the Virgin of the Purification.[29] Five years later, on 7 January 1588, King Philip II of Spain transferred administration of Santa Ana to the Augustinians. Under their aegis, the main chapel of the Virgin of Copacabana was begun in 1610 and consecrated on 6 April 1614. To accommodate ever greater numbers of pilgrims, the Sanctuary was enlarged between 1672 and 1684. Little remains of Inca Tupac Yupanqui's palace save the courtyard, the entrance to which is provided by a majestic portal, a Christian equivalent to the Inca *Intipuncu*, or "Gateway of the Sun," which once stood on Lake Titicaca's "Island of the Sun." The late seventeenth-century reconstruction of Copacabana resulted in a totally Baroque interior (Figure 20).[30] Composed of gilded wood and silver to simulate the metals of the sun and moon, the altarpiece functions as a Solomonic portal to heavenly wisdom. The retable is complemented by narrative paintings of the "Life of the Immaculate Virgin" which line the Gospel and Epistle walls.

During most renovations of Colonial churches, old altarpieces were either dismantled or destroyed. Fortunately, the Copacabana Sanctuary still retains its original altarpiece in a lateral chapel. Commissioned by the Augustinian prior Juan Vizcaino, the wooden retable bears the date of 1614 and the signature of the Indian artist Sebastián Acosta Tupac Inca (Figure 21).[31] Between reliefs of the Latin Doctors, the predella panels of *The Nativity of Christ* and *The Birth of the Virgin* present background views

Figure 20
Main Chapel of the Sanctuary of Copacabana,
1672-1684. (G. Rueda)

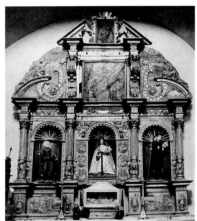

Figure 21
Sebastián Acosta Tupac Inca,
The Holy Kinship Retable, 1615.
Sanctuary of Copacabana. (H. Wethey)

of Lake Titicaca. The carvings effectively parallel the mystical nature of Christ's incarnation and Mary's conception. Female personifications of Faith and Hope are carved within the volutes of Acosta Tupac's altarpiece, and the remaining theological virtue of *Caritas* is highlighted by the central painting of *The Holy Kinship* (Figure 22). Attired in a rose gown and sky-blue mantle, Mary tenderly holds the Infant Christ, who is divine love incarnate. Protectively leaning over the mother and child is a young Joseph. Equally radiant in his dark green robe and deep tangerine mantle flecked with gold patterns, he offers his lily staff to Jesus. To the right is Anne, veiled and with her hands clasped in prayer. The patroness of the first Copacabana church is accompanied by her elderly husband Joachim. Beneath the figures of Joseph and Anne are the titular saints of Copacabana. The virgin martyr Barbara is shown with her tower, an attribute which also suggests Joseph's protection of Mary, the mystical Tower of David. A widow like Anne, St. Monica (331-387) raised three children, including St. Augustine (354-430).

Although the statues which once stood in the shell niches of the *Holy Kinship Altarpiece* are impossible to identify, the central recess might have contained Acosta Tupac's *Virgin of the Purification*, now in the Sevillian Convent of Madre de Dios. Carved medallions of Six Sibyls were intended to express the concept of Messianic expectation. Series of pagan sibyls were painted by Colonial artists for wealthy landowners, and they were featured in Viceregal processions. By an unknown late seventeenth-century cuzqueño master, a *Samian Sibyl* belongs to a lost set of female oracles. The matrons would have displayed oval vignettes showing the Immaculate Virgin and scenes of Christ's infancy and Passion. Like the Magi, the sibyls came to the West from the East. Originating in second-century Alexandria, a center for the narration of history under the guise of prophecy, the *Oracula Sibyllina* equated the female seers of the ancient world with the Hebrew prophets. A defender of Mary's perpetual chastity, St. Jerome praised the Hellenistic Sibyls for their virginity. Perhaps for this reason, his image appears not only in the predella, but also at the pinnacle of Copacabana's *Holy Kinship Altarpiece*.[32]

Acosta Tupac depicted only six of the twelve canonical sibyls: the Erythraean, Cumaean, Cumanan, Samian, Persian, and Egyptian.[33] The Indian sculptor's selectivity may be explained by his Inca heritage. The prognostications of the sibyls were relevant to the ancient Andean myth of genesis. After creating the planets and stars on Lake Titicaca, the supreme Viracocha made primordial ancestors from the clay residue of a deluge. He then sent them underground to emerge from caves and repopulate the earth. Extolled as revealers of the sovereign authority of the one true God, the sibyls also spoke about the universal flood and predicted the Armageddon. The Hellinistic oracles resembled the Inca diviners who once inhabited Lake Titicaca's Coata Island and sang mnemonic verses to proclaim cyclical regeneration. Sculptured fruit and vine tendrils embellish the *Holy Kinship Altarpiece*, Edenic symbols of redemption which suggest the harvests of a fecund earth. Crafted of wood, the retable is a celebration of the tree of the mystical grape.

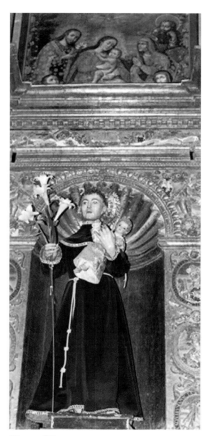

Figure 22
Sebastián Acosta Tupac Inca,
The Holy Kinship Retable (detail), 1615,
Sanctuary of Copacabana. (G. Rueda)

IV.

The incarnational theology of late medieval and early Renaissance Spain, as well as Isabelline support of the Immaculist crusade, contributed to the Viceregal elevation of the Virgin Mary's mother as the matriarchal founder of the original domestic church. In the humanist blending of Christian and pre-Columbian images and ideas at the Sanctuary of Copacabana, the theme of the "Holy Kinship," regarded as too unhistorical by the Council of Trent, continued to retain its intrinsic meaning as a spiritual *hortus conclusus* of virtuous women. Interpreted metaphorically as pointing to the perfection of the Immaculate Mary, the poetic passages of the Song of Songs are equally applicable to St. Anne, the Christian Pachamama of the Andean silver hills: "Before the day-breeze rises, before the shadows flee, I shall go to the mountain of myrrh, to the hill of frankincense. . . Your shoots form an orchard of pomegranate trees, bearing most exquisite fruit" (4:6,13).

NOTES

[1] On the Immaculate Conception and the "Tree of Jesse," see Suzanne Stratton, *The Immaculate Conception in Spanish Art* (New York: Cambridge University Press, 1994), 5-28. Also see Harold E. Wethey, *Gil de Siloe and His School: A Study of Late Gothic Sculpture in Burgos* (Cambridge: Harvard University Press, 1936), 81.

[2] Completed ca. 1424 for Florence's church of Sant'Ambrogio, a painting by Masolino and Masaccio in the Uffizi Museum is perhaps the best known example of the *Anne Metterza*.

[3] Beda Kleinschmidt, "Anna selbstdritt in der spanische Kunst," *Spanische Forschungen der Görresgesellschaft. Gesammelte Aufsatze zur Kulturgeschichite Spaniens, Erste Reihe* (Munster in Westfalen, 1928), 149-65, especially 151, and *Die Hielige Anna; ihre Verehrung in Geschichte, Kunst und Volkstum* (Dusseldorf, 1926), 86. In 1353, the Catalonian painter Ramón Destorrents provided a splendid *Education of the Virgin* for the Chapel of St. Anne, founded in 1307, at the Royal Palace of La Amudayna in Palma de Mallorca. Upheld by three angels, who recall the angelic visitation to Abraham and the barren Sarah, the metamorphical cloth of honor alludes to the temple veil which the Virgin Mary was weaving at the moment of Christ's Incarnation. Narrow panels to the sides of St. Anne depict the Annunciate Virgin, Archangel Gabriel, as well as the virgin martyrs SS. Catherine of Alexandria and Ursula, identified by their respective emblems of a spiked wheel and an arrow. See Judith Berg Sobré, *Behind the Altar Table. The Development of the Painted Retable in Spain, 1350-1500* (Columbia: University of Missouri Press, 1989), 206-208.

[4] Max Föster, "Die Legende von Trinubium der hl. Anna," in *Probleme der englischen Sprache und Kultur: Festschrift Joh. Hoops zum 69. Geburtstag*, edited by Wolfgang Keller, Germ. Bibl. 2 (Heidelberg: Karl Winter, 1925), 20.

[5] Kathleen Ashley and Pamela Sheinborn, "Introduction," to *Interpreting Cultural Symbols: St. Anne in Late Medieval Society* (Athens: University of Georgia Press, 1990), 1-68.

[6] Lucas Cranach's woodcut of *The Holy Kinship* (Berlin, Staatliche Museen Preussischer Kulturbesitz, Kuperferstichkabinett) reflects the Reformation's ideal structure of a Christian family. Mary Cleophas and Mary Salome are portrayed as maternal nurturers by contrast to their respective husbands Alpheus and Zebedee, who actively supervise their children's education. See Ton Brandenbarg, "St. Anne and Her Family: The Veneration of St. Anne in Connection with Concepts of Marriage and the Family in the Early Modern Period," in *Saints and She-Devils: Images of Women in the Fifteenth and Sixteenth Centuries*, edited by Lène Dresen-Coenders (London: Rubicon Press, 1987), 101-27.

[7] Relevant paintings evincing such an exalted view of St. Joseph are in Seville's Museo de Bellas Artes: Juan de Uceda's *Earthly and Heavenly Trinities*, ca. 1623, for the Convent of La Merced Calzada, and Juan de Castillo's *Workshop at Nazareth*, 1634-1635, once in the Convent of Mt. Sion.

[8] Montoro quoted by María Rosa Lida de Malkiel, *Estudios sobre la literatura española del siglo XV* (Madrid: Porrúa Turanzas, 1978), 295, cited and translated by Peggy K. Liss, *Isabel the Queen: Life and Times* (New York: Oxford University Press, 1992), 157.

[9] Pulgar quoted and translated in Liss, 154-55.

[10] Ross M. Merrill, "*Birth and Naming of St. John the Baptist*. Attributed to Juan de Flandes. A Newly Discovered Panel from a Hypothetical Altarpiece," *Bulletin of the Cleveland Art Museum*, May, 1976, 118-45.

[11] The pomegranate was also selected as an imperial device by Maxmilian I. Bernhard Strigel's painting of 1515 equates the dynastic household of Maxmilian I with the Cleophas family, a nuclear component of the Holy Kinship. By contrast with Isabel of Castile, who compared her lineage with the cadet familial branch of Anne's sister Esmeria, Maxmilian I preferred to trace his genealogy through agnastic rather than matrilineal lines. The group portrait celebrates triple betrothals. Between Maxmilian I and his second wife, Bianca Maria Sforza, is the heir-apparent Philip the Fair, who in September of 1496 had married Juana, the daughter of the Catholic Monarchs. He is identified as James the Minor. Philip's sons, Charles (Simon) and Ferdinand (Joseph the Just), were engaged respectively to Isabel of Portugal and Anna of Hungary. The third youth with a marriage wreath is Lajos III of Hungary and Bohemia, the brother of Anna, who was betrothed to Philip's daughter María. He is designated as Jude. See Pamela Sheingorn, "Appropriating the Holy Kinship: Gender and Family History," in *Interpreting Cultural Symbols: St. Anne in Medieval Society,* 169-198, especially 189.

[12] Their union was commemorated in *The Wedding Feast at Cana*, a panel of an altarpiece attributed to Diego de la Cruz. The work contains heralds belonging to the dynastic houses of the couple, and pomegranate blossoms adorn the bride's brocaded dress and cloth of honor. See Jonathan Brown and Richard G. Mann, *Spanish Paintings of the Fifteenth through Nineteenth Centuries* (Washington, D.C.: National Gallery of Art/New York: Cambridge University Press, 1990), 92-104.

[13] Stratton, 16. The altar reflects the influence of a Northern paradigm. Pisano may have worked with a Flemish collaborator.

[14] Isabel Cruz de Amenabar, *Arte y sociedad en Chile, 1500-1650* (Santiago de Chile, 1986), 276. Also see José de Mesa and Teresa Gisbert, *El pintor Angelino Medoro y su obra en Sudamérica* (Buenos Aires, 1965).

[15] R. Tom Zuidema, *Inca Civilization in Cuzco*, translated by Jean-Jacques Decoster (Austin: University of Texas Press, 1986).

[16] John F. Moffitt, "Mary as a 'Prophetic Seamstress' in *Siglo de Oro* Sevillian Painting," *Sunderdruck aus dem Wallraf-Richartz-Jahrbuch*, Band LIV (Dumont Buchverlag Köhn, 1993): 141-61.

[17] Victor Charland, *Les trois légendes de Madame Saincte Anne* (Montréal: Charland et Cie, 1898), 316.

[18] See R. Tom Zuidema, "Descendencia paralela en una familia indígena noble del Cuzco," *Fonix* 17 (Lima, 1967), and Irene Silverblatt, "Andean Women in the Inca Empire," *Feminist Studies* 4, no. 3 (October 1978):37-61, especially 39-40.

19 After Christ's Ascension, Mary Cleophas and Mary Salome had sailed to Provence with Mary Magdalen, Martha, and Lazarus. Evidence of the medieval belief in their intercessory powers for fishermen at sea, is a 40,000 verse poem by the French Carmelite Jean de Venette. The three Marys continued to be venerated as efficacious protectors of sailors in the Colonial Andes, largely due to the popularity of French cults in Bourbon Spain. See Chanoine Lamoureux, *Les Saintes Maries de Provence: Leur vie et leur culte* (Avignon: Aubanel Frères, 1898), 203-204, and Claude Gaignebet and Jean-Dominique Lajoux, *Art profane et religion populaire au Moyen Âge* (Paris: Presses Universitaires de France, 1985), 173b, 261-62.

20 Parallels were also seen between important Inca sky deities and Anne's grandsons, James and John, the "Sons of Thunder" (Mark 3:17). James had been venerated in Spain and Viceregal Peru as a patron of silk guilds. His feast was celebrated 25 July, the day after that of St. Anne, and proximate to Feast of the Transfiguration (6 August). The pilgrimage route to Santiago's shrine in northwest Spain was interpreted by medieval Europe as a celestial reflection of the Milky Way, hence its name Compostela (Field of Stars). At the northern end of the route to Galicia was the eagle and at the southern end was Sirius, the dog star. Sirius was linked with St. Christopher, who was described in the East as "dog-headed." See Francesca Sautman, "St. Anne in Folk Tradition: Late Medieval France," in *Interpreting Cultural Symbols: St. Anne in Late Medieval Society*, 69-94, especially 74; Gaignebet and Lajoux, 70-71, 173b, 261-63; Pierre Saintyves, "L'origine de la tête de chien de St. Christophe," *Revue anthropologique* 34 (1924): 336-83, and *St. Christophe, successeur d'Anubis, d'Hermès, et d'Héraclès* (Paris: Nourry, 1936). Throughout the Viceroyalty of Peru, St. Christopher was venerated as the patron saint of travelers, and, as a "Christ-bearer," he evoked St. Joseph, the protector "Atlas" who carried the young Christ on journeys. The Inca had distinguished the constellation Sirius as the Fox (Atoq), who transported water at twilight to the valleys from the sacred mountains of the *apukuna* (divine lords). After their conversion to Christianity, Andean Indians referred to Christ as *Apu Yaya Jesucristo*. During the Spanish reconquest, a militant James appeared on horseback in 834 to aid the troops of Ramiro I of Castile against the Moors. Yet Andean legend relates an equestrian James also appeared at Cuzco in 1536. Joined by the Virgin of Sunturhuasi, he aided the Spanish troops in quelling Manco Cápac II's six-month insurrection at the fortress of Sacsahuaman. Because James extinguished fires from the air, his identity was subsequently conflated with the omnipotent ancient sky god, Inti-Illapa, who assumed the form of three destructive brothers: Chijchi (hail), Riti (snow), and Kakya (lightening). By virtue of his emblematic eagle and apocalyptic prognostications, John the Evangelist may have been identified by Andean Indians with Illapa's "brother sun," Inti-Guauqui, who was a key figure in the cult worship of ancestors and Viracocha's condor warriors (*tarapakakuna*). See Pedro Querejazu, "Santiago en la pintura y escultura de Bolivia, Chile y Perú," Santiago Sebastián, "La iconografía de Santiago en el arte hispanoamericano," and Teresa Gisbert, "Santiago y el mito de Illapa," in *Historia & Cultura* 23 (Sociedad Boliviana de Historia, Fundación BHN, April 1994), 123-54, 275-298, 299-313, respectively. Both James and John had been favorites of Queen Isabel of Castile. After defeating the Portuguese at Toro (1476), she had adopted John's apocalyptic eagle as a royal emblem in the chapel of San Juan Bautista de los Reyes (Toledo). Formal portraits by Juan de Flandes indicate Isabel's high station as the supreme commander of the Order of Santiago. The centerpiece *Altarpiece of the Two Johns*, carved by Gil de Siloe and Felipe Vigarny (ca. 1522) at the Royal Chapel of Granada, contains a relief of Santiago Matamoros directly behind the queen's kneeling effigy.

21 To summon the procreative energy of the bounteous Pachamama and her daughters, the queen's elite sorority of courtly women would offer libations of *chicha* (fermented corn drink, also called *akkha*) while chants were sung in cadence to the melodic notes of flutes. See Silverblatt.

22 Carolyn S. Dean, "Copied Carts: Spanish Prints and Colonial Peruvian Paintings," *Art Bulletin*, 78 (1996): 98-110. Teresa Gisbert and José de Mesa, *Arquitectura andina: 1530-1830. Historia y análisis* (La Paz, 1985), 234, 242-43, were the first to identify the source of the compositions as Juan Bautista Valda's manuscript of 1663 illustrating a festival in Valencia held on the Feast of the Immaculate Conception (8 December 1662). Dean's contention that the Corpus Christi paintings show fictitious *carros* is belied by the documentary evidence of festival descriptions provided by Rafael Ramos Sosa, *Arte festivo en Lima virreinal: Siglos XVI-XVII* (Seville: Junta de Andalucía, 1992).

23 See Homer L. Firestone, *Pachamama en el cultura andina* (La Paz, 1988); Carol Cumes and Rómulo Lizárraga Valencia, *Pachamama's Children. Mother Earth and Her Children of the Andes in Peru* (St. Paul: Llewellyn Publications, 1995).

24 See Sabine MacCormack, "From the Sun of the Incas to the Virgin of Copacabana," *Representations* 8 (1984): 30-60; Alonso Ramos Gavilán, *Historia del Santuario de Nuestra Señora de Copacabana (1621)* (Lima: Ignacio Prado, 1988); Martín S. Noel, *El Santuario de Copacabana de la Paz a Tiahuanaco* (Buenos Aires: Academia Nacional de Bellas Artes, 1950). For information about the Inca *huacas* and their relationship to a network of invisible lines of energy called *cequekuna*, see R. Tom Zuidema, *The Ceque System of Cuzco: The Social Organization of the Capital of the Inca* (Leiden: E. J. Brill, 1964).

25 John Hemming, "Island of the Sun," *Monuments of the Incas* (Boston: New York Graphic Society/Little, Brown and Company, 1982), 54-59.

26 About 200 yards from the precinct stood the *Intipunchu*, or "Gate of the Sun," beyond which the average Inca pilgrim could not pass. On the southeastern shore of the "Island of the Sun," near the rock shrine, is the two-storied building known as *Pilco Caima*, which probably served as an occasional royal residence and lodgings for priests. The free-standing edifice with thirteen chambers, eight with corbeled domes, was originally covered with stucco and painted yellow by contrast with different hues of red which distinguished door moldings and niches. The island contained storehouses for maize cultivated on steep terraces (*pata patakuna*). See George E. Squier, *Peru: Incidents of Travel and Exploration in the Land of the Inca* (New York: Harper, 1877), 343-46, 359-66, and A. F.

Bandelier, *The Islands of Lake Titicaca and Koati* (New York, 1910). The Island of the Sun was called "Titicaca" (Rock of the Puma) by its earliest inhabitants. It and the Islands of the Moon are directly aligned with two islands in Lake Huanamaraka: Siriqui and Kalahuta. Kalahuta ("Stone Houses") was an Inca cemetery with burial towers (*chullpas*) that are several meters high. Three additional islands of Lake Huanamaraka (Taquiri, Incas, and Pariti) could also have been used for ceremonies honoring important deceased Inca. The axial disposition of two islands associated with birth (Sun and Moon), as well as two linked with death (Siriqui and Kalahuta), underscored the Inca belief in nature's cyclical regeneration.

[27] Bernabé Cobo, *Historia del Nuevo Mundo*, 2 vols., Biblioteca de autores españoles, vols. 91-92 (Madrid: Atlas, 1956), 2:193.

[28] Father Bernabé Cobo, *History of the Inca Empire: An Account of the Indians' Customs and Their Origin, Together with a Treatise on Inca Legends, History, and Social Institutions*, translated and edited by Roland Hamilton (Austin: University of Texas Press, 1990), 148-49.

[29] Through her name, St. Anne had been related typologically to Anna, the Jewish prophetess of Christ's Presentation, who, like Simeon, spoke of Israel's redemption. The Feast of the Presentation of the Lord and of the Purification of the Virgin were both commemorated on 2 February. In 1582, the Brotherhood commissioned Francisco Tito Yupanqui, the grandson of the Inca Tupac Yupanqui, to carve a statue of *La Candelaria*. The Indian made clay (*neque*) images before he traveled in 1576 to Potosí, where he learned the techniques of carving maguey with Diego de Ortiz. When the bishop of La Plata approved the commission requested by the Brotherhood of Santa Ana, Yupanqui was working in a studio at the Convent of San Francisco in La Paz. The Copacabana statue was completed in collaboration with the Spaniard Pedro de Vargas (b. 1553), who had arrived in Lima in 1569 and became a Jesuit in 1575. Both a painter and sculptor, Vargas worked with the Italian Jesuit Bernardo Bitti (b. 1548) throughout the Viceroyalty of Peru before migrating to Quito in 1587. The Indian Yupanqui professed the vows of an Augustinian oblate and died in Caima (Arequipa) on 6 December 1616. See Noel, xxxiv-xxxv.

[30] Fray Antonio Calancha, *Historia del Santuario de Imagen de Nuestra Señora de Copacabana (ca. 1638)* in *Crónicas Agustinas del Perú* (Madrid, 1972). Pedro Antonio Fernández de Castro (1632-1672), the Count of Lemos and Viceroy of Peru (1667-1672), traveled to Copacabana in 1671, presumably to advocate the construction of a larger basilica. The architect Francisco Jiménez de Sigüenza substantially finished the new temple by 1684, when documents attest that two domes were completed. See Guillermo Lohmann Villena, *El Conde de Lemos, Virrey del Perú* (Madrid, 1946).

[31] George Kubler and Martin Soria, *Art and Architecture in Spain and Portugal and their Colonial Dominions: 1500-1800*, 2nd ed. (Baltimore: Penguin Books, 1969), 372, n. 46, transcribe the inscription on the predella: ESTA CAPILLA Y RETABLO HIZO EL P[e] [Padre] F J[v] [JUAN] VIZCAINO SIENDO PRIOR CAPELLAN AÑO 1614 . . . RETABLO AÑO 1615 PINTOLO DON SEBASTIAN ACOSTOPA INCA [Don Sebastián Acosta Tupac Inca]. Cf. Harold Wethey, *Colonial Architecture and Sculpture in Peru* (Cambridge: Harvard University Press, 1949), 212, and 312, n. 7, who reads the date as 1618. Wethey cites Fernando M. Sanjinés, *Historia del Santuario e Imagen de Copacabana* (La Paz: Tipografía "La Unión," 1909), 113, as stating that the original location of retable was the *altar mayor* (high altar). Also see Harold Wethey, *Arquitectura virreinal en Bolivia* (La Paz: Instituto de Investigaciones Artísticas, Facultad de Arquitectura, Universidad Mayor de San Andrés, 1991), 107, 110, who observes the retable's origin in late Renaissance style, and its resemblance to the Michelangelesque patio of the Farnese Palace in Rome.

[32] In the *City of God* (Bk. 18, ch. 23), St. Augustine discusses only one ancient seer, whose activities extended over many years in the Greek colonies of Asia Minor. The prevalent view of the early Christian Church, however, was that sustained by second-century Alexandria. Edgar Hennecke-Wilhelm Schneemelcher, *New Testament Apocrypha, II: Writings Relating to the Apostles, Apocalypses, and Related Subjects*, translated and edited by R. McL. Wilson (Philadelphia: Westminister Press, 1964), 709-45 (second-century Greek *Oracula Sibyllina*, 15 books of oracles published in 1545).

[33] Lactancius' *Institutiones divinae* (4th c.), which fixed the number of sibyls at ten, was printed in 1465. A critical pictorial source was the *Discondantiae nonnullae inter sanctorum Hieronymum et Augustinum* (1481) by the Dominican friar Filippo Barbieri. To parallel perfectly the female oracle of Messianic expectation with the Old Testament prophets, Barbieri added two more sibyls to Lactancius' group. He also provided a description of the matrons, giving pertinent inscriptions and specifying their costumes. See Hennecke-Schneemelcher, 703-709. Evidence that copper engravings of the sibyls by Crispin de Passe the Elder (1564-1637) circulated in Alto Perú may be provided by the 1626 pageantry in Potosí commemorating the canonization of Ignatius of Loyola, Francis Xavier, Teresa of Ávila, Philip Neri, and Isidore the Farmer. See Bartolomé Arzans de Orsúa y Vela, *Historia de la Villa Imperial de Potosí (1705-1720)*, edited by Gustavo A. Otero (Buenos Aires, 1943), 1:391. The "Twelve Sibyls with Golden Inscriptions" Arzans de Orsúa y Vela describes have been related by Teresa Gisbert and José de Mesa to the Copacabana carvings: see their *Holguín y la pintura virreinal en Bolivia* (La Paz: Librería Editorial "Juventud," 1977), 304, 314.

LEO XIII, THE HOLY FAMILY, AND GREED

D. Stephen Long

As for the poor, the Church teaches insistently that God sees no disgrace in poverty, nor cause for shame in having to work for a living. Christ our Lord confirmed this by His way of life, when for our salvation He who "was rich became poor for our sake." He chose to be seen and thought of as the son of a carpenter, despite His being the Son of God and very God Himself; and having done so, made no objection to spending a large part of His life at the carpenter's trade. Contemplation of this divine example makes it easier to understand that a man's worth and nobility are found in his way of life, that is to say, his virtue; that virtue is the common inheritance of mankind, within easy reach of high and low, rich and unpropertied alike; and that the reward of eternal happiness is earned only by acts of virtue and service, by whomsoever they are performed. Indeed, the will of God Himself seems to give preference to people who are particularly unfortunate (*Rerum Novarum*, n. 23).

Joseph was of royal blood; he was espoused to the greatest and the holiest of all womankind; he was the father, as was supposed, of the Son of God; yet none the less, he devoted his life to labor, and by his hands and skill produced whatever was necessary for those dependent on him (*Quamquam Pluries*).[1]

Leo XIII was not pleased with the industrial capitalist order at the end of the nineteenth century. He found it marked by the "inhumanity of employers, the unbridled greed of competitors," and a "voracious usury."[2] Its culminating error was its abandonment of workers. This resulted from the wage contract, which reduced laborers to mere commodities. Labor lost its dignity. Although Karl Marx made a similar point,[3] Leo does not look to socialism for the answer to the workers' dilemma. Instead, he draws upon the Holy Family as an example of an alternative social practice.

Through reflection on the Holy Family, Leo XIII viewed labor not as a mere commodity subject to free competition, but as a dignified vocation. Labor provided the necessary condition both for Mary to give birth to the Messiah, and for Jesus to grow, develop, and mature. Thus, in *Quamquam Pluries* (1889), his encyclical on St. Joseph, Leo writes, "Joseph devoted his life to labor and by his hands and skill produced whatever was necessary for those dependent upon him." The word "necessary" in that sentence is no accident. When Leo reiterates the Church's traditional teaching on the just wage in *Rerum Novarum* (1891), he claims that "human work has stamped upon labor by nature two marks peculiar to it." First it is "personal," and second it is "necessary."[4]

Labor is personal because it is a function of the person acting. Thus a singular person should have the power of disposal over his or her acts. The personal aspect of labor requires some measure of freedom for people to obtain property and enter into contracts. But this freedom is not absolute for labor is not only personal, it is also necessary. The necessary aspect of labor prompts Leo to have serious reservations about the free market system.

In the free market system, workers must be "free" to enter into any contract they choose without either political or church interference. This system was first articulated by Adam Smith one hundred years before *Rerum Novarum*. Jeremy Bentham developed it more thoroughly. In his *Defense Against Usury*, Bentham wrote, "no man of ripe years, and of sound mind, ought, out of lovingkindness to him, to be hindered from making such bargain, in the way of obtaining money, as, acting with his eyes open, he deems conducive to his interest."[5] For Leo XIII, however, such so-called freely entered contracts between workers and employers are unacceptable. Each person has a duty to stay alive and labor is the *necessary* precondition to fulfill that duty. No one then has a right to enter into any contract which conflicts with this duty. But that is exactly what the wage-contract, and its so-called "freedom," does. It refuses to take into account the duty both employers and employed have to "produce whatever is necessary for those who are dependent on us."

At some level, even the Incarnation depended upon the necessary duty of labor, a duty fulfilled by St. Joseph. When God assumed human flesh, it was flesh like ours that was assumed. Therefore, it was a life bound by the conditions of family and labor and subject to all the vicissitudes our fleshly existence bears. Had Joseph worked for an employer who denied him a just wage, it would have been a threat equivalent to that of Herod's slaughter of the innocents. Yet Joseph could, through his own labor, provide "whatever was necessary for those dependent upon him." Had Joseph worked for a mining company, for the railroads, or in textiles at the latter part of the nineteenth century, his labor could not have provided for his family. The Incarnation itself would have been threatened. The Holy Family, then, provides evidence for the dignity of labor and of the duty for employers to provide a wage which can sustain life. No one has the right to establish a wage-contract for anything less than this. Such an act would be intrinsically evil.[6]

Because of labor's necessity, Leo also argues against the socialization of private property. Rather than common ownership, justice demands workers be given more "power of disposal over ownership." Labor's necessity requires that a worker has disposal over certain types of property; property which forms the precondition for a way of life older than the state itself, familial life.[7]

Thus, his appeals to the Holy Family resist both capitalism's wage-contract infringements upon the family and socialism's call for common ownership.[8]

One argument against Leo XIII's analysis of work is that, wittingly or unwittingly, it merely serves to keep the poor in their place and then designates those forced circumstances as "virtue." In other words, it is symptomatic of a traditional, hierarchical ordering of economic relations. If in 1891, a traditional, hierarchical ordering of economic relations was preeminent, then perhaps such a charge would be valid. However, by the end of the nineteenth century, economic relations were far from based on a hierarchical traditionalism. Instead, economic liberalism, with its opposition to all things traditional, was firmly entrenched. In fact, a transformation had occurred which based economic relationships solely upon the "free" market system. Thus, if the argument against the papal teaching is that it serves the interests of a hierarchical ruling ideology, then the teachings are, at most, potentially harmless, a residual form of hierarchical relations which buttress the power of no one actually wielding it, particularly no one in the United States in the 1890s.[9]

However, when compared with the dominant understanding of economic relations of the time, Leo XIII's insistence on the Holy Family as the exemplar of economic virtue is more than a mere residue of some long since discredited hierarchy. It is, in fact, a stinging critique of the most powerful economic philosophy of the day, the liberalism which was the foundational discourse, or perhaps the consequential discourse, of capitalism.

This discourse is marked by the loss of authority based in traditional social roles. People's moral actions are no longer intelligible because of their role within a community, but people are reconstituted as "individuals" who through their autonomous activities give value to the things in the world. This understanding of human action shapes moral meaning. No longer is moral meaning found outside the individual subject per se, but it must be imposed upon the world through our volitional activities. Thus morality, like the price of commodities in general, becomes viewed as a matter of "value," determined through subjective preference. This transformation is often identified as "modernity." Modernity is characterized by an emphasis on freedom, particularly a freedom from all constraints. One such traditional constraint was the family. And among the economic philosophers who scripted our baptism into modernity, the family, especially the poor family, is a fundamental threat to the so-called "perfect liberty" of the economic system.

Adam Smith, a moral philosopher who lived from 1723-1792, set the questions which formed the tradition of economic liberalism. A sign of the transformation that occurred is that whereas St. Thomas Aquinas discussed economic relations under the virtue of justice, Smith a moral philosopher taught them under the virtue of prudence, or expediency. His famous book published in 1776, *The Wealth of Nations*, developed out of his lectures on moral philosophy, forming the fourth part of those lectures which came under the category of expediency. For Aquinas, justice was the only moral virtue which regulated relationships between persons and between persons and things. For Smith, justice was a derivative concept of "perfect liberty." "Perfect liberty" was the precondition necessary for the market system to work out its logic and thus create plenty for all. Smith was explicit in arguing that "perfect liberty" required a curtailment of interference in the market, whether that interference be political based on justice or ecclesial based on charity. The central virtue

necessary for the logic of Smith's system was the prudence to seek one's own advantage. When this was done without undue interference by either the church or the state, then justice would result. Therefore, conflictual means would lead to a harmonious end.[10]

The conflict Smith envisioned was between two groups of people, laborers and owners: "What are the common wages of labor depends every where upon the contract usually made between those two parties, whose interests are by no means the same. The workmen desire to get as much, the masters to give as little as possible. The former are disposed to combine in order to raise, the latter in order to lower the wages of labor."[11] The masters pay the laborer's wage based on the "natural price" of labor now viewed as a commodity. The natural price is that price which will sustain the laborer so that he or she can work. It includes the cost incurred for the basic necessities of life, such as food, clothing, and shelter. But the value of the commodity produced depends upon the market price. If the natural price is lower than the market price, then profit results. If not, the laborers must be forced to live on a less than subsistent wage.

My point in this brief economics lesson is not to argue for or against Smith's analysis, but to show how economic liberalism narrates the relationship between owners and workers as conflictual and even violent.[12] Karl Marx often gets blamed for viewing economic relations as rooted in conflict, but in truth he is merely the inheritor of the liberal tradition which assumed such conflict first.[13] When this economic analysis becomes received wisdom, then family and children become a threat to a stable economic order. Adam Smith repeats a common expression of his time, "The rich get richer, and the poor get children." Children increase the natural price of labor and thus decrease profits for owners and the possibility of a subsistence wage for laborers. The lowest natural price, as was becoming clear in the United States, was from those commodities produced by slavery. Smith calculates that four children can be maintained for the cost of one slave. Thus, the marginal efficiency of a family with four children would have to be equal to that of one slave. The only exception to this is where land is abundant as in the New World. There, labor is needed, and thus children do not pose as much of a threat to the system. A greater return can be had for more laborers and until the land is no longer plentiful, large families will be economically profitable. In such places, Smith states, "the value of children is the greatest of all encouragements to marriage."[14]

For large families to survive, then, they must be mobile. They must be able to move, much like "commodities, to those places where there is need. Otherwise, the market is saturated and those families cannot be sustained. Because of this need for families to be mobile, Smith attacks the poor laws in England. The poor laws were the result of the English usurpation of the Catholic Church's property. The parish system provided poor relief through charity in each parish location. Smith argued that one of the important first steps toward perfect liberty was the dismantling of that system. It was a sign of churchly interference into the free workings of the market. So he wrote, "The constitution of the church of Rome may be considered as the most formidable combination that ever was formed against the authority and security of civil government, as well as against the liberty, reason and happiness of mankind, which can flourish only where civil government is able to protect them. . . . The gradual improvements of arts, manufactures, and commerce, the same causes which destroyed the power of the great barons, destroyed in the same manner, through the greater

part of Europe, the whole temporal power of the clergy. . . . Their charity became gradually less extensive, their hospitality less liberal or less profuse. The ties of interest, which bound the inferior ranks of people to the clergy, were in this manner gradually broken and dissolved. . . . As the clergy had now less influence over the people, so the state had more influence over the clergy. The clergy therefore had both less power and less inclination to disturb the state."[15]

For Smith's "perfect liberty" to become a social reality, the temporal power of the church had to be defeated. This occurred in two ways. First, the poor were released from this "oppressive" charity doled out by the church. Second, the power of the church over the educational system had to be broken. Smith derides the fact that the European educational system is "meant for the education of ecclesiastics, and geared toward "a proper introduction to the study of theology." And, he argues, "the greater part of what is taught in schools and universities does not seem to be the most proper preparation for the real business of the world."[16]

For Smith, the advance of freedom requires the loss of the church's influence over the educational system and over the poor. The state accomplished this by confiscating church properties and therefore rendering the church's hospitality less profuse. But then, the state erred by maintaining the church's work of charity through the introduction of what were know as the poor laws. "When by the destruction of monasteries the poor had been deprived of the charity of those religious houses, after some other ineffectual attempts, for their relief, it was enacted by the 43rd of Elizabeth that every parish should be bound to provide for its own poor and that overseers of the poor should be annually appointed, who, with the church-wardens, should raise by a parish rate competent sums for this purpose."[17]

Smith was not as vicious as James Stewart, an earlier economist who "scorned all public charity" and argued that wage-labor alone should discipline the needs of the poor.[18] Smith does not deny the legitimacy of relief. However, the relief of the poor still maintains vestiges of the parish system and thus an unwanted ecclesial interference now mediated through state intervention. To be eligible for poor relief, one had to secure a settlement which demonstrated that one actually lived in that geographical situation, and others could then testify to one's poverty. The poor were not to be strangers, but people who were known by their neighbors. But because such settlements were difficult to come by outside one's parish of origin, the mobility of the labor pool was severely restricted. Therefore, Smith argued for the eradication of the laws of settlement upon which the poor laws depended.[19] For Smith, the poor laws are the residue of the ancient practice of regulating wages by laws or justices. He wants the labor pool de-regulated so that the poor will be able to move off their geographical place of origin to places where labor was in demand.

Although Smith did not himself argue against the need for poor relief, the logic of his "perfectly free" market system led the next generation of economic philosophers to so argue. Daniel Malthus, in his 1798 "Essay on the Principle of Population as It Affects the Future Improvement of Society," developed the "population principle" which stated that population was increasing exponentially while food could only increase arithmetically. A cataclysmic famine was inevitable unless "epidemics, pestilence, and plague advance in terrific array and sweep off their thousands and ten thousands."[20] Thus, Malthus set the "power of population" against the "power of the earth to

provide sustenance." Large families were a threat, and educated people had a duty to limit their reproduction.

Malthus' principle of population had a profound impact on David Ricardo and John Stuart Mill. For Ricardo, who published his *Principles of Political Economy* in 1817, the poor laws "formed the habits of the poor" and caused them to act irrationally by bearing too many children. Thus, these laws need to be abolished. "The clear and direct tendency of the poor laws is in direct opposition to obvious [economic] principles: it is not, as the legislature benevolently intended, to amend the condition of the poor, but to deteriorate the condition of both poor and rich; instead of making the poor rich, they are calculated to make the rich poor; and whilst the present laws are in force, it is quite in the natural order of things that the fund for the maintenance of the poor should progressively increase, till it has absorbed all the net revenue of the country, or at least so much of it as the state shall leave to us, after satisfying its own never failing demands for the public expenditure. This pernicious tendency of these laws is no longer a mystery since it has been fully developed by the able hand of Mr. Malthus and every friend to the poor must ardently wish for their abolition."[21]

The central economic problem for Ricardo is that the poor have too many children. For the sake of the "prudence" necessary for the market system, the government has an obligation to regulate their numbers by refusing to support them. "It is a truth which admits not a doubt, that the comforts and well-being of the poor cannot be permanently secured without some regard on their part, or some effort on the part of the legislatures to regulate the increase of their number and to render less frequent among them early and improvident marriages. The operation of the system of poor laws has been directly contrary to this. They have rendered restraint superfluous, and have invited imprudence by offering it a portion of the wages of prudence and industry."[22]

Notice that not only the economy, but marriage and family are now defined under the virtue of prudence. And prudence now means sexual restraint. Ricardo concludes: "By gradually contracting the sphere of the poor laws, by impressing on the poor the value of independence, by teaching them that they must look not to systematic or casual charity, but to their own exertions for support, that prudence and forethought are neither unnecessary nor unprofitable virtues, we shall by degrees approach a sounder and more healthful state." For the "perfect liberty of the market," the poor laws must be rescinded, and the poor be taught to accept this and live accordingly "with as little violence as possible."[23]

John Stuart Mill, and the so-called Benthamite radicals, perpetuated the idea that a large family is a threat to the free working of the economy. Mill concretizes the intellectual underpinnings for this way of life with his development of that moral philosophy known as utilitarianism. He also makes note in his autobiography, posthumously published in 1873, of his embarrassment that he himself came from a large family. Commenting on his father's life, he wrote: "In this period of my father's life there are two things which it is impossible not to be struck with: one of them unfortunately a very common circumstance, . . . that in his position, with no resource but the precarious one of writing in periodicals, he married and had a large family; conduct than which nothing could be more opposed, both as a matter of good sense and of duty, to the opinions which, at least at a later period of life, he strenuously upheld."[24] Such an impartial and objective

critique of the numbers of his own siblings seems to me sinister. One wonders which siblings he thought it would have been more prudent that his father had not brought into the world.

Notice how Mill and Leo XIII conflict in their understanding of "duty." For Leo, life is a good to be received. Families should have children and even practice social reproduction so that they are open to life, perhaps lots of it. The economy should then serve the interests of those families by providing a just wage that will sustain the entire family. For Mill this is reversed. The economy comes prior to family. The role of the economy is not a function of the family, but the family is a function of the economy. Now we have a duty not to have children until we can be assured that we can provide for them. [25]

The classical, liberal economic philosophers envisioned a world where the social institution of the market would be freed from all interference, whether it be political, moral, theological, or familial. This is the world we have inherited. The fact that Leo XIII recognized the threat this world posed both to the church and to the family makes his work much more than the longings for a defunct hierarchical paternalistic world. Instead, we are reminded of three things. First, economic relations should not be based on prudence alone, but on the virtues of charity and justice. Second, labor is not a commodity, but a prerequisite for the cultivation of virtue. It serves the interest not of the state nor of the market, but of the family. Any wage which prevents a family from fulfilling the necessity of subsistence is intrinsically evil. No amount of future possibilities can justify such exploitative means. Third, the family is one social community that should be freed from infringement by the free market logic. The family holds forth the possibility of an internal good. It is a social community which should not be justified in terms of its usefulness for external ends. The purpose of a family is to be a family. It should not be forced to serve the end of other social institutions. The family is not good because it is the backbone of the state nor because it is the primary consumer or producer for the market nor because it is a feeder system for the military. The family is good because it is a family. [26]

NOTES

[1] The text of *Quamquam Pluries*, Leo XIII's encyclical on St. Joseph, may be found in Francis L. Filas, S.J., *The Man Nearest to Christ: Nature and Historic Development of the Devotion to St. Joseph* (Milwaukee: Bruce Publishing Company, 1944), 168–76. This quotation is at 174.

[2] *Rerum Novarum*, n. 2.

[3] Marx wrote, "The exchange of commodities of itself implies no other relations of dependence than those which result from its own nature. On this assumption, labour-power can appear upon the market as a commodity, only if, and so far as, its possessor, the individual whose labor it is, offers it for sale, or sells it, as a commodity. In order that he may be able to do this, he must have it at his disposal, must be the untrammelled owner of his capacity for labour, of his person" (Karl Marx, *Capital*, vol. 1, [New York: International Publishers, 1973], 168). Marx goes on to critique the so-called freedom of the Benthamites which makes it possible for labor to be reduced to a mere commodity because it is assumed that this is the only property certain people have to sell. "There alone rule Freedom, Equality, Property and Bentham. Freedom because both buyer and seller of a commodity, say of labour-power, are constrained only by their own free will. They contract as free agents, and the agreement they come to, is but the form in which they give legal expression to their common will. Equality, because each enters into relation with the other, as with a simple owner of commodities, and they exchange equivalent for equivalent. Property because each disposes only of what is his own. And Bentham because each looks only to himself" (176). Compare Marx's critique with that of Leo XIII in *Rerum Novarum* when the latter writes: "It is argued that given that the scale of wages is decided by free agreement, it would appear that the employer fulfills the contract by paying the wage agreed upon, that nothing further is due from him and that injustice will be done only if the employer does not pay the full price or the worker does not perform the whole of his task. In these cases and not otherwise it would be right for the political authority to intervene and require each party to give to the other his due. This is an argument which a balanced judgment can neither entirely agree with nor easily accept. It does not take every consideration into account; and there is one consideration of the greatest importance which is omitted altogether. This is that to work is to exert oneself to obtain those things which are necessary for the various requirements of life and most of all for life itself. . . . Thus, human work has stamped upon it by nature, as it were, two marks peculiar to it. First, it is personal, because the force acting adheres to the person acting; and therefore it belongs entirely to the worker and is intended for his advantage. Second it is necessary because man needs the results of his work to maintain himself in accordance with a command of nature itself which he must take particular care to obey. . . . Let worker and employer, therefore, make any bargains they like, and in particular agree freely about wages; nevertheless, there underlies a requirement of natural justice higher and older than any bargain voluntarily struck: the wage ought not to be in any way insufficient for the bodily needs of a temperate and well-behaved worker. If, having no alternative and fearing a worse evil, a workman is forced to accept harder conditions imposed by an employer or contractor, he is the victim of violence against which justice cries out" (*Rerum Novarum*, nn. 44–45).

[4] *Rerum Novarum*, nn. 44–45.

[5] Jeremy Bentham, *Defense Against Usury* in his *Economic Writings*, vol. 1, edited by W. Stark (London: The Royal Economic Society, 1952), 163.

[6] Notice that Pope John Paul II, in *Veritatis Splendor*, n. 80, repeats that "degrading conditions of work which treat labourers as mere instruments of profit and not as free responsible persons," as well as "subhuman living conditions" are both examples of "intrinsically evil acts." Here he quotes from the Second Vatican Council's document *Gaudium et Spes*, n. 27.

[7] The argument for and against private ownership usually takes place with little intelligent reflection. The question is not whether we have private ownership or not; the question is what is held private and what public. Most people desire that basic resources like toothbrushes, undergarments, and deodorant be one's own private property. Likewise, most of us desire that our personal libraries, homes, bicycles, and automobiles remain at our disposal. The more difficult question arises when we come to those industries that are necessary for our survival, or when we discuss so-called "public" utilities and modes of transportation, such as buses, trains, and planes. In the United States today, roads are basically socialized although this was not always the case, and in Mexico today the creation of roads occurs through private companies that then ask for tolls. Often dirt roads develop next to those private roads since many cannot afford the toll. Few people would argue that educational systems, police forces, judicial courts, and military organizations should be privatized, although they often serve private interest. The question, then, is not do we have private property, but what industry is to be "privatized" such that we have no control over it in any publicly recognizable way. In fact, a careful analysis of Marx's teachings argues for something quite similar to Leo XIII when it comes to the personal aspect of labor. Leo thought workers should have more power of disposal over the products they created. Marx stated something quite similar to this when he wrote, "the transformation of the individualised and scattered means of production into socially concentrated ones, of the pigmy property of the many into the huge property of the few, the expropriation of the great mass of the people from the soil, from the means of subsistence, and from the means of labour, this fearful and painful expropriation of the mass of the people forms the prelude to the history of capital. Self-earned private property, that is based, so to say, on the fusing together of the isolated, independent labouring-individual with the conditions of his labour, is supplanted by capitalistic private property, which rests on exploitation of the nominally free labour of others, i.e. on wage-labour" (*Capital*, 1:762). Marx and Leo XIII would agree that "Self-earned private property, that is based, so to say, on the fusing together of the isolated, independent labouring-individual with the

conditions of his labour" is the goal of a just economic order. They would disagree over the possibility of this kind of private property in a capitalistic order. Marx thought it was impossible. Leo XIII thought the church's teaching could make the adjustments necessary to the economy so that this kind of private property would be more generally distributed. Then one's possessions, one's property, would be a direct function of one's labor and not merely one's access to credit financed endeavors. In fact, this is the same reason for the usury proscription which was carefully explained in Bernard Dempsey, S.J., *Profit, Interest and Usury* (Washington, D.C.: American Council on Public Affairs, 1943).

[8] Leo writes, "It follows that when socialists endeavor to transfer privately owned goods into common ownership they worsen the condition of all wage-earners. By taking away from them freedom to dispose of their wages they rob them of all hope and opportunity of increasing their possessions and bettering their condition" (*Rerum Novarum*, n. 4.) Marx and Leo XIII agreed that the capitalist order was destroying the family, but Marx thought the conflict between the "market" and the family would result in a stronger and better form of family relations: "modern industry, in overturning the economic foundation on which was based the traditional family, and the family labour corresponding to it, had also unloosened all traditional family ties. . . . It was not, however, the misuse of parental authority that created the capitalistic exploitation, whether direct or indirect, of children's labour; but, on the contrary, it was the capitalistic mode of exploitation which, by sweeping away the economic basis of parental authority, made its exercise degenerate into a mischievous misuse of power. However terrible and disgusting the dissolution, under the capitalist system, of the old family ties may appear, nevertheless, modern industry, by assigning as it does an important part in the process of production, outside the domestic sphere, to women, to young persons and to children of both sexes, creates a new economic foundation for a higher form of the family and of the relations between the sexes. It is, of course, just as absurd to hold the Teutonic-Christian form of the family to be absolute and final as it would be to apply that character to the ancient Roman, the ancient Greek or the Eastern forms which, moreover, taken together form a series in historical development. Moreover, it is obvious that the fact of the collective working group being composed of individuals of both sexes and all ages, must necessarily, under suitable conditions, become a source of humane development" (*Capital*, 1:490).

[9] The financiers, that is, super-efficient accountants like John Pierpont Morgan, are the wielders of power in the 1890s. This power is not based on birth, nobility, or any traditional hierarchical ordering. It solely stems from "free" competition. In the panic of 1893, then president Grover Cleveland had to call upon Morgan to get the United States out of trouble when a run on gold threatened the economic viability of the nation. See H. W. Brands, *The Reckless Decade* (New York: St. Martin's Press, 1995.)

[10] As can be clearly seen from his *Theory of Moral Sentiments*, Smith's free market system contained an explicit theology. He wrote: "The ancient stoics were of opinion, that as the world was governed by the all-ruling providence of a wise, powerful and good God, every single event ought to be regarded, as making a necessary part of the plan of the universe, and as tending to promote the general order and happiness of the whole: that the vices and follies of mankind, therefore, made as necessary a part of this plan as their wisdom or their virtue; and by that eternal art which educes good from ill, were made to tend equally to the prosperity and perfection of the great system of nature" (*Theory of Moral Sentiments* [Indianapolis: Liberty Fund, 1982], 36). To argue that Smith freed the market from theological interference is incorrect. He freed it from church interference, but the free market still serves the interests of a stoic theology.

[11] Adam Smith, *Wealth of Nations* (New York: The Modern Library, 1965), 66.

[12] Laborers, suggest Smith, "have always recourse to the loudest clamour, and sometimes to the most shocking violence and outrage. They are desperate, and act with the folly and extravagance of desperate men, who must either starve, or frighten their masters into an immediate compliance with their demands. The masters upon these occasions are just as clamorous upon the other side, and never cease to call aloud for the assistance of the civil magistrate, and the rigorous execution of those laws which have been enacted with so much severity against the combinations of servants, labourers and journeymen. The workmen, accordingly, very seldom derive any advantage from the violence of those tumultuous combinations. . . ." (*Wealth of Nations*, 67). This conflict is accepted as inevitable and built in to the system. The papal teachings conflict with both the free market system and Marxism on this point. They consistently argue, beginning with *Rerum Novarum*, that the relationships within the economy should be based on cooperation, peace, and harmony, not on conflict and antagonism.

[13] For an excellent discussion of this, see Bernard Dempsey, S.J., *The Functional Economy* (Englewood Cliffs: Prentice-Hall, 1958).

[14] *Wealth of Nations*, 71.

[15] *Wealth of Nations*, 755-57.

[16] Smith writes: "In the ancient philosophy the perfection of virtue was represented as necessarily productive, to the person who possessed it, of the most perfect happiness in this life. In the modern philosophy it was frequently represented as generally, or rather as almost always inconsistent with any degree of happiness in this life; and heaven was to be earned only by penance and mortification, by the austerities and abasement of a monk; not by the liberal, generous, and spirited conduct of a man. Casuistry and an ascetic morality made up, in most cases, the greater part of the moral philosophies of the schools. By far the most important of all the different branches of philosophy, became in this manner by far the most corrupted. . . . The alterations which the universities of Europe thus introduced into the ancient course of philosophy, were all meant for the education of ecclesiastics, and to render it a more proper introduction to the study of theology. But the additional quantity of subtlety and sophistry; the casuistry and the ascetic morality which those alterations introduced into it, certainly did not render it more proper for the education of gentlemen or men of the world, or more likely either to improve the understanding , or to mend the heart. . . . The greater part of what is

taught in schools and universities, however, does not seem to be the most proper preparation for the real business of the world" (*Wealth of Nations*, 726).

17 *Wealth of Nations*, 135-36.

18 See John Milbank's *Theology and Social Theory* (Oxford: Basil Blackwell, 1990), 34-37.

19 Smith wrote: "The obstruction which corporation laws give to the free circulation of labour is common, I believe, to every part of Europe. That which is given to it by the poor laws is, so far as I know, peculiar to England. It consists in the difficulty which a poor man finds in obtaining a settlement, or even in being allowed to exercise his industry in any parish but that to which he belongs. The difficulty of obtaining settlement obstructs even that of common labour" (*Wealth of Nations*, 135).

20 Robert Heilbronner, *The Worldly Philosophers: The Lives, Times and Ideas of the Great Economic Thinkers* (New York: Simon and Schuster, 1986), 90.

21 David Ricardo, *On the Principles of Political Economy and Taxation* (New York: Cambridge University Press, 1990), 106.

22 Ricardo, 107.

23 Ricardo, 108-109.

24 John Stuart Mill, *Autobiography* (London: Penguin Books, 1989), 26.

25 If this analysis is correct, and if this is the world we have inherited, then, Catholic families are placed in a bind. They live within a Church that teaches them to be open to children and that the economy should provide the means by which life can be received. And they live in an economy which seeks to discipline us against children by habituating "prudence" into us as late marriage, few children, and sexual restraint (or non-procreative sexual activity). Given this bind, it seems to me, Catholics are tempted to turn against the teaching of the Church and not recognize that sexuality can serve the interest of the economy by adopting the sexual practices perpetuated by the market's discipline.

26 The family is one social institution that remains somewhat impervious to the detrimental effects of Adam Smith's cultural logic. Few of us who are parents make decisions about our children's health care, nourishment, or education based on the anticipated marginal return of our investment. Even though Smith's free market system has greatly impacted the size of our families and we often perpetuate the moral condemnation of large poor families, we still recognize the family as a place where relations should not be based on the logic of commodities.

Without a doubt there is in the papal encyclicals an idealization of the family. I admit that many families do not promote the internal good of togetherness. Too many families embody the opposite tendency, which Sartre pointed out when he called the family the "hell-hole of togetherness." But I don't find this to be a decisive critique of Leo XIII. The fact that many families do not embody the ideal provides more need for an ideal against which the abuse of the family should be checked. Certainly, the papal teachings on the family can be unfairly used to thoroughly privatize the family. This can result in an unchecked form of violence and abuse where the family becomes the domain of the father, his castle, and he rules as a tyrant. Unfortunately, the history of the family also includes this narrative. This is found in our everyday speech. The term "rule of thumb" comes from English common law where a husband was not guilty of abuse for beating his wife unless he used a stick larger than his thumb. Also the famous nursery rhyme, "Peter Piper pumpkin eater had a wife and couldn't keep her, so he put her in a shell and there he kept her very well" is a story about keeping one's wife pregnant and in the kitchen so that she can deliver the goods the husband enjoys. If the family is to serve as an economic alternative it cannot be merely the patriarchal family that serves the interest of the father alone. And this is accomplished when the role of the father is not only breadwinner but also breadmaker.

Nor should the family be turned into a salvific institution. Only the church, and not the family offers salvation. To ask the family to save, is to destroy its internal good by placing upon it a burden it cannot and should not bear. Nevertheless, the family remains one place where virtue can be cultivated. But this requires that the social institution of the family should be free as an internal good, and that commodities should serve the interest of the family. This cannot happen when commodities are kept free, and the family is forced to serve their interest.

THE IGNATIAN-SALESIAN IMAGINATION AND FAMILIED LIFE

Wendy M. Wright

It seems fitting, in the context of a symposium which invites us to gaze upon devotional images of the Holy Family, to approach the contemporary question of family spirituality from the vantage point of imagery, specifically from the vantage point of the Ignatian-Salesian imagination. Thus, the purpose of this brief paper is, first, to suggest what the imaginative world of the historic Ignatian and Salesian spiritual traditions might be. And, second, to consider the contemporary family in light of that imaginative world. For we do not only gaze *upon* images, but we gaze *through* images as well. That is, we encounter and interpret our human experiences through the medium of imaginative lenses. Just as a photographer does not simply record what is "real," but selects, filters, highlights, and takes a perspective on what she sees from behind the camera, so too we take a perspective, we *see into* our world with eyes (and hearts and minds) adjusted according to the images we live by most intimately. However, a fine photographer does not set out merely to photograph what he *imagines* should be visible through his lens. Rather, there is a delicate interplay between what is discovered and what is imagined to be there. What is seen shapes how the artist sees, and vice versa. How the artist sees shapes what is seen.

The same is true for the creative process of fashioning a "spiritual picture" of the family. What is seen will influence our portrait as much as what we expect to see. In the interplay between the real and the ideal, we find ourselves in the presence of the Spirit.

THE IGNATIAN-SALESIAN IMAGINATION

Ignatius of Loyola (1491-1556), famed as the founder of the Society of Jesus, and Francis de Sales (1567-1622), most remembered as the author of the devotional classic *Introduction to the Devout Life,* may be said to be the founders of the Ignatian and Salesian spiritual traditions.[1] Both lived in

the period of the Catholic or Counter Reformation, a period of intense Christian humanism. Christian humanism takes a positive view of the created world and of human nature. It assumes that the world is fundamentally revelatory of divine life and God-directed, that human talents and capacities are given by God to go to God, and that they must be cultivated for that great task. In other words, the mystery of the Incarnation—the mystery of divinity revealed in humanity—is taken seriously in the Christian humanist agenda.[2] Both Ignatius of Loyola and Francis de Sales espoused a profoundly incarnational, sacramental, and dynamic spirituality. They expected to see divine life imaged and revealed in what is most human. In their view, one did not need to withdraw from the immense beauty and terror of created life to seek a glimpse of the holy; one sought that glimpse precisely *within* the fabric of created life. God was to be found in all things. The entire world was thus sacramental—a visible sign of invisible, indwelling presence—and human beings were to awaken to this mystery and dedicate themselves in active service to its full realization. They were to cultivate contemplation in action.

To put it another way, at the theological heart of the Ignatian-Salesian imagination is the incarnational insight that to encounter the infinite one must go through the finite. Not around or above or below the finite. Not bypassing or eliminating the finite. But through it, in all its unique, unrepeatable particularity. The finite and the infinite are simultaneously encountered in this imaginative apprehension. The startling truth of the Incarnation, fully human-fully divine, becomes a lens through which all created reality is apprehended as fully human-fully divine. Thus, the finite is the privileged place of encounter with God.[3]

Consequently, for both of these spiritual masters, the imagination—the human faculty that can elicit this kind of sacramental vision—and its proper formation was of paramount concern. Ignatius fashioned a series of *Spiritual Exercises* focused upon the life, death, and resurrection of Jesus—the image of God with us—which exercised the imagination. The *Exercises* allowed those practicing them to finely hone their own imaginative capacities for seeing so that the radical ever present truth of the Incarnation—God's indwelling—might then be perceived within the ordinary fabric of everyday life.

The most prominent image of Jesus that emerged from Ignatius' own rendering of the *Exercises* is that of Jesus tempted in the wilderness. Given the choice between privilege, power, and possessions gained in service to the "world" (and the devil), and humility, powerlessness, and poverty associated with God's kingdom, Jesus chose the latter. It follows then (in Ignatius' mind) that the followers of Jesus, faithful to the incarnate God imaged for them, will likewise choose humility, powerlessness, and poverty in the service of God's coming kingdom. Free from the need to acquire privilege, power, and possessions, they will be truly free to serve in love where they are needed.

Ignatius, of course, was building upon a well established medieval devotional tradition of imaginative meditation upon the Passion of Christ. But he perfected the practice almost to the status of an art form. His *Exercises* were disseminated not only by the members of the Society of Jesus, but also by the pupils in the numerous schools that the Society founded. Francis de Sales was a student at the Jesuit College of Clermont in Paris, and he was schooled there not only in the humanistic curriculum, but also in the imaginative world of the *Spiritual Exercises*. When Francis

gazed on Jesus and allowed what he saw to inform and form his own seeing, his focus fell on the Jesus imaged in Matthew 11:28-30: the Jesus who was gentle and humble of heart. Francis developed a comprehensive spirituality centered on the heart of the gentle Savior, who, in his eyes, most clearly expressed the choice of humility, poverty, and powerlessness. Francis believed that human hearts were created to beat in concert with the heart of God. Divine love inclined toward creation, and creation was in turn fashioned to incline lovingly toward God. Human hearts loved most authentically when they loved as Jesus did—with a gentle, loving heart. To love in this way was to let Jesus live. Consequently, Francis' motto was "Vive Jesus!" Salesian spirituality, like Ignatian, assumed that the entire created world provides the opportunity for sacramental encounter. Anyone, in any walk of life, could realize the love of God fully in the duties of his or her "state in life." This included the family. Being responsive to the "will of God," as it was manifest in the particular responsibilities of one's life, constituted the path. The path was to be walked in the manner of the gentle Jesus. With liberty of spirit—without inordinate attachments or the need to acquire power, possessions, and privilege—one would be able to respond generously to the will of God as expressed in one's ordinary life. And with a gentle heart one could love as one was loved, with infinite tenderness and compassion. Salesian spirituality, therefore, focused on the "little virtues"—the kind, patient, thoughtful, relational gestures—that cumulatively create a kingdom of charity among those who practice them. This kingdom was made manifest in community, but it began in the hidden recesses of the heart. The real transformation was interior, and the disciple, one for whom gentleness and humility were habits of the heart. Ordinary, unobtrusive, requiring great determination, Francis' spiritual vision was, nonetheless, radical, as it imagined a transformed humanity through its appropriation of the heart of the gentle, humble Jesus.[4]

THE CONTEMPORARY FAMILY

Neither Ignatius of Loyola or Francis de Sales was a familied man. Both embraced celibacy as their religious visions matured. Nor did either of them design a spiritual program exclusively for familied people, although Salesian spirituality is not linked to any particular lifestyle and is seen to be applicable to persons in all walks of life. Moreover, Francis wrote his famous manual, *Introduction to the Devout Life*, mindful of the spiritual needs of the laywomen who consulted him, most of whom were familied. He suggested to them a variety of spiritual practices and taught them how to integrate religious devotion into the fabric of their everyday lives, cultivating a recollected heart (i.e., realizing the heart of Jesus) while busily engaged in the activities of the world. He encouraged them to be fully present to both temporal and eternal realities at one and the same time.

But, as eloquent as it is, it is not Francis de Sales' specific advice that, to my mind, forms the surest basis for a contemporary spirituality of family. Rather, it is the underlying imaginative vision, the "deep grammar" of his writing that speaks most profoundly. And much of the deep grammar he shared with his predecessor Ignatius.

That deep grammar, first of all, affirms that any contemporary spirituality of family must take seriously the idea of "finding God in all things." This leitmotif of the Ignatian tradition finds its echo in Francis de Sales' insistence that "it is an error, or rather a heresy, to try to banish the devout life

from the regiment of soldiers, the shop of the mechanic, the court of princes or the home of married folk."[5] In other words, in family God is discovered not primarily by "journeying" into some far-off wilderness, distant from where most of us presently live. Nor is God met solely in the solitary one-on-one encounter or in some disembodied "spiritual" arena clearly demarcated from the fierce, conflicting pressures of society. A proper spirituality of family does not necessarily look "churchy" or pious. It does not mimic monastic spirituality and seek to cultivate disinterested love. Rather, it emerges from the dynamics of life specific to family. It is about intense, intimate community, bodies intermingled and conjoined, the noise and busyness of providing, caretaking, and stewarding, the complexities of intergenerational struggle, the love of particular persons. It is about dwelling in one place for a long time with a community of not always like-minded people, about immersion in the conflicting, sometimes soul-devouring dynamics of the social, political, and economic world. The spiritual lessons of family are thus derived from the experiences of being very much "in the world," not apart from it. Those lessons are legion. They include, among others, the spiritual arts of welcoming and letting go and of intimacy and otherness, the enactment of rituals of mutual need and nourishment, the contemplation of the "isness of things," and, especially, the continual practice of radical forgiveness.[6]

Similarly, the deep grammar of the Ignatian-Salesian spirit impels one to locate a contemporary spirituality of family within the family as it really is, rather than within the family as it might ideally be. In other words, one must find God in the finite, in the particular, in the real. One cannot identify the presence of God with the perfect family of the right size, configuration, achievement, or functionality. Instead, one must become attentive to the animating presence of God wherever it is uncovered—in the touch of mercy, grace, forgiveness, and healing that emerges from within each unique community of persons that call themselves a family.[7]

Thus, a diversity of family forms and lifestyles will be revelatory. For it is not only the much lauded nuclear family that can mediate God's presence, but the extended, blended, single parent, childless, and complex family as well. One can be "surprised by the joy" there (to use C. S. Lewis' phrase), not to the extent that one discovers what is expected but to the extent that one deeply engages with the mysterious *particularity* of persons in family. In other words, one must love what *is*. Not what might be or ought to be. Love is to be found amid all the wonder and the warts and idiosyncrasies and failings and gifts and fleshiness of it all.

Ignatian and Salesian spirituality invite us into this sort of intense sacramental encounter with the particular. Francis de Sales himself has been said to have practiced spiritual direction in the belief that each person who came to him was a unique "world" into him/herself. He never directed two people in quite the same way, but always respected the autonomy of conscience and the integrity of individual difference.[8] Similarly, one of Ignatius' later spiritual sons, the Jesuit poet Gerald Manley Hopkins, developed the concept of "inscape," the infinitely wondrous and particular beauty of any created place which reveals itself to the artist-poet's responsive eye. An Ignatian-Salesian spirituality of family might justly approach the contemporary family with the artist-poet's eye which discovers the grandeur of God enfleshed in the irreducible particularity of each concrete family.

Finally, such an imagination encourages one to identify the presence of God in family with all that is humble, poor, and powerless, or, to give it the Salesian twist, with all that is gentle and lowly

of heart. Most obviously, this means that divine presence can be identified in family with the sacrament of the care of others, with the mutual sacrifices and loving service performed on each other's behalf, in the hospitality offered to those outside the family, in the rituals of mutual need and nourishment enacted at the family table, in the solicitous protection and instruction of the young and the honor and care given to the elderly. The kingdom can be recognized in the cultivation of the "little virtues" of relational attentiveness.

Less obviously, divine presence can be also discovered in family life in all that is broken, wanting, and lost: in the unexpected and hidden pockets of pain and abandonment, in estrangement, loss, and privation. These too are lowly places where we can be made vulnerable enough to know our need of God and one another. An Ignatian-Salesian imagination encourages such a vision. For these spiritual traditions suggest that humiliation (Ignatius' term) and abjection (Francis' term) are priviledged places of divine-human encounter. While it is certainly part of the spiritual quest to repair and restore all that blights and diminishes the family, it does not follow that only the separated, the perfected, or the ideal family can be said to be spiritual. While affirming the good done in striving to achieve the ideal, Francis de Sales taught a practice he referred to as "loving your abjections" which invites one to embrace in great trust and gratitude all that will not or cannot change. There, in the deep humility of lack and needfulness, one creates an entryway for that which God alone can provide.

The Ignatian-Salesian imagination suggests that such a spirituality of family first takes root in the inner recesses of the heart. It challenges contemporary familied people to cultivate a profoundly contemplative vision of their own lives, to gaze with eyes opened and imaginations awakened to the presence of divine life in the midst of the density and complexity of their everyday lives. They must become contemplatives in action.[9]

The deep grammar of the Ignatian-Salesian imagination can inform our seeing when we consider the contemporary family. Profoundly incarnational and sacramental and thus open to finding God in the midst of the world, convinced that finitude and particularity give us priviledged access to infinity and thus embracing of the wide diversity of familied experience, partial to the humble, the gentle, the hidden, and the poor and thus attentive to the divine touch in both the ordinary gestures of human caretaking and in the depth of human suffering, this imaginative world dares us to open our eyes to the holiness made visible through all human families.

NOTES

[1] Primary sources for these two are found in *Oeuvres de St. François de Sales*, 27 vols. (Annecy: J. Niérat et al., 1892-1964), and *Monumenta Historica Societas Iesu*, the historical records or sources of the Society of Jesus in critically edited texts, most of them from the Society's Archives in Rome. This scholarly series of 131 volumes was begun in Madrid in 1894 and transferred to Rome in 1929, where it is being continued by the Jesuit Historical Institute. In other contexts, I have argued that the Salesian tradition was collaboratively founded by both Francis de Sales and Jane de Chantal: see, e.g., *Francis de Sales, Jane de Chantal: Letters of Spiritual Direction*, edited and introduced by Wendy M. Wright and Joseph F. Power, O.S.F.S., translated by Péronne-Marie Thibert, V.H.M. (New York: Paulist Press, 1988). However, as indicated in that volume, Jane's perspective is somewhat variant from that of her mentor. She breathes more the air of the later French School, and this air is quite distinctive from the air one breathes in an Ignatian atmosphere. Therefore, for the purpose of linking the Ignatian and Salesian imaginations I will look primarily to Francis, which is the perspective scholars traditionally have taken. For a discussion of Francis de Sales and his kinship to Ignatius, see F. Charmot, S.J., *Ignatius Loyola and Francis de Sales: Two Masters, One Spirituality*, translated by Sr. M. Renelle, S.S.N.D. (St. Louis: Herder, 1966). On Francis' relationship to the French School, see Wendy M. Wright, "The Salesian and Bérullian Spiritual Traditions" in *Alive for God in Christ Jesus: Proceedings of the Conference on the Contemporary Significance of the French School of Spirituality, 1995* (Buffalo: John Eudes Center, 1995), 157-68.

[2] On the Christian humanism of this era, see the works of Henri Bremond, *L'humanisme dévot (1589-1660)*, vol. 1 of *Histoire littéraire du sentiment religieux en France depuis la fin des guerres de religion jusqu'à nos jours* (Paris: Bloud et Gay, 1921) (English translation [London: Society for Promoting Christian Knowledge, 1930]), and *Autour de l'humanisme d'Erasme à Pascal* (Paris: Éditions Bernard Grasset, 1937); Julien Eymard d'Angers, *L'humanisme chrétien au XVII siècle: St. François de Sales et Yves de Paris* (La Haye: Martinus Nijhoff, 1970); Cecelian Streebing, *Devout Humanism as a Style: St. François de Sales' Introduction à la vie dévote* (Washington, D.C.: Catholic University of America Press, 1954).

[3] This characterization might be made of the Catholic imagination in general. William Lynch has characterized it thusly in "Theology and the Imagination," *Thought*, 29 (Spring 1954): 61-86, and "The Imagination and the Finite" *Thought*, 33 (Summer 1958): 205-26. However, I would suggest that this imaginative perspective, while present in one form or another in most Catholic spiritual traditions, is perhaps most vividly exhibited in the Ignatian-Salesian world.

[4] John A. Abruzzese, *The Theology of Hearts in the Writings of St. Francis de Sales* (Rome: Institute of Spirituality, Pontifical University of St. Thomas Aquinas, 1983), has thoroughly discussed the saint's doctrinal presentation on love using the heart as a synthesis. Henri Lemaire's *Étude des images littéraires de S. François de Sales* (Paris: Éditions A.G. Nizet, 1969) is a useful compendium of Salesian imagery. Also see Wendy M. Wright, "'That Is What It Is Made For': The Image of the Heart in the Spirituality of Francis de Sales and Jane de Chantal," in *Spiritualities of the Heart: Approaches to Personal Wholeness in Christian Tradition*, edited by Annice Callahan, R.S.C.J. (New York: Paulist Press, 1990), 143-58.

[5] Francis de Sales, *Introduction to the Devout Life*, translated by John K. Ryan, (New York: Image Books, 1955), 40.

[6] For a thorough treatment of family spirituality, see Wendy M. Wright, *Sacred Dwelling: A Spirituality of Family Life*, 2nd revised edition, (Leavenworth: Forest of Peace Publishing, 1994). Other excellent attempts to delineate family spirituality are Ernest Boyer, *Finding God at Home: Family Life as Spiritual Discipline* (New York: Harper & Row, 1984); Dolores Leckey, *The Ordinary Way* (New York: Crossroad, 1982); Mitch and Kathy Finley, *Christian Families in the Real World* (Chicago: Thomas More Press, 1984) and *Your Family in Focus* (Notre Dame: Ave Maria Press, 1993); Gertrude Mueller Nelson, *To Dance with God: Family Ritual and Community Celebration* (New York: Paulist Press, 1986); and Margaret Hebblethwaite, *Motherhood and God* (San Francisco: Harper & Row, 1984). Forgiveness has been cited, in *Family Spirituality: The Sacred in the Ordinary*, A Report of the National Association of Catholic Diocesan Family Life Ministers, 1984, as the single most significant dynamic of family life.

[7] On this, see Wendy M. Wright, *"Living the Already but Not Yet: The Spiritual Life of the American Catholic Family,"* Warren Lecture Series in Catholic Studies, no. 25 (University of Tulsa, 1993).

[8] These issues are explored in Wendy M. Wright, "Salesian Spirituality and the Art of Spiritual Direction," *Studies in Spirituality* (Louvain, Belgium), no.6 (1996): 194-219, as well as "Jane de Chantal's Guidance of Women: The Community of the Visitation and Womanly Values," in *Modern Christian Spirituality: Methodological and Historical Essays*, edited by Bradley C. Hanson (Atlanta: Scholars Press, 1990), 113-38.

[9] On the topic of the cultivation of a contemplative attitude, see Padraic O'Hare, *The Way of Faith: Contemplation and Formation in the Church* (Valley Forge: Trinity Press International, 1993).

CONTRIBUTORS

Barbara von Barghahn is Professor of Art History at George Washington University, Washington, D.C.

Joseph F. Chorpenning, O.S.F.S., is Editorial Director of Saint Joseph's University Press, Philadelphia.

Roland Gauthier, C.S.C., is Director *emeritus* of the Centre de Recherche et de Documentation, St. Joseph's Oratory, Montreal, and founding Editor of the *Cahiers de Joséphologie.*

D. Stephen Long, formerly Assistant Professor of Theology at Saint Joseph's University, Philadelphia, is Assistant Professor of Systematic Theology at Garrett-Evangelical Theological Seminary, Chicago.

Thomas M. Lucas, S.J., is founding Chair of the Fine and Performing Arts Department at the University of San Francisco; from 1988 to 1991 he designed and supervised the architectural restoration of the Rooms of St. Ignatius Loyola in Rome.

Scott R. Pilarz, S.J., is Assistant Professor of English at Georgetown University, Washington, D.C.

John Saward, formerly Professor of Systematic Theology at St. Charles Borromeo Seminary, Philadelphia, is Professor of Dogmatic Theology at the International Theological Institute in Gaming, Austria.

Carlos A. Sevilla, S.J., is Bishop of Yakima (Washington) and a member of the U. S. Bishops' Committee on Marriage and Family Life.

Christopher C. Wilson recently received his Ph.D. in Art History from George Washington University, Washington, D.C.; the subject of his doctoral thesis was the iconography of St. Teresa of Ávila in Mexican Colonial Art.

Wendy M. Wright is Professor of Theology at Creighton University, Omaha, Nebraska.